The Art of Drawing
Dragons

Mythological Beasts and Fantasy Creatures

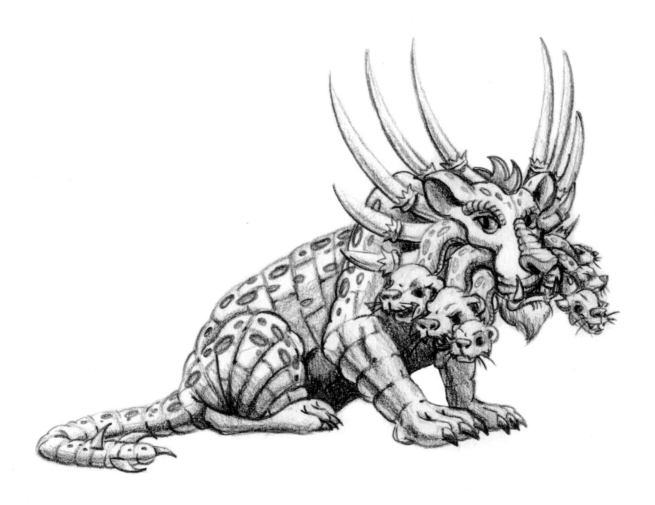

The Art of Drawing
Dragons

Mythological Beasts and Fantasy Creatures

WALTER FOSTER PUBLISHING, INC.

3 Wrigley, Suite A
Irvine, CA 92618
www.walterfoster.com

CONTENTS

Getting Started

In this book, you'll find a wealth of different types of dragons, mythological beasts, and fantasy creatures, which I've categorized using the more common terms and definitions from role-playing games, fantasy books, video games, and mythological tales. The exercises in this book are designed to be accessible to all—no matter how ambitious the final drawings may seem, they all are broken down into simple, step-by-step instructions. Over the next few pages, you'll discover a little about my methods for drawing these fanciful creatures, including how to build on basic shapes and apply different shading techniques. And you'll learn how to get the most out of a variety of media—from charcoal pencil to India ink—so you can make your dragon drawings the best they can be.

TOOLS AND MATERIALS

One of the great joys of drawing is that you can do it just about anywhere. There is a wide array of time-tested materials available for the amateur and professional artist alike, from pencils and papers to erasers and sharpeners. You get what you pay for, so purchase the best you can afford at the time, and upgrade your supplies whenever possible. Although anything that will make a mark can be used for some type of drawing, you'll want to make certain your magnificent efforts will last and not fade over time. And, if you want to give your dragon drawings a bit more pizzazz, there are materials such as ink, charcoal, and watercolor paint that can be used to do just that. Here are some of the materials that will get you off to a good start.

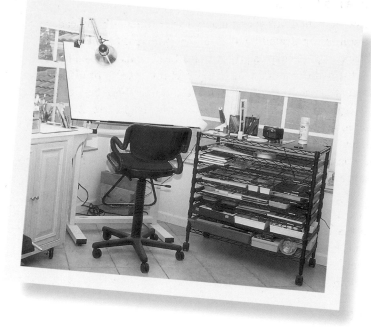

▶ **Sketch Pads** Conveniently bound drawing pads come in a wide variety of sizes, textures, weights, and bindings. They are particularly handy for making quick sketches. Medium-grain paper texture (which is called the "tooth") often is an ideal choice for practice sketches.

▲ **Work Station** You don't need a studio to draw, but it is a good idea to set up a work area with good, natural lighting and enough room to spread out your tools and materials. When drawing at night, you can use a soft white light bulb and a cool white fluorescent light to provide both warm (yellowish) and cool (bluish) light. You'll also need a comfortable chair and a table (preferably near a window). You may want to purchase a drawing board that can be adjusted to different heights and angles, as shown above—but it isn't necessary.

▶ **Drawing Papers** For finished works of art, it's best to use single sheets of drawing paper, which are available in a range of surface textures: smooth grain (*plate finish* and *hot pressed*), medium grain (*cold pressed*), and rough to very rough. Depending on the media you use, you may want to experiment with different textures; rough paper is ideal when using charcoal, whereas smooth paper is best for ink.

Vinyl eraser

Art gum eraser

Kneaded eraser

◀ **Artist's Erasers** Different erasers serve different functions; you'll want a few different kinds on hand. You can form a kneaded eraser into small points to remove marks in tight areas. A vinyl eraser removes pencil marks thoroughly, and it serves as a workhorse for me. An art gum eraser crumbles easily, so it is less likely to mar the paper's surface—use this when doing a lot of erasing!

◀ **Ink** To add dynamism to my artwork, I sometimes incorporate India ink, which is available in bottles. For dark, permanent lines, apply pure (undiluted) India ink with a paintbrush. I also sometimes dilute the ink with water to apply a thin, light gray tone (called a "wash"). These washes also help add depth to a drawing.

▶ **Tortillons** These paper tools (also called "blending stumps") can be used to blend and soften pencil strokes in small areas where your finger or a cloth is too large. You also can use the sides to quickly blend large areas. After use, gently rub dirty stumps on a cloth to remove excess graphite.

▲ **Color Blender** A *color blender* is a soft, rubber-tipped tool that is designed to manipulate paint on canvas. In pencil drawing, it comes in handy for making deliberate, controlled smudges.

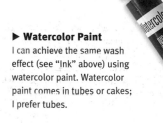

▶ **Watercolor Paint** I can achieve the same wash effect (see "Ink" above) using watercolor paint. Watercolor paint comes in tubes or cakes; I prefer tubes.

DRAWING PENCILS

Drawing pencils are classified by the hardness of the lead (graphite), indicated by a letter. The soft leads (labeled B for "black"—or perhaps also "breaks a lot!") make dense, black marks, and the hard leads (labeled H for "hard") produce very fine, light gray lines. An HB pencil is somewhere between soft and hard, making it an excellent tool for beginners. A number accompanies the letter to indicate the intensity of the lead—the higher the number, the harder or blacker the pencil. To start, purchase a minimum of three pencils: 2B, HB, and H. Any of the leads can be sharpened into the points illustrated at right, but you'll get a different quality of line depending on the hardness of the lead and the texture of your paper. Make some practice strokes with various tips and leads to see the differences among them. Aside from graphite pencil, you also can use a charcoal pencil for very dark black marks or a colored pencil for softer black marks.

INK PENS

When I want to define my pencil lines with ink but want more control, I use waterproof ink pens. These pens are available in a variety of tip sizes, each with its own function. If you're looking for lighter, thinner lines, you even can use a regular ballpoint writing pen!

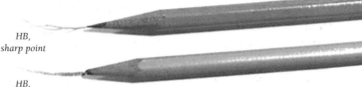

HB, sharp point

HB, dull point

HB An HB pencil with a sharp point produces crisp lines, offering a good amount of control. With a dull point, you can make slightly thicker lines and shade small areas.

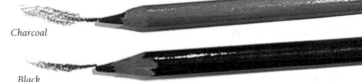

Charcoal

Black colored pencil

Charcoal and Colored Pencil Charcoal is very soft, so it smudges easily and makes a dark mark. A black colored pencil has a waxy binder that resists smudging, to a degree—as a result, colored pencil is rather difficult to erase.

Permanent marker

Permanent Marker The line produced by a permanent marker is bold, thick, and very easy to control. The ink of many "permanent" markers will fade over time, so you may want to spray your drawing with fixative.

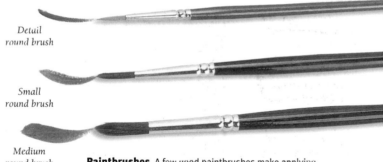

Detail round brush

Small round brush

Medium round brush

Paintbrushes A few good paintbrushes make applying ink more enjoyable. Round brushes like these taper to a natural tip—purchase them in a variety of sizes, from very small for adding details to medium for filling in larger areas.

Waterproof Ink Pens
The thicker tips of waterproof ink pens (such as the .5 mm) are great for creating heavy lines, whereas the finer points (such as the .2 mm tip) are best for detail lines and small areas. Medium tips (such as .3 mm) offer more versatility, as you can use the side of the pen for thicker lines and the point of the pen for thinner ones.

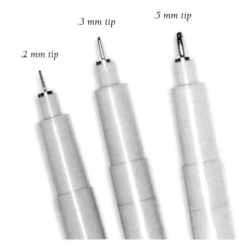

.5 mm tip

.3 mm tip

.2 mm tip

SHARPENING YOUR DRAWING IMPLEMENTS

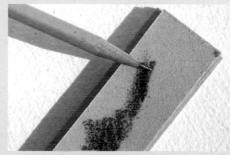

Utility Knife This tool can form more different points (chiseled, blunt, or flat) than an ordinary pencil sharpener can. Hold the knife at a slight angle to the pencil shaft; and always sharpen away from you, taking off only a little wood and graphite at a time.

Sandpaper Block Sandpaper will quickly hone the lead into any shape you wish. It also will sand down some of the wood. The finer the grit of the paper, the more controllable the resulting point. Roll the pencil in your fingers when sharpening to keep the shape even.

Rough Paper The tooth of the paper is wonderful for smoothing a pencil point after it has been tapered with sandpaper. It also is a great way to create a very fine point for small details. Be sure to gently roll the pencil while honing it to sharpen the lead evenly.

SHADING YOUR DRAWINGS

Once you sketch the basic shape of your subject, you can create realism and add texture by applying a variety of shading techniques. The information on these two pages will help you render everything from scaly dragon skin to transparent wings and soft fur—and you'll find that you can use the same techniques with virtually any medium, from graphite pencil to charcoal and ink. When deciding which medium to use, consider the appearance of your subject—does it have soft, fluffy hair or rough, cracked scales? Think about the textures you want to render; then refer back to these pages to see the effects you can achieve with each medium. Whichever method or medium you choose, remember to shade evenly. Instead of shading in a mechanical, side-to-side direction, use a back-and-forth motion over the same area, often changing the direction of your strokes.

UNDERSTANDING VALUE

Shading gives depth and form to your drawing because it creates contrasts in *value* (the relative lightness or darkness of black or a color). In pencil drawing, values range from black (the darkest value) through different shades of gray to white (the lightest value). To make a two-dimensional object appear three-dimensional, you must pay attention to the values of the highlights and shadows. Imagine the egg at upper right with no shading, just an outline. The egg would be just an oval. But by adding variations of value with light and shadow, the egg appears to have form. When shading a subject, you must always consider the light source, as this is what determines where your highlights and shadows will be. The angle, distance, and intensity of the light will affect both the shadows on an object, called "form shadows," and the shadows the object throws on other surfaces, called "cast shadows." But before you start drawing, look at a few objects around your home and study them in terms of their values. Squint your eyes, paying attention to all the lights and darks; look at the different values in the shadows cast by the objects. Then find the values you see in the value scales shown at right.

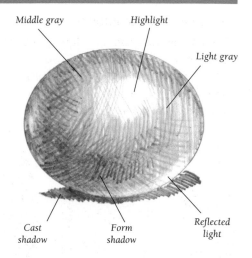

Light and Shadow The *highlight* is the lightest value, where the light source directly strikes the object. The light gray area surrounds the highlight, and the middle gray is the actual color of the egg, without any highlights or shadows. The cast shadow is the shadow that the egg casts onto the ground. The form shadow is the shadow that is on the object itself. *Reflected light* bounces up onto the object from the ground surface.

Middle gray *Highlight* *Light gray*

Cast shadow *Form shadow* *Reflected light*

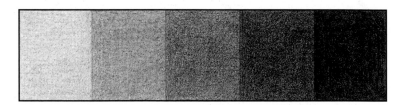

Value Scale Making your own value scale, such as the one shown above, will help familiarize you with the different variations in value. Work from light to dark, adding more and more tone for successively darker values. Different pencils produce varying value ranges; this scale was drawn with a standard HB pencil.

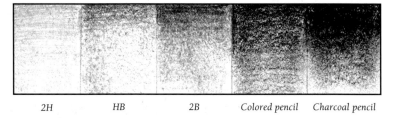

2H *HB* *2B* *Colored pencil* *Charcoal pencil*

Pencil Scale As the scale above demonstrates, I can produce a range of values using different pencils. A 2H pencil creates a very light tone, whereas a charcoal pencil makes the softest, darkest tone.

SHADING STYLES

Artists use many different methods of shading—most build up tones from dark to light, shading the dark shadows first and then developing the entire drawing. I prefer to refine one section at a time because it helps me concentrate on the individual features—such as the head, arms, or legs. Separately attending to individual areas also forces me to constantly move my hand around the drawing, which helps me avoid smudging the graphite. As you can see here, I completely develop the face and most of the headpiece before moving on to shading the torso and legs—and I finish the torso and legs before focusing on the feet, tail, and wings.

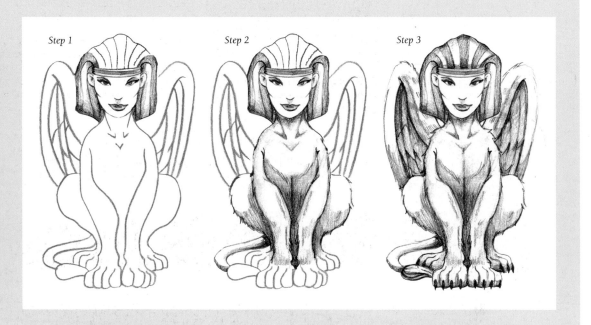

Step 1 *Step 2* *Step 3*

BASIC SHADING TECHNIQUES

By studying the basic techniques on this page, you'll be able to render a range of textures for your dragon drawings. The effect will vary among media, but the methods are the same. For example, shading with charcoal will give your drawing a dramatic, dark look, whereas shading in pencil can produce a subtler, softer appearance. And shading in ink adds a slick, smooth feel!

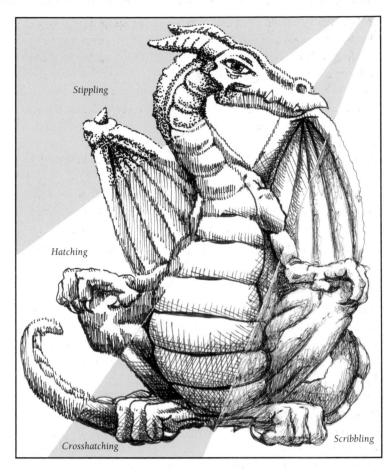

Hatching The most basic method of shading is to fill an area with hatching, which is a series of parallel strokes.

Crosshatching For darker shading, go over your hatching with a perpendicular set of hatch marks.

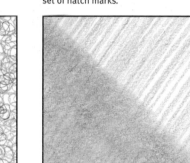

Circular Strokes By moving your pencil in tight, small circles, you can create a texture that is ideal for a mop of unruly hair.

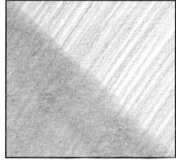

Blending For smooth shading, rub a tissue, cloth, or blending tool over heavily shaded areas to merge the strokes.

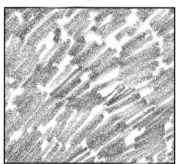

Stippling A series of dots can create a mottled texture for skin, scales, and hair; the denser the dots, the darker the tone.

Scribbling To create loose, spontaneous strokes, hastily move the pencil around in quick, random motions.

Putting Ink Strokes to Use In this sectioned drawing, you can see how each shading technique results in a different look and feel for the finished piece. In the first section, I stipple with an ultra-fine permanent marker to create dynamic shadows; for darker values, I apply denser dots. For the next area, I use a .3 mm ink pen to create closely spaced hatch marks that suggest a rough texture. I crosshatch the next section with a .5 mm ink pen to create a rough, scaly look. For the final section, I build up a loose scribble with a ball-point pen to achieve a cracked, worn texture.

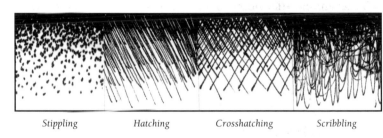

Stippling *Hatching* *Crosshatching* *Scribbling*

Using Ink You can use the same shading techniques with ink as those used with pencil, as the example above demonstrates. However, ink is a much less forgiving medium than pencil—you cannot erase your marks. To avoid making mistakes, sketch the entire drawing (including details) in pencil first; then apply the ink. When the ink is completely dry, gently go over the entire drawing with an eraser to pick up any stray pencil marks. If you've diluted the ink to a wash, be sure to allow more time for drying.

VARYING VALUES WITH PAINT AND INK WASHES

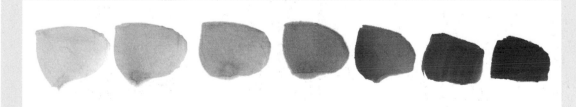

Adjusting the amount of water you use in your ink or paint washes provides a range of values. When creating a wash, it is best to start with the lightest value and build up to a darker value, rather than adding water to a dark wash to lighten it. To learn how to mix various values, create a value chart like this one. Start with a very diluted wash, and gradually add more ink or paint for successively darker values.

CREATING TEXTURES

Practicing the techniques shown below will help you create the appearance of textures such as scales, feathers, fur, and hair—features you'll find on the dragons, mythological beasts, and fantasy creatures throughout this book. When drawing these textures, remember that it's often helpful to use a photo reference of a real human or animal with features similar to those you want to depict for your creatures. For example, look at patterns on turtle shells and fish for scale inspiration!

Smooth Scales For smooth scales, first draw irregularly shaped ovals; then shade between them. Smooth scales like these are ideal for the slick skin of sea-dwelling dragons.

Rough Scales To create rough scales, draw irregular shapes that follow a slightly curved alignment. Shade darkly between the shapes; then shade over them with light, parallel strokes.

Spiny Scales For sharp, pointed scales, sketch the form with a 2H pencil, adding details with a black colored pencil. Lightly grip the pencil to create softly curving arcs for the differently shaped spines.

Fishlike Scales To depict scales such as those found on most Asian dragons, draw arcs of various sizes. Partially cover each scale with the next layer, and add a cast shadow below each to show overlap.

Fine Feathers For light, downy feathers, apply thin, parallel lines along the feather stems, forming a series of V shapes. Avoid crisp outlines, which would take away from the softness.

Heavy Feathers To create thicker, more defined feathers, use heavier parallel strokes and blend with a tortillon. Apply the most graphite to the shadowed areas between the feathers.

Short Hair To create short hair, make quick, overlapping hatch marks with the broad side of the pencil. For subtle wrinkles and folds in the skin, vary the values by changing the pressure on the pencil.

Long Hair To render long hair—whether it's all over the body or just on the head or tail—use long, sweeping strokes that curve slightly, and taper the hairs to points on the ends.

Rough Hair For a subtle striped pattern, apply short strokes in the direction that the hair grows. Overlap some strokes to create darker values, and keep your strokes farther apart for light areas.

Smooth Hair For smooth, silky hair, use sweeping parallel pencil strokes, leaving the highlighted areas free of graphite. Alternate between the pencil tip and the broad side for variation.

Curly Hair Curly hair or fur can be drawn with overlapping circular strokes of varying values. For realism, draw curls of differing shapes and sizes, and blend your strokes to soften the look.

Wavy Hair For layers of soft, wavy curls, stroke in S-shaped lines that end in tighter curves. Leave the highlights free of graphite and stroke with more pressure as you move to the shadows.

COMBINING REFERENCES

Most mythological creatures are amalgams of real animals—and even people! For example, dragons can have features of serpents, lions, eagles, fish, and many other animals. This makes it easy to use photo references to help you create these elements. For instance, I can use a photo reference of a bird wing and a bat wing when drawing a dragon wing. Using photo references can help lend an aspect of realism to your fantasy drawings. However, don't feel as if you must be a slave to your reference material—dragons are mythological creatures, so realistic anatomy is not essential.

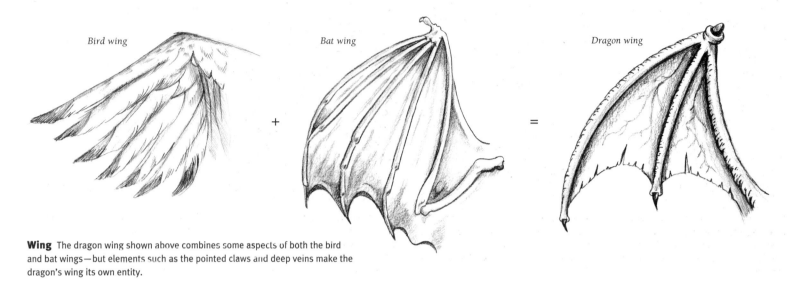

Bird wing + *Bat wing* = *Dragon wing*

Wing The dragon wing shown above combines some aspects of both the bird and bat wings—but elements such as the pointed claws and deep veins make the dragon's wing its own entity.

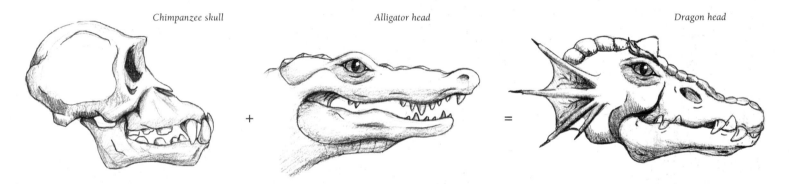

Chimpanzee skull + *Alligator head* = *Dragon head*

Head In this example, I merge a chimpanzee skull with an alligator head to create a dragon head. You can see elements of both animal influences in the final product, including the long snout and eye of the alligator and the jaw and skull shape of the chimp. Of course, I incorporate some fantasy elements too—the finlike ears are pure imagination.

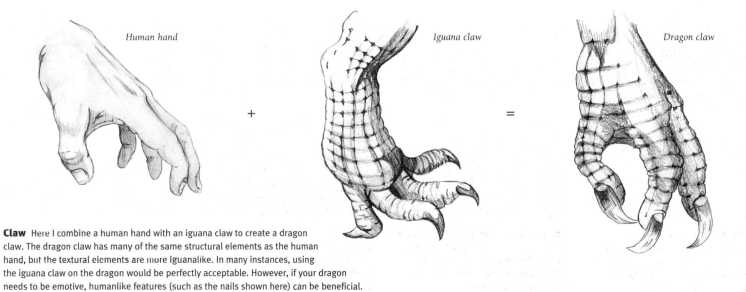

Human hand + *Iguana claw* = *Dragon claw*

Claw Here I combine a human hand with an iguana claw to create a dragon claw. The dragon claw has many of the same structural elements as the human hand, but the textural elements are more iguanalike. In many instances, using the iguana claw on the dragon would be perfectly acceptable. However, if your dragon needs to be emotive, humanlike features (such as the nails shown here) can be beneficial.

CONSTRUCTING CREATURES

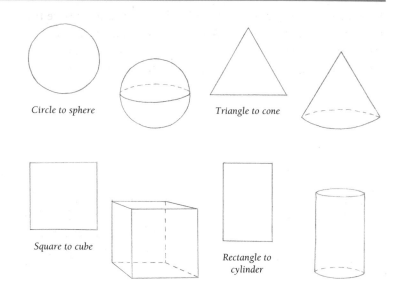

Approaching a drawing becomes a much simpler process when you begin by breaking down the subject into basic *forms,* or three-dimensional shapes. And these simple shapes, with a little refinement, easily can become body parts of your creature. In my drawings, cylinders often act as the underlying forms of legs, and cubes usually become feet. (See the examples below for a demonstration of this drawing method.) That's all there is to the first step of every drawing: sketching the shapes and developing the forms. After that, it's just a matter of connecting and refining the lines and adding details.

Circle to sphere *Triangle to cone*

Square to cube *Rectangle to cylinder*

BEGINNING WITH BASIC SHAPES

When you draw the outline of your subject, you are drawing its shape. But your subject also has depth and dimension, or form. The corresponding forms of the four basic shapes—circles, rectangles, squares, and triangles—are spheres, cylinders, cubes, and cones. For example, a ball and a grapefruit are spheres, a jar and a tree trunk are cylinders, a box and a building are cubes, and a pine tree and a funnel are cones. Once you've learned to develop the forms of simple shapes, you'll be able to draw any subject!

Transforming Shapes into Forms Here I've drawn the four basic shapes and their respective forms. I think of the shapes as flat frontal views of the forms; when tipped, they appear as three-dimensional forms. Use ellipses to show the backs of the circle, cylinder, and cone; draw a cube by connecting two squares with parallel lines.

Starting with Shapes
This is what a dragon ankle would look like rendered entirely with geometric forms. I use cylinders for the leg, a circle for the ball of the foot, and triangle shapes for the claws.

Shading for Depth
By adding variations of value (shading) to the basic shapes, I've given them form. I wouldn't go this far when building up a real drawing, though; this is an intermediate step to demonstrate how shading produces dimension.

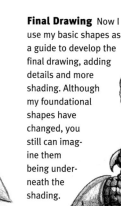

Final Drawing Now I use my basic shapes as a guide to develop the final drawing, adding details and more shading. Although my foundational shapes have changed, you still can imagine them being underneath the shading.

TRANSFORMING BASIC SHAPES

Here is an example of the way I use simple shapes and forms to develop a mythological beast, the satyr. In the first step, I use a circle for the head, an oval for the chest, a cube for the hips, and cylinders for the arms and legs. In the next step, I add more cylinders to complete the arms, legs, and neck, as well as additional squares for the hands. In the third step, I build up the shapes and forms to begin refining the upper half of the body, erasing my construction lines as I draw.

PLACING THE FEATURES

Believe it or not, dragons and other fantasy creatures have the same general facial *proportions* (the comparative sizes and placement of parts to one another) as humans. Understanding the proper proportions and using placement guidelines will help you determine the correct sizes and locations of the facial features for the creatures in this book. Whether you are viewing the subject from the front, in profile, or from a three-quarter view, the basic proportions are the same.

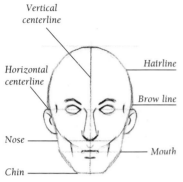

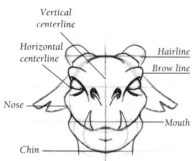

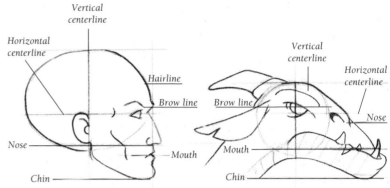

Human Facial Guidelines To locate the facial guidelines on a human face, divide the face in half horizontally and vertically. Then divide the bottom portion in half again to show where the end of the nose will be. Divide once more to see where the bottom lip ends. The hairline is about one-third of the way down from the top of the head to the eyes, and the brow line is just above the ears. The eyes are centered between the vertical centerline and the sides of the head, and there is one eye width between them.

Dragon Facial Guidelines The dragon head follows the same general rules of proportion as the human head, although the guidelines (and the features) are spaced a little differently on the dragon. For example, the dragon's hairline is higher, and the space between the bottom of the nose and the horizontal centerline is much smaller than on the human. Even still, these lines serve the same purpose and operate in the same manner as the lines on the human head.

Human Profile When drawing a human head in profile, use a large cranial circle as a guideline for placing the features. The nose, lips, and chin fall outside the circle, whereas the eye and ear remain inside the circle. When the head is turned in profile, the facial guidelines remain in the same positions as the frontal view.

Dragon Profile Use a smaller cranial circle for the head, as dragons don't have the large brains that humans do. The nose and mouth fall outside the circle, whereas the eye remains inside the circle. The ear begins inside the circle, but dragons' ears tend to be longer and larger than humans', so their ears extend farther.

SHIFTING PROPORTIONS

Once you understand the basics of proper proportion, you can experiment with modifying the "average" proportions to fit the unique, individual characteristics of your subject. You'll notice that the sizes, placement, and even the number of the features vary from creature to creature; so you'll sometimes need to tweak the "normal" proportions above to fit the individual subject. Study the examples below to see how the features undergo change as you approach different characters.

Normal Proportions The pixie's facial proportions are fairly average: There is about one eye width between the eyes, which lie on the horizontal centerline; the nose is positioned halfway between the brow line and the bottom of the chin; and the ears line up with the brows.

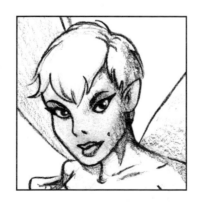

Abnormal Proportions The cyclops differs vastly from the status quo, simply in that he has only one eye. The rest of the features line up in an average way, but the eye is nowhere near proportional to the ears, nose, and mouth, as it takes up the majority of the face.

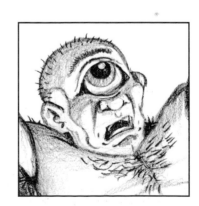

Less Normal Proportions The troll's eyes are much smaller than average, and there are about two eye widths between them. The nose is oversized compared with the tiny mouth, and the chin is very short and small. The ears also are oversized, and they are placed lower on the face.

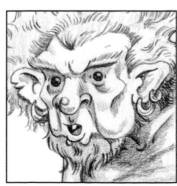

Exaggerated Proportions In this example of a gremlin, the eyes and ears are about twice as big as they should be, following standard guidelines. The nose is almost nonexistent, and the mouth nearly stretches across the entire face. These alterations provide more personality to the little gremlin.

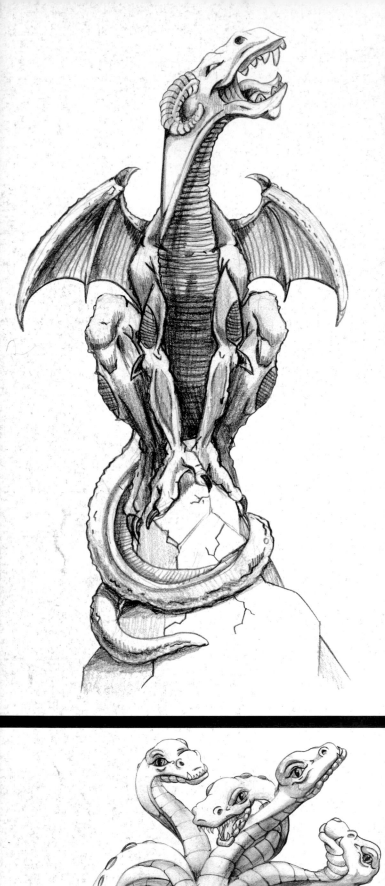

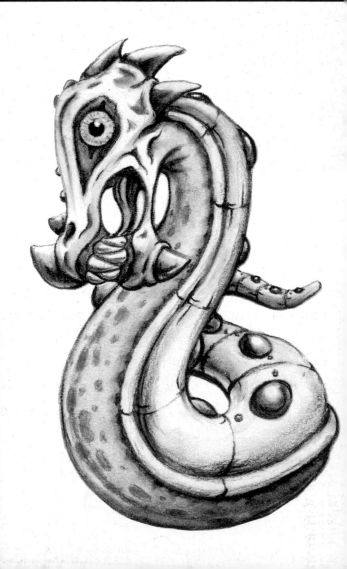
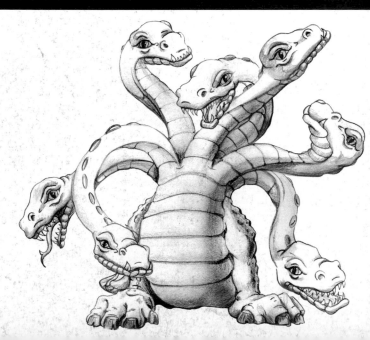

TYPES OF DRAGONS

Although dragons take on very different roles in myths and legends, they often display physical or behavioral characteristics that allow them to be categorized into distinct groupings. Different sources may provide conflicting descriptions of the types of dragons, but I try to use the most popular and logical nomenclature for each classification. In this book, I include some creatures that may not appear very dragonlike (such as the naga on page 25 and the amphisbaena on page 34), but they belong here because they function as dragons in certain regional mythologies. Keep in mind that the categories in this book are by no means comprehensive, as new species of dragons pop up all the time!

FIRE DRAGON

Elemental dragons are those that are related to the elemental spheres: fire, earth, air, and water. These dragons tend to personify their respective element. The fire dragon is the most unpredictable of the elementals. Often dwelling in dormant volcanoes, this dragon is red, orange, or yellow in color. Its body is thick and heavy, and its legs and tail are long and snakelike.

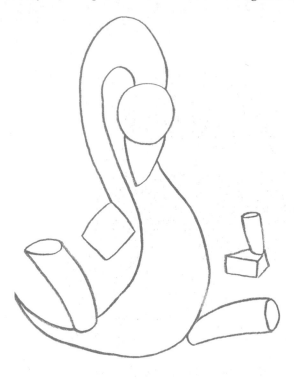

Step One I begin drawing the fire dragon using a 2H pencil and basic shapes. I start with an S shape for the body, adding a circle and a triangle for the head. Then I draw cylindrical legs and boxlike hands.

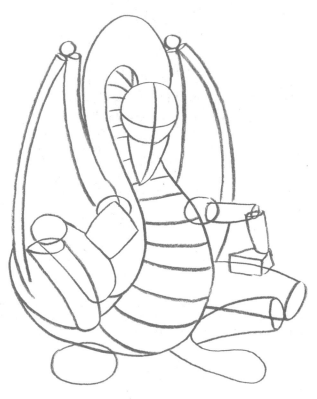

Step Two I add more cylindrical shapes to form the legs and arms. I rough in the feet and the wings, using long, tapered lines and circles. I add horizontal lines down the belly. Then I add horizontal and vertical facial guidelines to help me place the features.

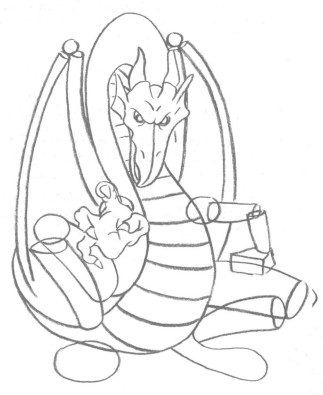

Step Three Now I focus on the head. I add two curved horns and the wide ears, and I draw the sloping eyes and the birdlike beak, erasing guidelines as they're no longer needed. Next I develop the reaching hand, converting the box shape from step one into the palm. I draw pointed fingers, complete with long nails. Notice that the hand is almost as big as the head—this is an example of *foreshortening,* in which the drawing is distorted to make certain areas of the drawing (in this case, the hand) appear to be closer to the viewer than other parts. Foreshortening helps create the appearance of depth.

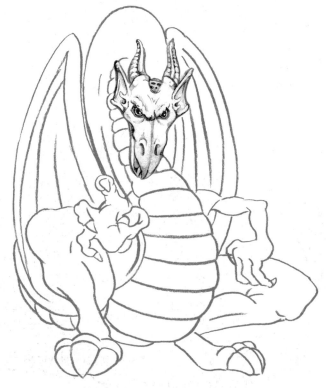

Step Four Using my construction lines as a guide, I draw the muscular legs, the thin arm, the fingers on the dragon's left hand, and the large, pointed toes. I also add a curve to each segment of the belly to make it look three-dimensional. I refine the wings. Then, with a blunt HB pencil, I define the creases and recesses of the face. I use a sharp 2B to add tone to the ears, horns, eyes, nose, and mouth; then I add dark spots on the head.

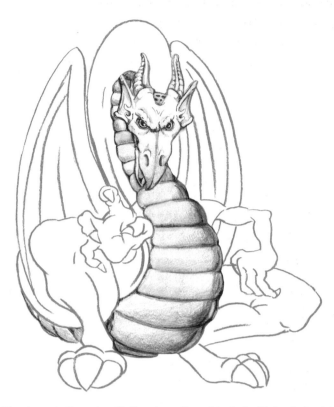

Step Five I move to the neck and belly, using a 2B pencil to shade with fine, horizontal strokes. To show that the light is coming from the left, I leave highlights along the dragon's right side, gradually darkening the value toward its left side and underbelly.

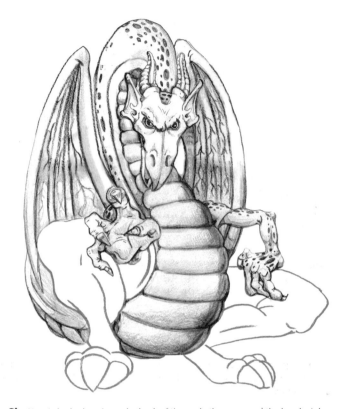

Step Six Next I shade the wings, the back of the neck, the arms, and the hands. I draw spots on the neck and arms, and I add thin, branching lines for the veins on the inner wings. Then I make short strokes for the wrinkles on the hands.

DID YOU KNOW?

- In Chinese astrology, if you were born between January 31, 1976, and February 17, 1977, you were born under the sign of the Fire Dragon.

- In Greek mythology, Prometheus stole fire from the gods to protect the fireless humans, and he was tortured for his act of kindness.

Step Seven I continue shading the rest of the body with a 2B pencil. Then I add spots to the legs and the top of the dragon's left foot. I remove any remaining underlying pencil lines with an art gum eraser, and then I reinforce the darkest areas with more shading, as shown.

WATER DRAGON

Another elemental dragon, the water dragon usually does not have legs or wings, and thus does not fly. Blue, silver, or blue-green in color, this dragon lives in seas, lakes, rivers, and other bodies of water. The water dragon is thought to represent calm and fluidity. It has been sighted most often off the coasts of Scandinavia, the British Isles, and Denmark.

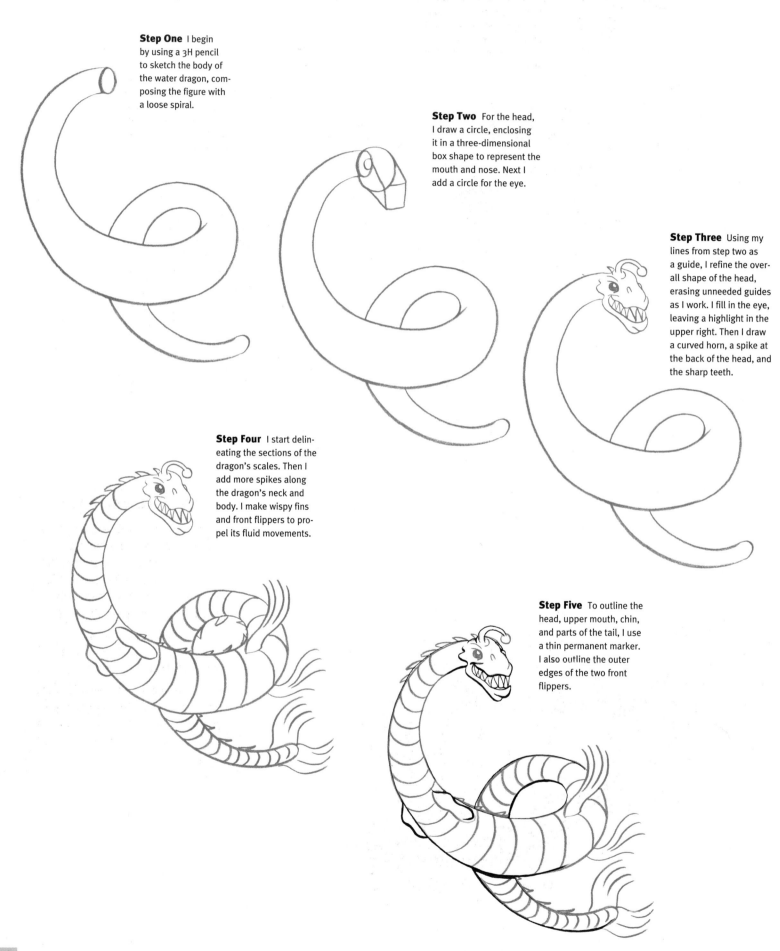

Step One I begin by using a 3H pencil to sketch the body of the water dragon, composing the figure with a loose spiral.

Step Two For the head, I draw a circle, enclosing it in a three-dimensional box shape to represent the mouth and nose. Next I add a circle for the eye.

Step Three Using my lines from step two as a guide, I refine the over-all shape of the head, erasing unneeded guides as I work. I fill in the eye, leaving a highlight in the upper right. Then I draw a curved horn, a spike at the back of the head, and the sharp teeth.

Step Four I start delin-eating the sections of the dragon's scales. Then I add more spikes along the dragon's neck and body. I make wispy fins and front flippers to pro-pel its fluid movements.

Step Five To outline the head, upper mouth, chin, and parts of the tail, I use a thin permanent marker. I also outline the outer edges of the two front flippers.

Step Six Using the same marker, I shade the fins and flippers with crosshatching. I also add some extra spikes to the underside of the tail, shading all the spikes so that they resemble shark fins. I outline the flippers and draw webbed tips. Then I darken the eye and fill in the nostril.

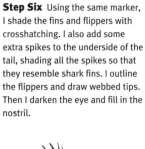

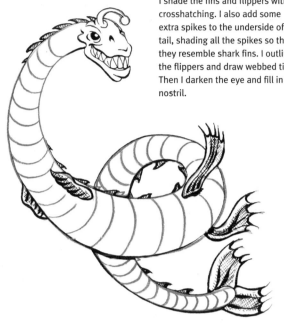

Step Seven I add scales and shading to the dragon's body. I think about shellfish as I draw. I put round tips on the ends of the fins and tail, perhaps as tantalizing bait for unsuspecting fish passing by.

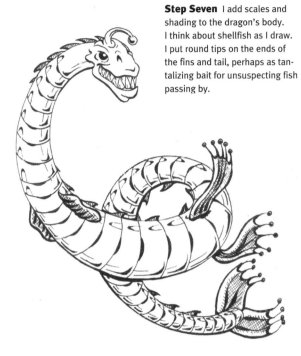

Step Eight Finally, I ink in some churning bubbles to make sure our water dragon is not confused with a flyer! Once the ink is dry, I erase any visible pencil lines.

DID YOU KNOW?

- There are two species of reptiles that go by the name "water dragon": One is Chinese and the other Australian. These real-life lizards are able to remain submerged for long periods of time.

- Like many lizards, the water dragon has a third eye at the top of its head.

- If you were born between January 27, 1952, and February 13, 1953, you were born under the Chinese astrological sign of the Water Dragon.

EARTH DRAGON

The earth dragon is the most practical and levelheaded of the elemental dragons. Usually green or brown in color, it resides in mountains and forests. The earth dragon tends to have a heavier body, with four legs, wings, and a long neck and tail. The earth dragon is very responsible and takes its life and relationships quite seriously.

Step One I start this dragon by using a 3H pencil to make a large oval for the body. I draw a small circle at the bottom of the oval for the head, and I add a squarish shape to block in the muzzle. Then I draw two thicker, curved lines outside the oval for the neck and tail. I draw a horizontal guideline through the head for feature placement.

Step Two I block in the forms of the wings and legs with cylindrical shapes. I also draw a half-circle at the horizontal guideline for the eye, and I add another line that bisects the nose to suggest the mouth. Then I add the tip of the tail.

Step Three Using my construction lines, I refine the shapes to make the basic outline of the dragon, adding two wings folding over the body. I add horns to the tops of the wings, and I erase any guidelines I no longer need. Follow the example to refine your own drawing.

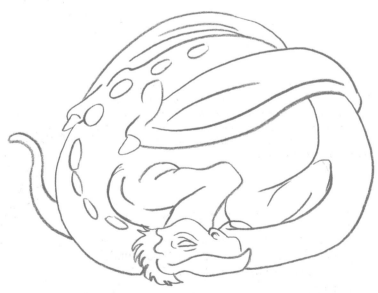

Step Four Moving to the head, I draw a curved line for the lower jaw, creating an underbite. Then I add the spiky hair, nose, and eye details. I also draw a series of oval shapes for the spikes down the dragon's neck and over its back.

Step Five I want to achieve a very dark value for this dragon, so I decide to use a black ballpoint pen to add tone. I start with the wings, using a scribbling motion. The idea behind this technique is similar to hatching: The tighter the lines, the darker the tone. However, these lines are put down in a faster, more haphazard fashion. This is scribbling at its finest!

Step Six I continue the scribble-hatch on the limbs, and I apply tone to the spikes on the back, working my way toward the head. I add some hatching to the underside of the neck, as well.

Step Seven I continue the scribble-hatch to shade the rest of the dragon's body, including the end of the tail. I also add bumps to the backside of the tail. As I approach the head, I need to think about what personality I want the dragon to have. This is going to be a tired dragon, old and world-weary. I extend his hair tuft to reach under his chin and begin to express deep, somber eyes.

DID YOU KNOW?

- If you were born between February 6, 1988, and February 5, 1989, you were born under the Chinese astrological sign of the Earth Dragon.

- In magic, Earth represents strength, abundance, and stability—characteristics of the earth dragon.

Step Eight To finish, I add simple circles to the dragon's skin, giving it a rougher texture. I also reinforce the tangled mess of fur on the head. Then I continue refining the facial features, adding creases and cracks to produce a worn appearance.

Storm Dragon

The storm dragon controls the element of air, including storms and weather. Often long and slender, this creature usually is blue or yellow in color—but changes to red, orange, purple, or black when controlling storms. The storm dragon represents flexibility of the mind and openness to new ideas.

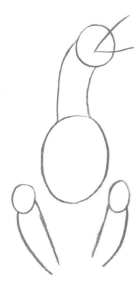

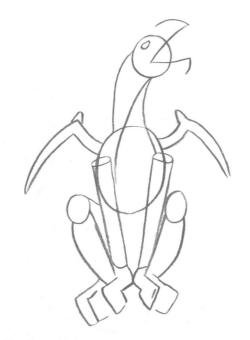

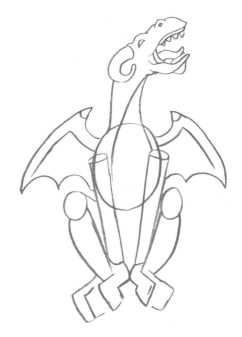

Step One I use a 2H pencil to block in the basic shapes that will make up the storm dragon. I start with a circle for the head, an oval for the body, and two circles for the knees. Then I add a thick neck and the lower back legs. I indicate the mouth with two lines coming from the head.

Step Two With the same pencil, I draw more basic shapes to continue building the body. I add the sickle-like wing bones. Then I add the blocky feet, as well as the cylindrical front legs. I place the small eye and continue developing the guidelines for the mouth.

Step Three I draw the outline of the wings around the bones. Next I refine the face. I finish the nose and mouth, adding a curled tongue and sharp teeth. Then I draw a ridge on the nose and add a nostril. I also add the curved horn below the eye.

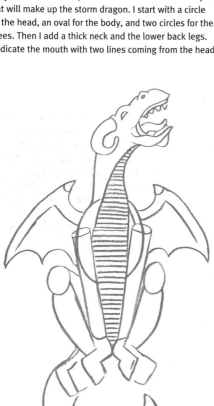

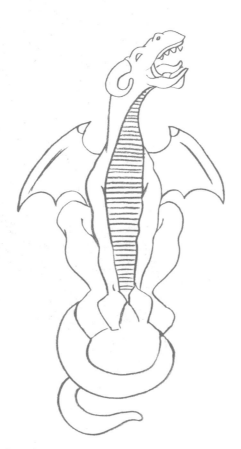

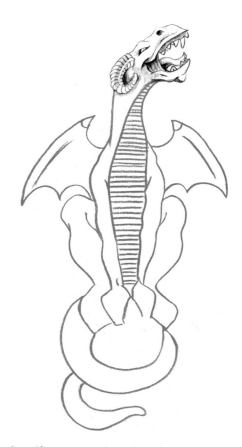

Step Four Moving to the torso, I draw tight, horizontal lines down the neck and belly. Then I add the tail, which will wrap around an icy perch.

Step Five Using my construction lines as a guide, I refine the shapes of all four legs and feet. I erase any guidelines I no longer need.

Step Six Switching my focus to the head, I refine the shapes and add the details with a 2B pencil. I shade the tongue, making it darker toward the back of the mouth. I add curved lines to the horn and shade the underside. I also darken the nostril and the eye, and I shade the area around the jaw.

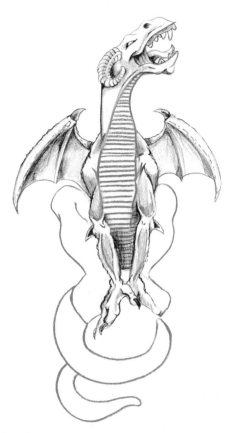

Step Seven Still using the 2B, I draw and then shade around the ridges inside the wings to create depth. Next I shade the front legs, giving the joints sharp spikes to match the wings. I also darken the claws.

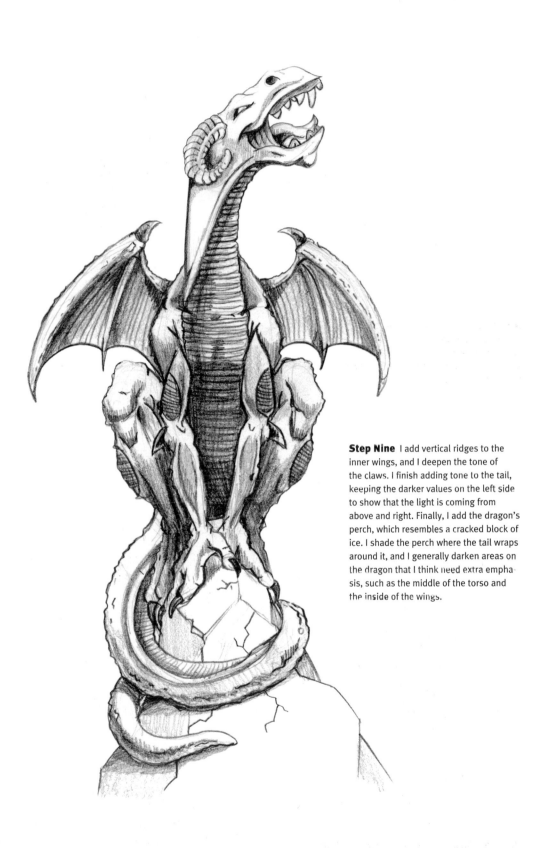

Step Nine I add vertical ridges to the inner wings, and I deepen the tone of the claws. I finish adding tone to the tail, keeping the darker values on the left side to show that the light is coming from above and right. Finally, I add the dragon's perch, which resembles a cracked block of ice. I shade the perch where the tail wraps around it, and I generally darken areas on the dragon that I think need extra emphasis, such as the middle of the torso and the inside of the wings.

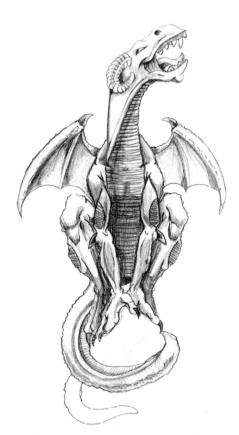

Step Eight I shade around the lines on the neck and belly. To create a dark, ridged texture, I add tone to the legs, repeating the ridged texture on patches of skin. I make the back legs appear knobby and bent. Next I carry the tone onto the tail, where I draw lighter, looser ridges.

HATCHLING

A hatchling is a baby dragon—not to be confused with a drag-onet, which is a miniature adult dragon. A group of dragon eggs is called a "clutch."

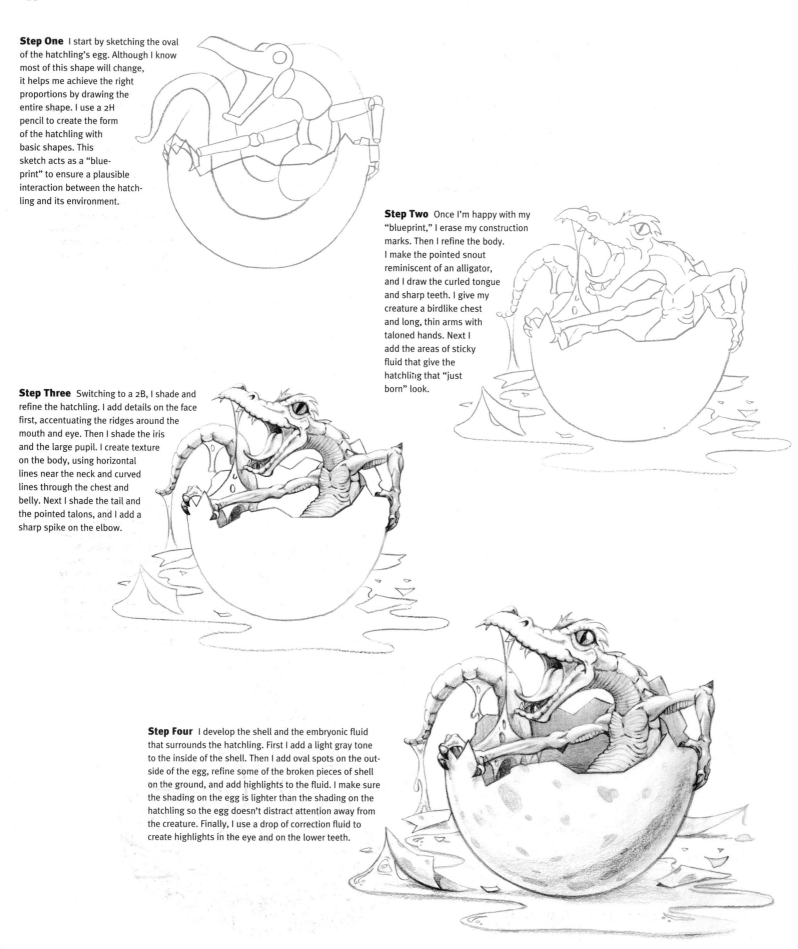

Step One I start by sketching the oval of the hatchling's egg. Although I know most of this shape will change, it helps me achieve the right proportions by drawing the entire shape. I use a 2H pencil to create the form of the hatchling with basic shapes. This sketch acts as a "blue-print" to ensure a plausible interaction between the hatch-ling and its environment.

Step Two Once I'm happy with my "blueprint," I erase my construction marks. Then I refine the body. I make the pointed snout reminiscent of an alligator, and I draw the curled tongue and sharp teeth. I give my creature a birdlike chest and long, thin arms with taloned hands. Next I add the areas of sticky fluid that give the hatchling that "just born" look.

Step Three Switching to a 2B, I shade and refine the hatchling. I add details on the face first, accentuating the ridges around the mouth and eye. Then I shade the iris and the large pupil. I create texture on the body, using horizontal lines near the neck and curved lines through the chest and belly. Next I shade the tail and the pointed talons, and I add a sharp spike on the elbow.

Step Four I develop the shell and the embryonic fluid that surrounds the hatchling. First I add a light gray tone to the inside of the shell. Then I add oval spots on the out-side of the egg, refine some of the broken pieces of shell on the ground, and add highlights to the fluid. I make sure the shading on the egg is lighter than the shading on the hatchling so the egg doesn't distract attention away from the creature. Finally, I use a drop of correction fluid to create highlights in the eye and on the lower teeth.

Naga

Although not a true dragon, the half-human, half-serpent naga performed the same roles and functions of mythological dragons in ancient civilizations that lacked dragon lore.

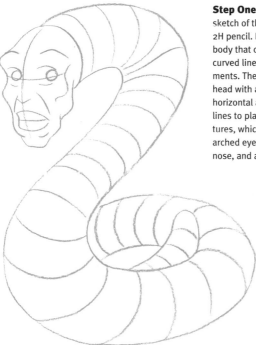

Step One I begin with a rough sketch of the creature using a 2H pencil. I draw a wormlike body that curls around, with curved lines to define the segments. Then I add a human head with a large jaw. I use horizontal and vertical guidelines to place the facial features, which include round eyes, arched eyebrows, a hooked nose, and a wide, toothy mouth.

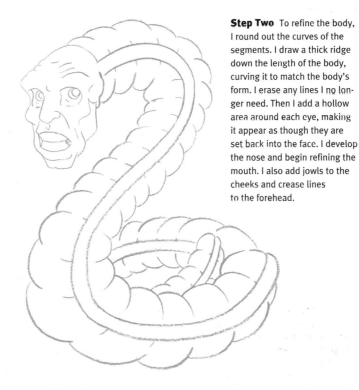

Step Two To refine the body, I round out the curves of the segments. I draw a thick ridge down the length of the body, curving it to match the body's form. I erase any lines I no longer need. Then I add a hollow area around each eye, making it appear as though they are set back into the face. I develop the nose and begin refining the mouth. I also add jowls to the cheeks and crease lines to the forehead.

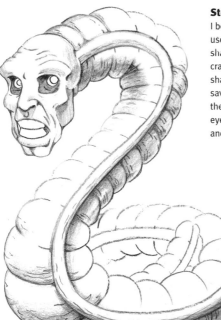

Step Three With a 2B pencil, I begin shading the body. I use my finger to smudge the shading, and then dash in cracked lines on top of the shading. Next I shade the face, saving the darkest values for the hollowed-out areas of the eyes. I leave the actual eyes and the teeth pure white.

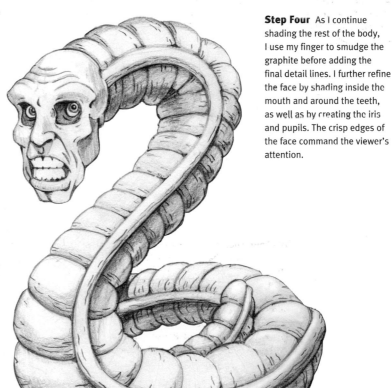

Step Four As I continue shading the rest of the body, I use my finger to smudge the graphite before adding the final detail lines. I further refine the face by shading inside the mouth and around the teeth, as well as by creating the iris and pupils. The crisp edges of the face command the viewer's attention.

DID YOU KNOW?

- In India, nagas are underground dwellers.
- The word "naga" is rooted in Sanskrit and means "serpent."
- Nagas can cause flooding or drought at will.

DRAKE

Often mistaken for an adolescent dragon, the drake is merely a type of dragon without wings. (Dragons' wings do not grow until adulthood.) A drake usually is referred to by its element, such as the earthdrake shown here.

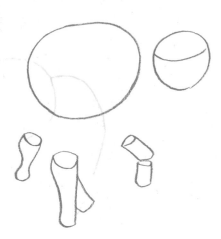

Step One I start by drawing the basic shapes of the drake with a 3H pencil. I draw an oval for the torso and a circle for the head. Then I block in the legs. Notice that I am not connecting any of these shapes yet. I add a curved horizontal guideline to the head, which indicates that the drake will be looking to the viewer's left.

Step Two Now I add the rest of the basic shapes. I connect the shapes to form the thick snout and jaw, the curved neck, the large tail, and the bulky feet.

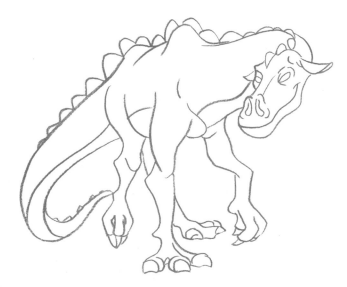

Step Three I begin to refine the body, tail, legs, and feet, erasing my construction lines as I go. Then I start rendering the facial features, including the large, cowlike nostrils.

Step Four As I add the curved mouth and the floppy ears, I continue imagining a cow. Then I think of a stegosaurus as I add the plates that extend from the forehead to the tip of the tail. I refine the feet, adding three toes with long, sharp nails.

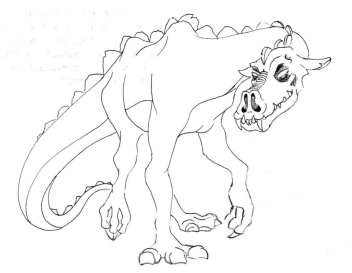

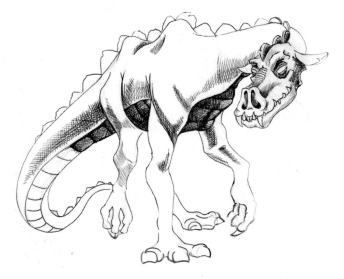

Step Five I want this drake to really stand out from the paper, so I outline my pencil sketch with .2 mm waterproof ink pen. I add details to the head, such as the pointy teeth, the ridged nose, the dark eye sockets, and the notched ear.

Step Six After creating horizontal lines that reach down the underside of the tail, I establish the shading on the body and head by laying down a series of hatch marks. I create darker areas, such as the underbelly, by crosshatching on top of the first layer.

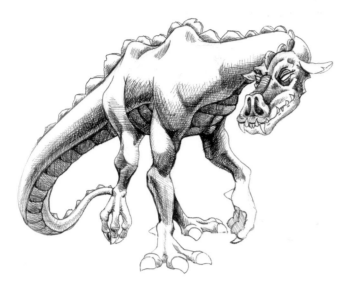

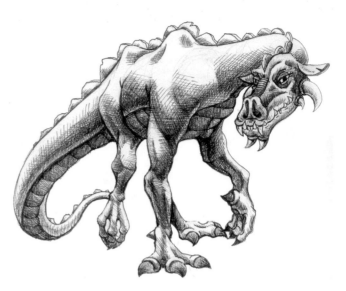

Step Seven I carry the hatch and crosshatch techniques down the limbs, onto the spine, and back to the face. Areas that may have appeared finished before may need to be revisited and strengthened so they aren't overpowered by other, less important areas.

Step Eight When finished with the initial hatching on the legs and feet, I return to create darker areas. The closer the hatching, the darker the tone. Next I decide to add some details to the face, so I draw the horns on the sides of the face and the two spikes underneath the chin. I also fill in the pupil and darken the notch in the ear.

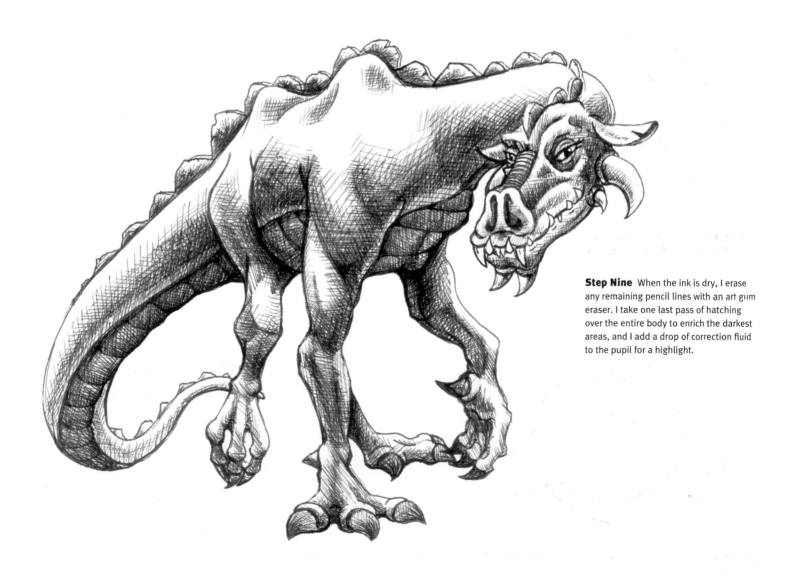

Step Nine When the ink is dry, I erase any remaining pencil lines with an art gum eraser. I take one last pass of hatching over the entire body to enrich the darkest areas, and I add a drop of correction fluid to the pupil for a highlight.

WYRM

A wyrm is a serpentlike dragon with a long, slender, wingless body. This creature is fairly mean-spirited and spends most of its time guarding treasure. It can be found in or near bodies of water.

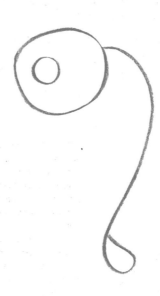

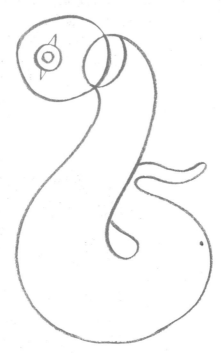

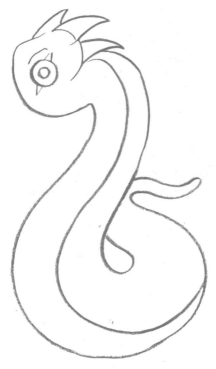

Step Three I draw a curved line down the center of the body to separate the back from the belly. I also add three spikes to the back of the head, which I adjust and refine a bit. Then I add a crease above the eye.

Step One With a 3H pencil, I draw a large circle for the head, with a smaller circle inside for the eye. Then I add a long, curved line that forms a teardrop shape at the end for the foundation of the wyrm's body structure.

Step Two Building on my original line, I draw an S-shaped body that tapers at the end into a rounded tail. Then I draw a smaller circle inside the eye for the pupil, using two triangles to define the eye.

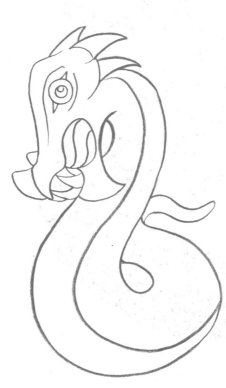

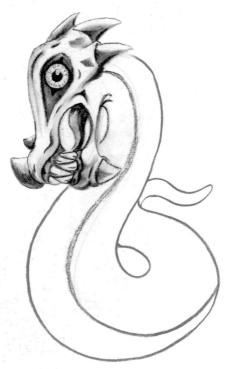

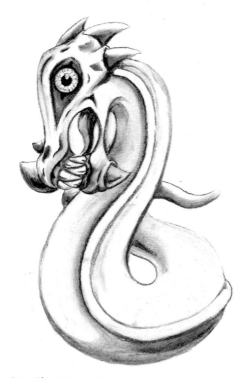

Step Six Still using the medium charcoal pencil, I continue adding tone to the body of the wyrm, blending the charcoal to create the smooth texture.

Step Four After I extend the head to accommodate the large, angular jaws—including three horns—I add the huge teeth. I draw a pupil in the eye, and I extend the line above the eye to reach about halfway down the nose.

Step Five Because this wyrm has slick skin, I use a medium charcoal pencil to add smooth, blended tone. I blend large areas with a stump and tight areas with a color blender (see page 6). I make the teardrop-shaped area around the eye very dark and the iris very light to create contrast. I leave highlights on the tops of the horns on the head, as well as on the tips of the horns on the jaw.

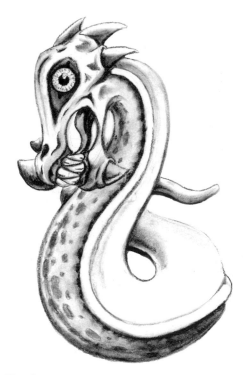

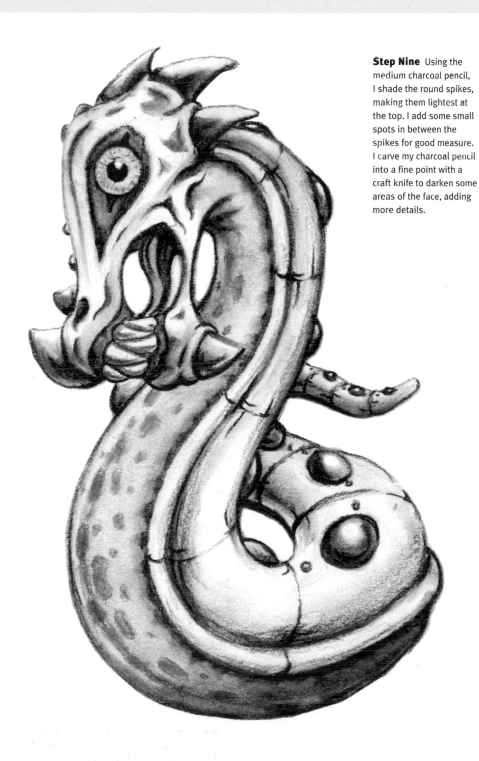

DID YOU KNOW?

- The wyrm is the oldest type of dragon from European folklore.
- If cleaved, a wyrm is capable of rejoining its body parts.
- Ancient wyrms often are shown devouring their own tails—this symbol is called the "ouroboros," whether it depicts a dragon or a serpent.
- The wyrm once was found in small bodies of water but later headed out to sea to avoid human crowding and pollution.

Step Nine Using the medium charcoal pencil, I shade the round spikes, making them lightest at the top. I add some small spots in between the spikes for good measure. I carve my charcoal pencil into a fine point with a craft knife to darken some areas of the face, adding more details.

Step Seven I strengthen some of the outlines, as shown. Then I give the wyrm some belly spots to liven him up. I make the simple shapes with the charcoal pencil, then blend them with a stump.

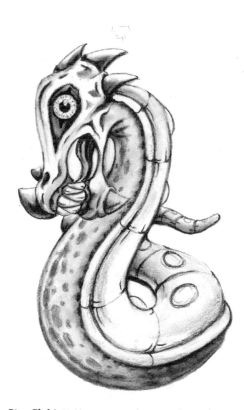

Step Eight Making some rough segmenting on the wyrm's back gives it an armored appearance. I draw round spikes that extend from the back of the neck to the tip of the tail, and I add some cracks on the segments to show texture.

SEA SERPENT

The sea serpent is a legendary dragon that resides in fresh or salt water. It spends most of its life in freshwater lakes and streams, but it will migrate to warmer waters when necessary. The unwary occasionally mistake this beast for a mass of kelp or a giant squid—a mistake that can lead to an untimely demise!

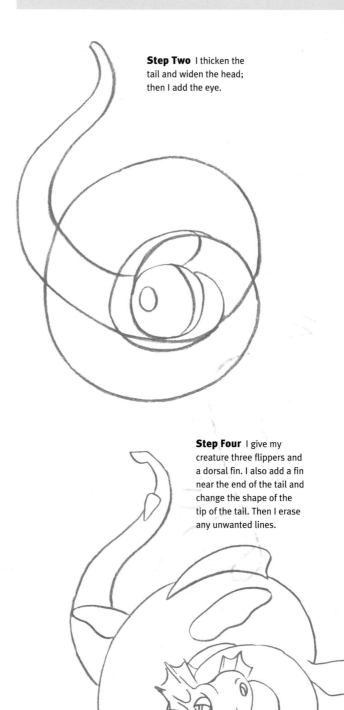

DID YOU KNOW?

- The sea serpent is the most commonly sighted dragon in the modern age.
- Early cartographers often would mark dangerous or uncharted expanses of ocean with the warning, "Here there be dragons!" in reference to sea serpents.
- Scotland's Loch Ness Monster (or "Nessie") is the most well-known sea serpent.

Step One I begin by using a 3H pencil to sketch the round head and the corkscrew body.

Step Two I thicken the tail and widen the head; then I add the eye.

Step Three Now I focus on adding the facial features, including the raised blowhole, finlike ears, and ducklike bill. I also add the sharp teeth.

Step Four I give my creature three flippers and a dorsal fin. I also add a fin near the end of the tail and change the shape of the tip of the tail. Then I erase any unwanted lines.

Step Five Using a sharp 2B pencil, I begin shading the tail with hatch marks. (I'm right-handed, so I work from left to right to avoid smudging the graphite.) I try to keep the lines in a uniform direction to evoke motion.

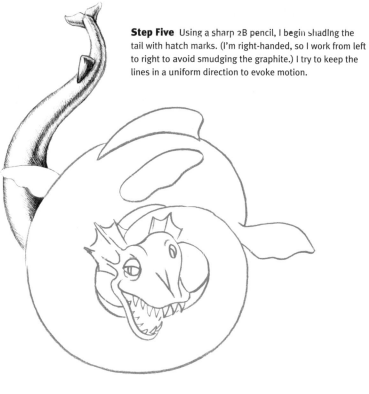

Step Six To shade more of the body, I continue hatching (always in the same direction). It's tempting to start cross-hatching because it would be quicker (and more intuitive), but I stick with the sleeker one-direction hatch. I shade and detail the fins and two of the flippers.

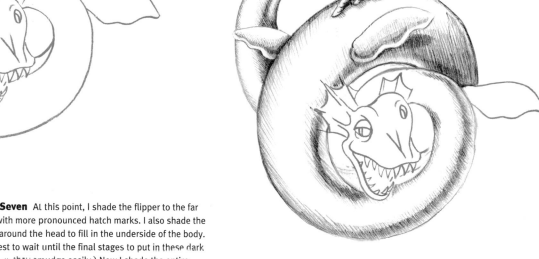

Step Seven At this point, I shade the flipper to the far right with more pronounced hatch marks. I also shade the areas around the head to fill in the underside of the body. (It's best to wait until the final stages to put in these dark tones, as they smudge easily.) Now I shade the entire head, including the inside of the blowhole.

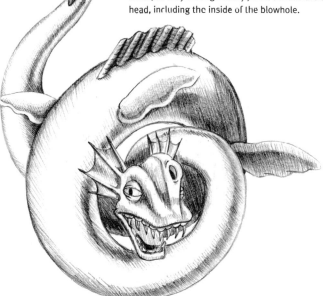

Step Eight I clean up all the edges with a vinyl eraser. Then I add flurries of bubbles to frame the subject. Besides giving context to the sea serpent, the bubbles show that this dragon knows how to have a good time!

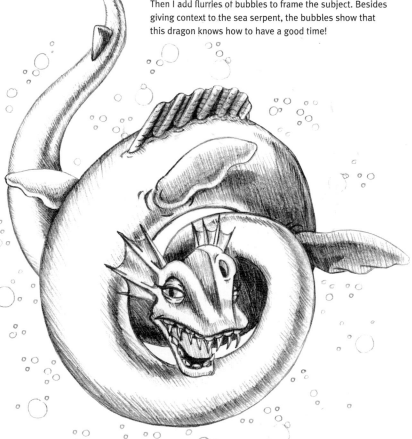

HYDRA

A hydra is a many-headed dragon. It can have as few as seven or as many as one million heads! The hydra has notoriously bad breath because it exhales poison or acid. This monster often inhabits rivers.

Step One I start by using a 2H pencil to draw the basic shape of the hydra. My main concern in this step is to make sure all these darn heads can exist in the same place in a plausible way!

Step Two I draw the legs and feet, which at this point look like a robot's. Then I continue building the shapes, adding facial guidelines to the heads. I also delineate the fronts of the necks with lateral lines.

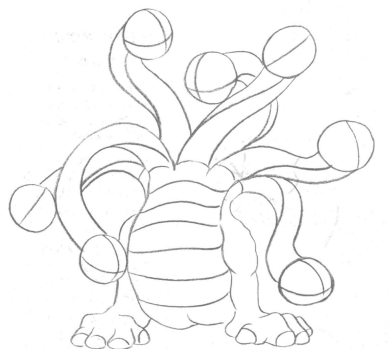

Step Three Using my construction lines, I refine the legs and feet. I make the feet a cross between a human's and an elephant's, with large, squarish nails. Then I add horizontal lines on the torso that curve with the body's form.

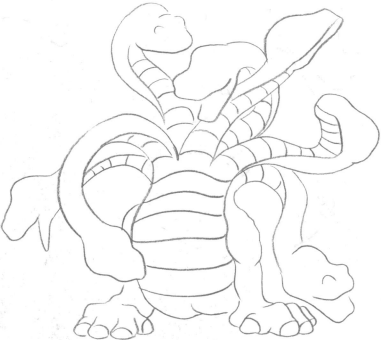

Step Four I continue the curved lines up the fronts of the necks, refining the heads as I go and erasing my construction lines as I no longer need them. These heads are quite rounded, rather than angular—they remind me of baby dinosaurs.

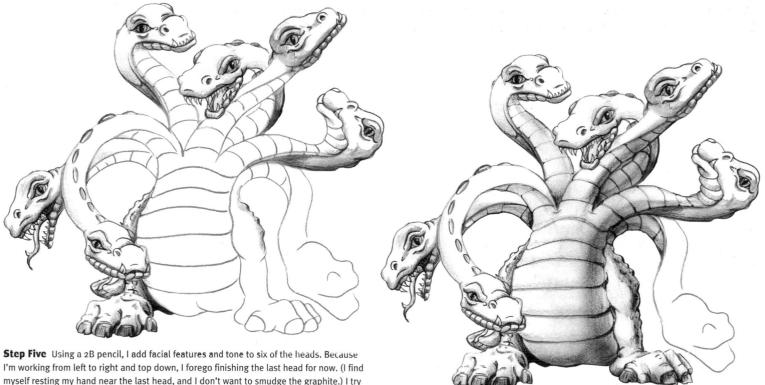

Step Five Using a 2B pencil, I add facial features and tone to six of the heads. Because I'm working from left to right and top down, I forego finishing the last head for now. (I find myself resting my hand near the last head, and I don't want to smudge the graphite.) I try to give each head a different personality while maintaining general uniformity, so I vary their poses and features. When adding tone to the heads, I lightly rub the graphite with a paper towel to create a simple gradation. I draw ridges on some of the necks, and then I move to the creature's haunches, where I add a rough, bumpy texture. I continue this texture down the creature's right leg and onto its foot. I add small circles to enhance the texture, and I draw very unkempt toenails.

Step Six As I continue to build up the overall tone with the soft graphite, I make sure not to grind it into the paper so that I can blend the tone later. Then I shift my attention to the belly scales, shading them and blending with a paper towel. I continue the bumpy texture down the creature's left leg and apply the same ragged-toenail treatment to the creature's left foot.

Step Seven Now I'm ready to render the final head. After doing so, I use a paper towel to blend heavy areas of graphite, creating dark, rich, even tones. I run a vinyl eraser along the contour edges to clean up any stray marks. I also use the eraser to pull out highlights; I use a craft knife to carve specialty shapes in my eraser so I can reach tight areas.

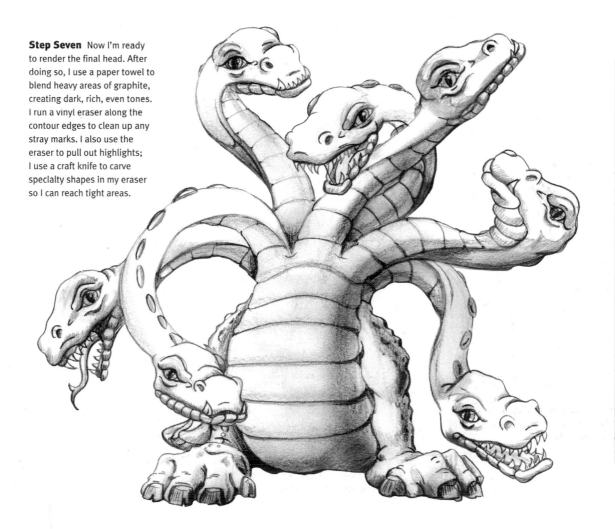

DID YOU KNOW?

- Greek hero Heracles killed a hydra as one of his Twelve Labors (see page 66).

- A hydra is born with seven heads, but each time one head is severed, two heads grow in its place!

- In Greek mythology, the Hydra guarded one of the entrances to the underworld.

- The only way to kill a hydra is to cut off its heads and sear the necks with fire before new heads can grow.

AMPHISBAENA

An amphisbaena is a two-headed, ant-eating serpent. This warm-blooded reptile can travel quickly by grabbing one set of jaws in the other and rolling like a hoop. Amphisbaena skin will cure colds and can help lumberjacks cut down trees!

Step One Using a 2H pencil, I lightly sketch the shape of the dragon. I add two circular heads and draw vertical guidelines on both.

Step Two I begin drawing the features of the upper head, using the vertical line from step one as a guide. I add two thick horns, one donut-shaped and one button-shaped eye, a wide nose, and an open, tooth-filled mouth. I also indicate the tongue.

Step Three After adding tufts of hair to the upper head, I begin drawing the lower head. I draw similar features, except this head has its mouth closed, its horns lie flat on its head, and its eyes look up. Then I draw a curving line down the body to differentiate the front from the back.

Step Four Using vine charcoal, I begin adding soft, dark tone to the upper head's horns and neck, as well as to the underside of the belly and the area where the upper head's chin casts a shadow on the lower head's neck. Then I use a medium-black charcoal pencil to darken the eyes, nostrils, and inside of the mouth. I pull out a highlight in the pupil with a kneaded eraser. Then I use the charcoal pencil to add spots to the upper head's neck.

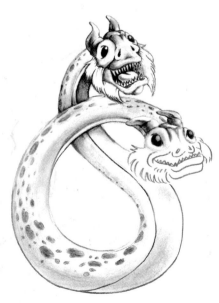

Step Five Switching back to vine charcoal, I continue adding tone to the lower head, softly blending the tone with my finger. (Charcoal smudges easily, so it is especially important to avoid resting your hand on the drawing.) Next I darken the lower head's eyes with the charcoal pencil, and I continue the spot pattern down the rest of the body.

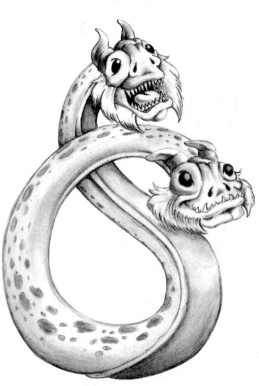

Step Six As I finish building tone on the lower head, I also introduce darker tones to the underside of the belly. I use a craft knife to fashion a fine point on my charcoal pencil and carefully darken the sections that warrant it. Lastly, I go in with a kneaded eraser and pull out more highlights.

Amphitere

Lacking both arms and legs, an amphitere is a plumed, winged serpent. Admired for its beautiful coloration, the amphitere has a hypnotic gaze. If you plant an amphitere's fangs in soil, your very own loyal army will emerge from the ground.

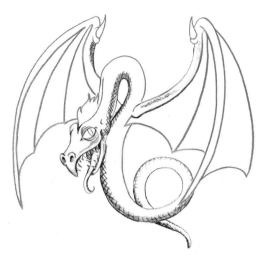

Step One I rough in the general body shapes with a 2H pencil. The wings are large and batlike, the body is slim and serpentine, and the head is birdlike.

Step Two Still using my 2H pencil, I establish more of the dragon's contours, erasing construction lines as I work. I draw the eye, nose, and mouth, and I add a long, curling tongue.

Step Three On the head, I use my 2B pencil to refine the features and shade the nostrils and the inside of the mouth. I add the sharp teeth and draw the tuft of hair. Next I define the wings, adding sharp spikes to the tips. Then I establish a simple crosshatch pattern for the scales on the body. I keep the scales confined to areas of shadow, or along exterior contour lines. Because the 2B is soft, I can blend by lightly rubbing my finger over the scales.

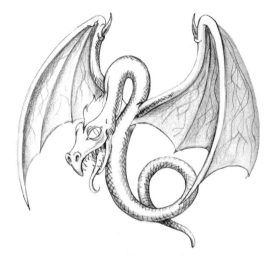

Step Four I finish crosshatching the body before turning my attention to the wings. I make sure my 2B pencil has a rounded, soft point; then I draw the light, squiggly veins.

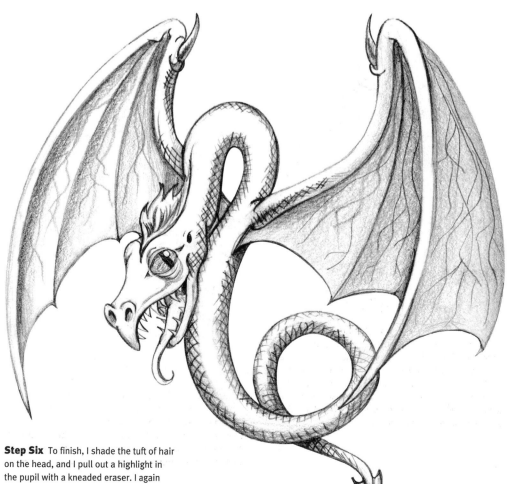

Step Five I go back and darken the areas that need it, like the pupil, the wing joints, and the overlapping body parts. Then I add a pointed tip to the tail.

Step Six To finish, I shade the tuft of hair on the head, and I pull out a highlight in the pupil with a kneaded eraser. I again darken the blackest areas, making sure my pencil has a sharp point so I can get into small areas and draw fine details.

Lindworm

A lindworm is an armless dragon with legs and wings. A large creature known for eating cattle, the lindworm was recognized by ancient Europeans as a symbol of war. Despite having wings, this beast generally does not fly.

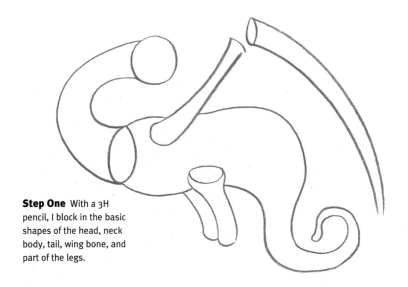

Step One With a 3H pencil, I block in the basic shapes of the head, neck body, tail, wing bone, and part of the legs.

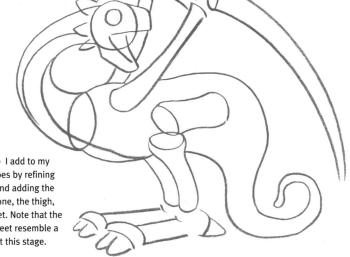

Step Two I add to my initial shapes by refining the head and adding the far wing bone, the thigh, and the feet. Note that the head and feet resemble a rooster's at this stage.

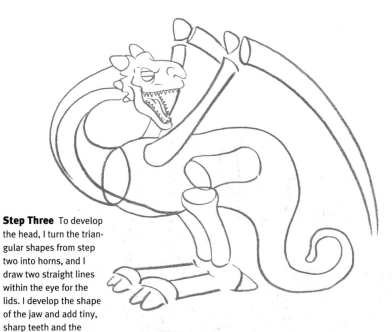

Step Three To develop the head, I turn the triangular shapes from step two into horns, and I draw two straight lines within the eye for the lids. I develop the shape of the jaw and add tiny, sharp teeth and the tongue. Then I add the nose.

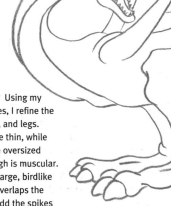
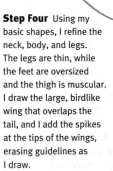

Step Four Using my basic shapes, I refine the neck, body, and legs. The legs are thin, while the feet are oversized and the thigh is muscular. I draw the large, birdlike wing that overlaps the tail, and I add the spikes at the tips of the wings, erasing guidelines as I draw.

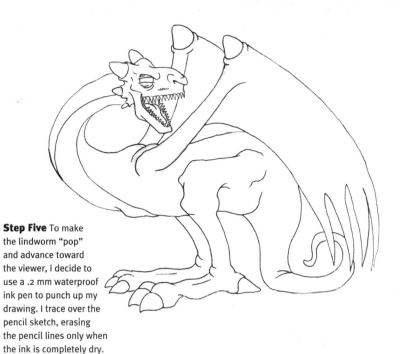

Step Five To make the lindworm "pop" and advance toward the viewer, I decide to use a .2 mm waterproof ink pen to punch up my drawing. I trace over the pencil sketch, erasing the pencil lines only when the ink is completely dry.

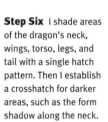

Step Six I shade areas of the dragon's neck, wings, torso, legs, and tail with a single hatch pattern. Then I establish a crosshatch for darker areas, such as the form shadow along the neck.

Step Seven For darker tones, especially on the wings and the underside of the belly and tail, I continue crosshatching. Then I make a simple zig-zag scribble pattern along the belly. To distinguish the belly from other areas of the dragon, I draw the zig-zag pattern with a light touch, allowing the line to break and fade.

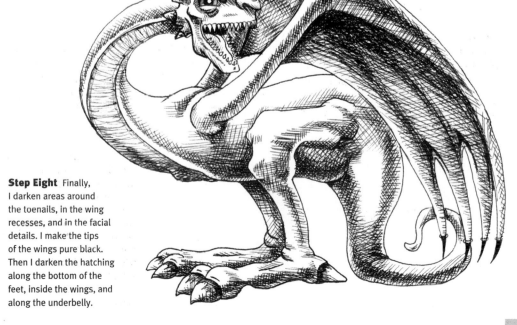

DID YOU KNOW?

- The lindworm is known as "lindorm" in Scandinavia and as "lindwurm" in Germany.

- In Nordic and Germanic heraldry, the lindworm is equivalent to the wyvern.

- The lindworm often is depicted without wings.

Step Eight Finally, I darken areas around the toenails, in the wing recesses, and in the facial details. I make the tips of the wings pure black. Then I darken the hatching along the bottom of the feet, inside the wings, and along the underbelly.

Wyvern

Related to the lindworm, the wyvern is a carnivorous, energetic beast that usually possesses two legs, batlike wings, and a barbed tail. It does not have arms. This creature was popular as a heraldic icon in the medieval period.

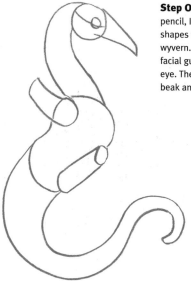

Step One With a 3H pencil, I sketch the basic shapes that make up the wyvern. Using a horizontal facial guideline, I place the eye. Then I draw a pointed beak and a whiplike tail.

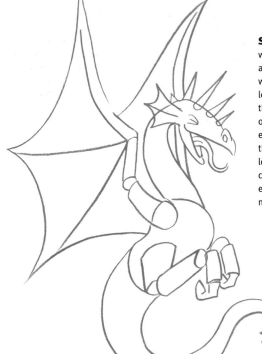

Step Two Continuing with the basic shapes, I add two large, angular wings, a pair of curled legs, and spikes along the head and at the end of the tail. I add a finlike ear that is reminiscent of the wings. Then I draw the lower jaw, adding a long, curled tongue. I refine the eye a bit and add a large nostril.

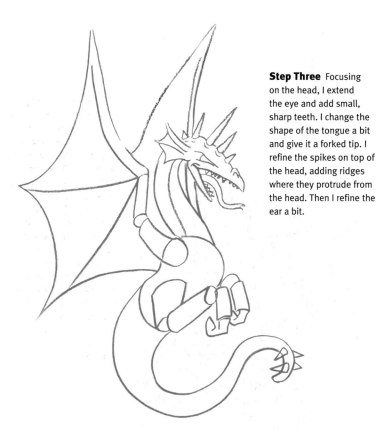

Step Three Focusing on the head, I extend the eye and add small, sharp teeth. I change the shape of the tongue a bit and give it a forked tip. I refine the spikes on top of the head, adding ridges where they protrude from the head. Then I refine the ear a bit.

Step Four Building on my initial wing structures, I add definition and connect the base of the wing to the body. Then I refine the legs, using the basic shapes to create their forms. I add a claw to the foot, then draw a line to delineate the front of the tail. Next I erase any unwanted lines.

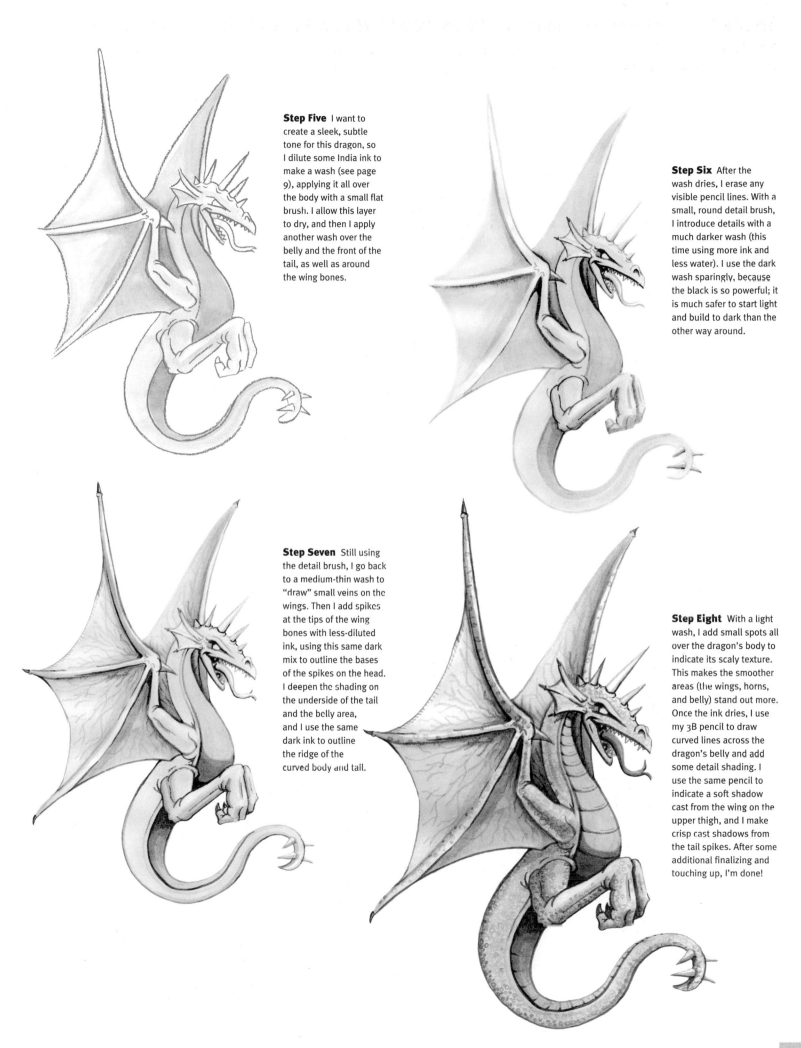

Step Five I want to create a sleek, subtle tone for this dragon, so I dilute some India ink to make a wash (see page 9), applying it all over the body with a small flat brush. I allow this layer to dry, and then I apply another wash over the belly and the front of the tail, as well as around the wing bones.

Step Six After the wash dries, I erase any visible pencil lines. With a small, round detail brush, I introduce details with a much darker wash (this time using more ink and less water). I use the dark wash sparingly, because the black is so powerful; it is much safer to start light and build to dark than the other way around.

Step Seven Still using the detail brush, I go back to a medium-thin wash to "draw" small veins on the wings. Then I add spikes at the tips of the wing bones with less-diluted ink, using this same dark mix to outline the bases of the spikes on the head. I deepen the shading on the underside of the tail and the belly area, and I use the same dark ink to outline the ridge of the curved body and tail.

Step Eight With a light wash, I add small spots all over the dragon's body to indicate its scaly texture. This makes the smoother areas (the wings, horns, and belly) stand out more. Once the ink dries, I use my 3B pencil to draw curved lines across the dragon's belly and add some detail shading. I use the same pencil to indicate a soft shadow cast from the wing on the upper thigh, and I make crisp cast shadows from the tail spikes. After some additional finalizing and touching up, I'm done!

WESTERN DRAGON

Dragons originating in Western mythology have four legs, long necks, a thick body, and batlike wings, which don't grow until adulthood. The traditional meal for a Western dragon is a sheep, an ox, or a human—consumed monthly. The Western dragon usually is a malevolent, fire-breathing creature that lives underground and hoards treasure.

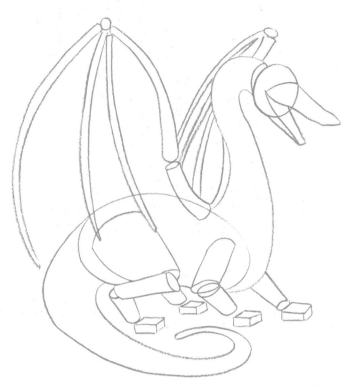

Step One I start by using a 2H pencil to construct my dragon-to-be with simple shapes, such as cylinders, cubes, and cones. This helps me understand how these individual parts exist in real space and interact with one another.

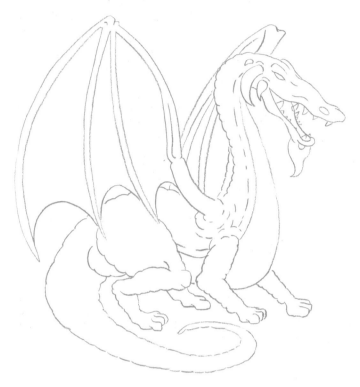

Step Two I develop the contour lines around the basic shapes with my 2H pencil. I add the eye, teeth, beard, and horns to the crocodile-like head. When I'm happy with my basic drawing, I erase the construction lines.

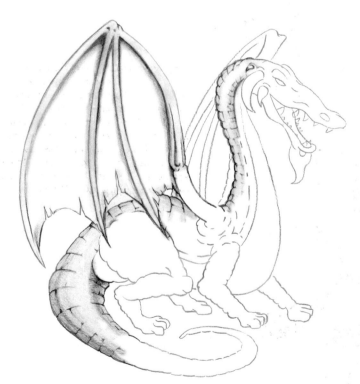

Step Three Jumping in with my 2B pencil, I begin the tonal rendering. I want to establish two textures right away—the hard, rough texture of the dragon's skin and the leathery, thin surface of its wings. I use cobblestone as inspiration for the dragon's skin.

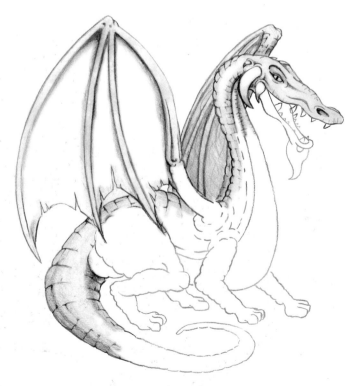

Step Four I darken the far wing to give it a lower contrast and push it back into the picture, providing a sense of distance. Then I shade down the top of the head, detailing the pupil, brow, and nostril. I also go over some of the teeth to darken them.

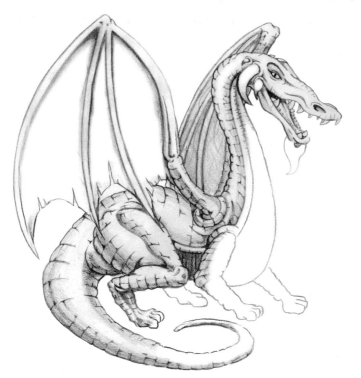

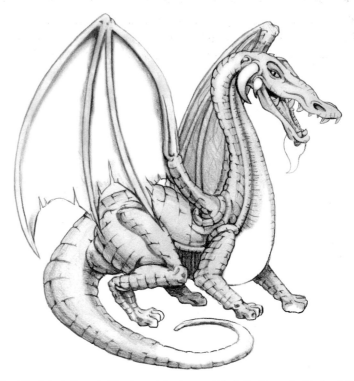

Step Five As I continue to shade the dragon's body, I add "cracked" scales that follow the form of the body. (Notice that the scales are smaller at the end of the tail than they are at the beginning, where the surface is wider.) I shade inside the mouth, making the back of the mouth the darkest area.

Step Six I shade the rest of the dragon's body, except the belly. I draw short horizontal lines from the top of the neck down toward the belly to indicate ridges. Then I continue the scales down the front legs and refine the lionlike paws.

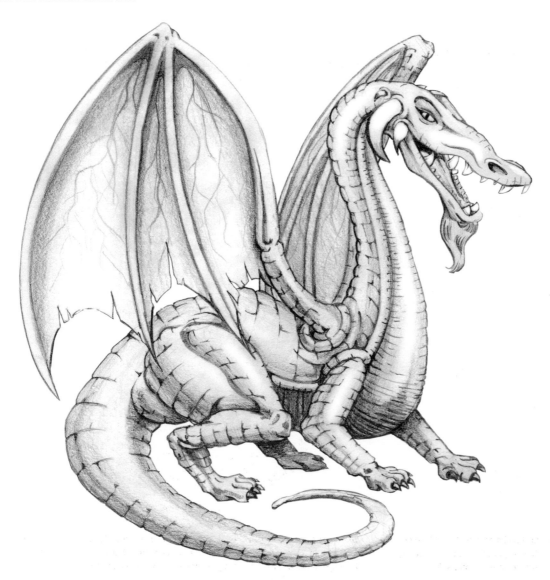

Step Seven I finish shading the front of the dragon, adding more horizontal ridges as I reach the belly. Then I shade inside the wings, creating the veins with a very blunt, rounded 2B pencil; I detail the veins with a very sharp 2B. I draw sharp claws on three of the paws and shade the beard, adding curved lines to show its form. Then I clean up any errant pencil marks with a vinyl eraser; I use the same eraser to lift out highlights on the teeth and horns.

EASTERN DRAGON

astern dragons are described as having a mane of feathers, tiger paws, antlers, eagle claws, carp scales, bull ears, rabbit eyes, and a snake body. Traditionally, most Eastern dragons are water dragons. Many of them lack wings and do not breathe fire. A benevolent creature, the Eastern dragon's power comes from the pearl it holds.

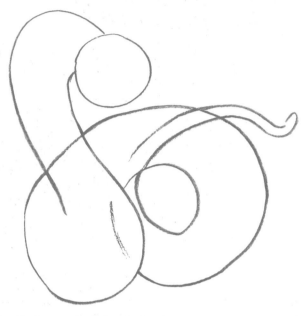

Step One First I use an HB pencil to sketch the body, including the S-shaped neck, the curled torso, and the thin, curved tail.

Step Two I add the front legs, feet, mouth, and eye. Then I draw a circle for the pearl. Notice how the beast's head looks like a duck at this stage.

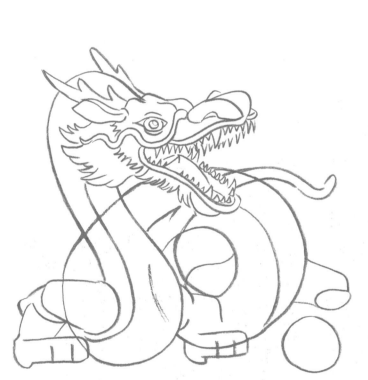

Step Three Turning my attention to the head, I add the details. I draw the antlers at the back of the head, the ear, and the wispy mane on the side of the face. Next I draw the giant nose. I add sharp teeth and a large tongue inside the mouth. I also extend the choppy mane around the mouth, and I add the rest of the details around the nose, eye, and mouth.

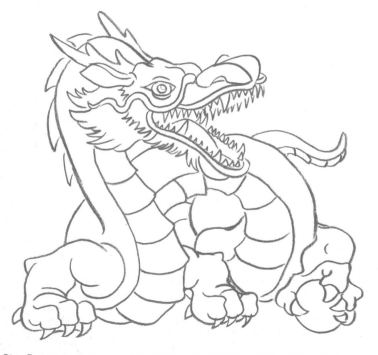

Step Four Using my construction lines, I refine the rest of the body. I make the limbs short and pudgy, adding spikes of skin at the joints. Then I add sharp claws to the feet, and I draw the back foot that grasps the pearl. I add ridges to the dragon's torso and the underside of the tail, and I erase any unnecessary lines.

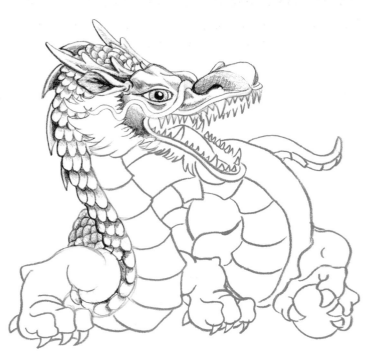

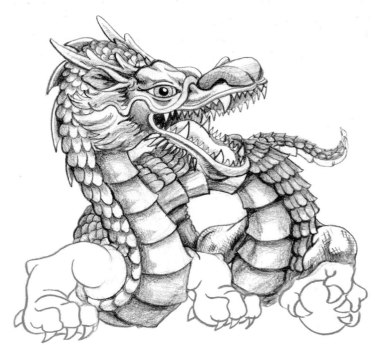

Step Five I draw a scale pattern starting at the back of the head and extending to the dragon's right foreleg. I want the scales to look fishlike, so I use medium-sized U shapes. I begin to create areas of gradation across the scales with a 3B pencil. This pencil is very soft and easily smudged, so I work carefully from left to right. Then I move to the face and begin shading the nose, around the eye, and the area near the mane. I also shade the iris and add the dark pupil, leaving a large highlight in the pupil.

Step Six I continue the scale pattern along the rest of the tail, including the tip. Then I return to the face and shade inside the mouth. I darken the outlines of the teeth, making them more prominent. Next I shade the mane and the scales on the torso and the underside of the tail. I want this area to look shiny, so I leave many highlights.

DID YOU KNOW?

- Three-toed dragons are Japanese.
- Four-toed dragons are Indonesian.
- Five-toed dragons are Chinese or Korean. (But according to some sources, ordinary Chinese dragons have four toes, whereas imperial dragons have five.)

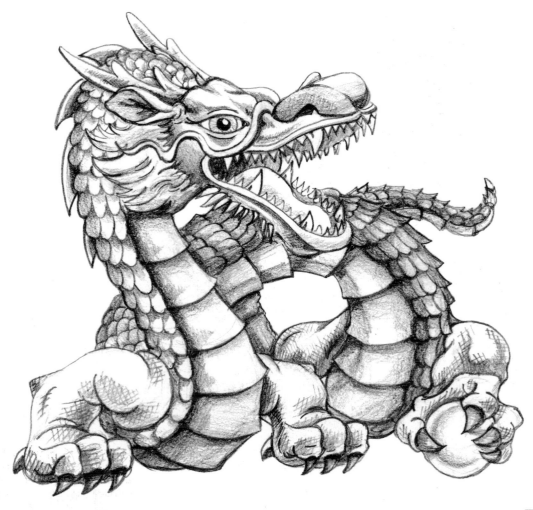

Step Seven To give the dragon an entirely different scale pattern on the limbs, I use a simple crosshatching technique to establish a shiny, low-relief scale pattern. I continue that pattern onto the front limbs. Then I begin to add definition to the pearl. The texture of a pearl is very different from the dragon's scales—I build up tones there very softly, so it looks smooth in comparison with the rough, scaly dragon. Using a vinyl eraser, I remove any stray marks and clean the area around the image. I use a craft knife to carve the eraser so I can work with it in smaller areas. I darken my final tones along the torso, and I fill in the claws, leaving a highlight on each one.

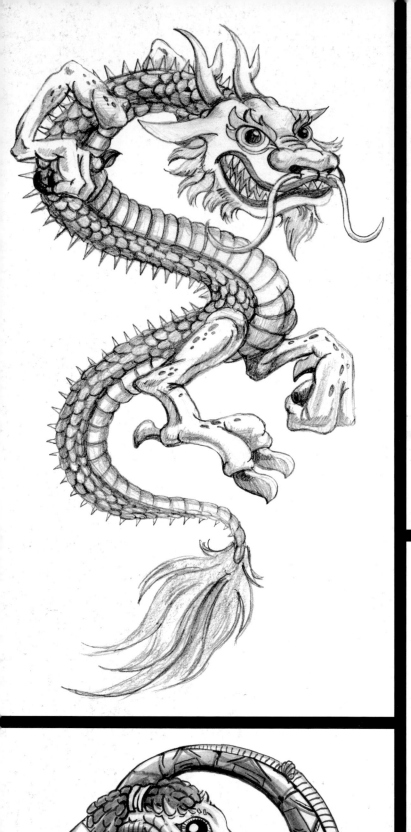
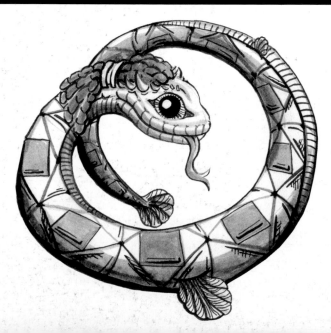
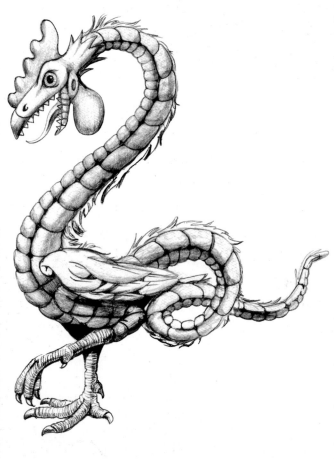
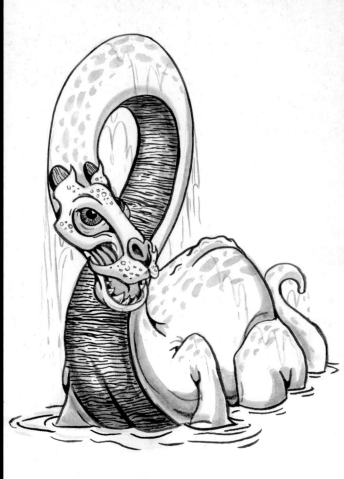

LEGENDARY
DRAGONS

In most of their appearances in regional mythologies and legends, dragons represent tradition and ritual. They often are associated with creation stories and can take on benevolent or malevolent characteristics, depending on the region. Dragons and dragonlike creatures pervade legends and myths from nearly every culture, from Australia to India, and references to dragons can be found in ancient and modern literature alike. The dragon is often represented as the oldest of Earth's residents, and sightings of sea serpents (such as the Loch Ness Monster) continue to this day.

JORMUNGANDR NORSE

Also known as the "World Serpent," Jormungandr is long enough to encircle the planet and swallow his own tail.

In Norse mythology, Jormungandr is destined to face his nemesis Thor, the god of thunder, at Ragnarök—the end of the cosmos.

Step One I use a 2H pencil to start my drawing with a simple sketch of a serpentine shape encircling an orb. I add the blocky head, two ridges for the nostrils, and a ring around the end of the tail for the mouth.

Step Two Lateral lines running the length of Jormungandr's body ensure that the scales and plates will line up in a feasible pattern. Much of this drawing will later be erased, so I draw softly with a 2H pencil.

Step Three Now I concentrate on the head. I refine the shape, making it reminiscent of an alligator. I add two curved horns to the forehead and a plate to the back of the head. Then I draw the large, snakelike eye; the sharp teeth; and the nostrils.

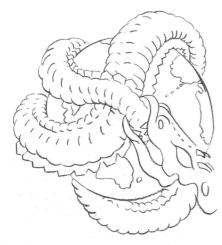

Step Four After refining my lines and erasing my initial guidelines, I use an HB pencil to draw the armorlike scale pattern by following the lateral lines from step two. Jormungandr is a mean fellow, so I want his scales to reflect his demeanor. Next I outline the landmasses on the planet.

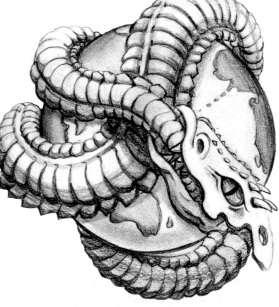

Step Six After extending and refining the scale pattern, I shade the entire body, saving the darkest tones for the shadow cast by the end of the tail onto the midsection and the undersides of the tail where it wraps around the planet. Then I shade the planet itself, keeping the tone more subtle so the planet doesn't draw the viewer's eye away from Jormungandr.

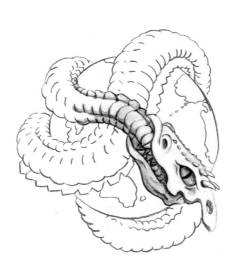

Step Five I start detailing the face with a 2B pencil. I draw the bony ridges that travel up the face. I also fill in the hole in the plate structure at the back of the head, and I add more bottom teeth. Then I draw the narrow pupil and shade the iris. Finally, I begin shading the face and tail.

DID YOU KNOW?

- Jormungandr is a sea serpent.
- Jormungandr is also known as the "Midgard Serpent."
- He is the son of Loki, the Norse god of mischief.

RAINBOW SERPENT AUSTRALIAN

The rainbow serpent, a dragon from Aboriginal mythology, also goes by the names Ngalyod and Borlung. When this serpent slithered across the Australian continent, it created ditches and gullies that collect rainwater. Residing in permanent waterholes, this creature controls water, and thus gives life. This wyrm protects its people and punishes lawbreakers.

Step One I use a 3H pencil to sketch the body and head of the rainbow serpent, using a photo of a snake as a reference. Notice how I lightly draw the parts of the body that are hidden by other parts. This is called "drawing through," and it is helpful for setting up proper proportions and gaining the correct perspective. I will erase these light lines in the next step.

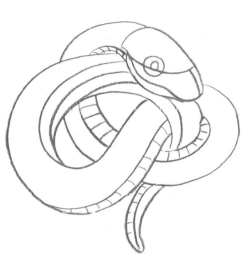

Step Two Switching to a softer 2B pencil, I add lateral lines along the serpent's body to delineate the top and bottom of the body. Then I begin drawing curved lines along the body, extending to the end of the tail. A 2B pencil is very soft, so I keep it sharp to make crisp lines.

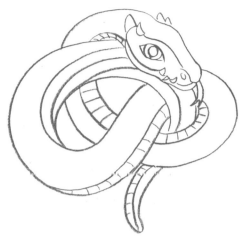

Step Three Now I focus on the head. Using my photo reference of a snake, I draw the eye, nose, and tongue. Then I introduce four horns at the back of the head and three sharp teeth along the mouth.

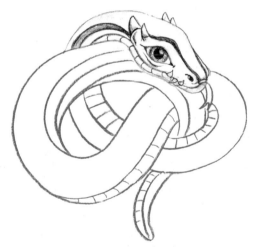

Step Four Using my now-dull 2B pencil, I shade the nostril and the eye, making the pupil very dark and leaving a small white highlight. Then I begin shading the dark stripes on the serpent's body.

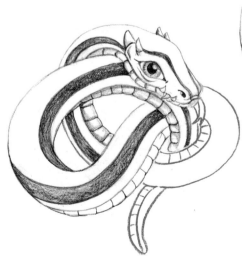

Step Five I continue shading the stripes with my dull 2B pencil. I finish the curved lines on the underside of the tail, and then begin softly shading them. I make sure the stripes are darker in value than the ridges. Using a color blender, I smooth out the areas of heavy black. I use a paper towel and a small stump to smudge some of the lighter areas.

Step Six Now I shade the lighter stripes on the body and the sides of the head. I also shade the tongue and draw a line down its center for realism. Lastly, I finish shading the belly ridges and the tip of the tail.

QUETZALCOATL MEXICAN

This powerful serpentine god is classified as an amphitere, or a dragon with wings but no arms or legs. Quetzalcoatl, meaning "feathered snake," taught the Aztec people the craft of agriculture. It has the power to assume human form at will.

Step One With a 3H pencil, I sketch the S-shaped body of a snake. I taper the tip of the tail and make a circle for the head.

Step Two I add a small circle for the eye, a curved line for the mouth, and a rounded cone shape for the nose. Then I add the wings. Most dragons have batlike wings, but Quetzalcoatl has bird wings.

Step Three Using my guidelines and an HB pencil, I build up the head, which resembles a snake. I add the nostril, the fangs, and a mane of feathery hair. I draw stripes for ridges on the bottom jaw. Then I thicken the body by adding the underside line, which disappears as the tail tapers. Next I develop the wings.

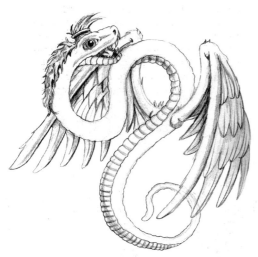

Step Four Still using the HB pencil, I add the striped scale pattern on the underside of the body, making the scales smaller as they near the tail. Then I softly build up tone on the face, scales, and feathers. I draw wavy lines in the hair and additional feathers in the wings.

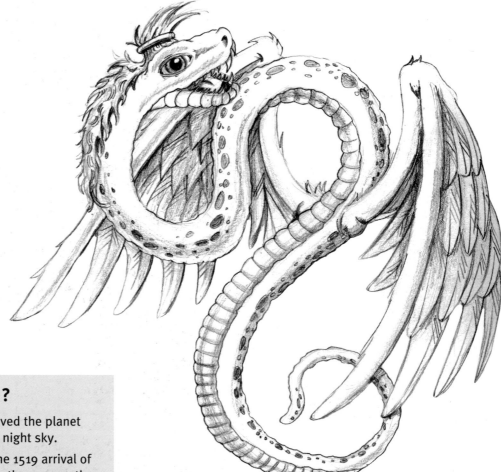

DID YOU KNOW?

- The ancient inhabitants of Mexico believed the planet Venus was Quetzalcoatl ruling over the night sky.
- Aztec Emperor Moctezuma II mistook the 1519 arrival of Spanish conquistador Hernán Cortés for the resurrection of Quetzalcoatl.
- The resplendent quetzal is a bird whose feathers were a rare, precious commodity in the Aztec culture.

Step Five I continue creating the feathered wings by adding crisp contour lines with the sharp point of my HB pencil. I create darker areas of tone on the inside of the wings, where the light would be blocked. I also add a cast shadow on the end of the tail, where the wing overlaps it. Then I add some spots to liven up the sparse areas of the body, and I deepen the tone on the belly scales.

BASILISK NORTH AFRICAN

The basilisk is said to have a lethal gaze, and it leaves a trail of venom in its wake. The basilisk has been described as a giant snake or lizard, as well as a three-foot-tall rooster with snake fangs and tail, as it is represented here.

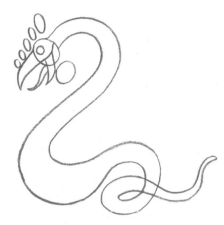

Step One I start by sketching the basic shape of the basilisk with a 3H pencil.

Step Two I add the shapes of the head, including the circular eye and the pointed beak. I use a series of ovals to suggest the comb on top of the head, also adding a larger oval below the jaw for the waddle. Then I add the tongue.

Step Three To make the ridged comb, I connect the ovals. I also connect the waddle to the jaw. Then I detail the eye, add the nostril, and draw the sharp teeth. I begin creating the scales on the body and add feathers to the base of the neck, erasing my guidelines as I draw.

Step Four I add a few more scales, and then I draw the small wing at the midsection. I also draw the large feet.

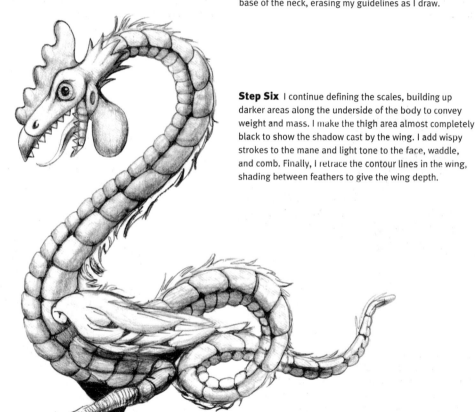

Step Six I continue defining the scales, building up darker areas along the underside of the body to convey weight and mass. I make the thigh area almost completely black to show the shadow cast by the wing. I add wispy strokes to the mane and light tone to the face, waddle, and comb. Finally, I retrace the contour lines in the wing, shading between feathers to give the wing depth.

Step Five I sharpen my pencil so I can draw the tight, thin lines on the feet. I fill in the pupil, and I add form to the scales by shading the areas between them. I also add the sharp talons, as well as the light feathers along the back of the creature.

DID YOU KNOW?

- A basilisk can be killed by hearing the crow of a rooster or seeing its reflection in a mirror.
- Hanging a basilisk's corpse in your home will prevent spiders.
- Rubbing silver with the ashes of a dead basilisk will turn the silver into gold.

APALALA PAKISTANI

Apalala is a naga, with both human and serpentine features. A Hindu river guardian, Apalala is said to dwell in the Swat River in Pakistan. Apalala protects its countryside from wicked dragons. As a result, these areas flourish.

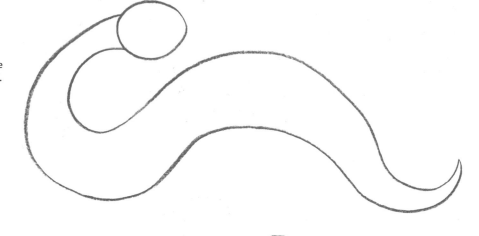

Step One With a 2H pencil, I rough in the general shape of a snake's body and head.

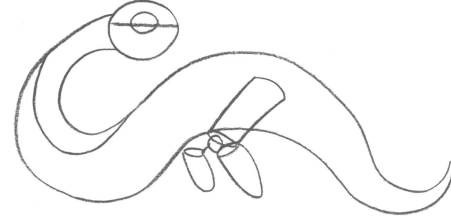

Step Two Now I add basic shapes to block in the humanlike legs. I also draw a horizontal guideline across the head, using it to add the almond-shaped eye. Then I indicate the spine with another curved line.

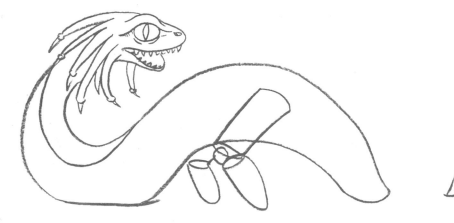

Step Three For the details on the head, I add the catlike pupil, the open mouth, the brow ridge, and the sharp teeth. I also draw a small nostril before erasing my guideline. Then I add the spikes on the back of the head. I erase the middle section of the tail, rounding off the corners of the remaining pieces so it appears that the tail is partly submerged in water.

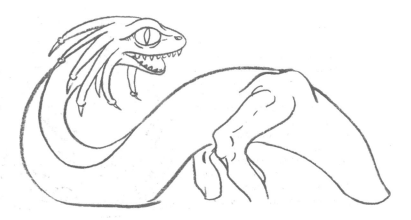

Step Four Now I refine the legs, making knobby knees, a bony thigh, and scrawny calves. I also add a ridged bump above the thigh to indicate the hip. I erase my construction lines as I draw.

Step Five I add small, sharp spikes that travel from the back of the head to the submerged part of the tail to mimic the sharp teeth. Then I add two side fins and another fin on the tip of the tail. I also draw a sharp ridge on the far side of the body to reflect the creature's right hip.

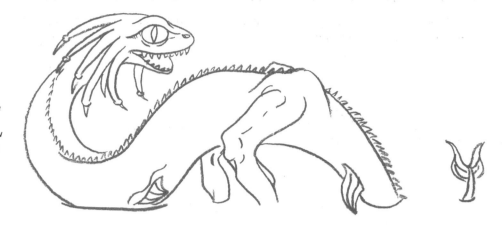

Step Six With a .3 mm waterproof ink pen, I trace the outline of the head and legs. I switch to a smaller .2 mm tip for the delicate lines in and around the eyes and inside the mouth.

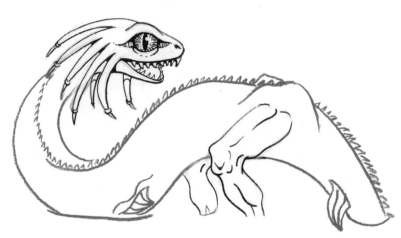

Step Seven I use a .5 mm pen to ink a thick line along the underbelly, and I draw the thinner lines beneath it with a .2 mm pen. I also use this smaller pen to detail the spikes on the spine. I add shadows beneath the neck, thigh, and knees with the .5 mm pen. Next I draw fine lines on the fins with the .2 mm pen. Then I use an HB pencil to draw light circles around the dragon to indicate rippling water.

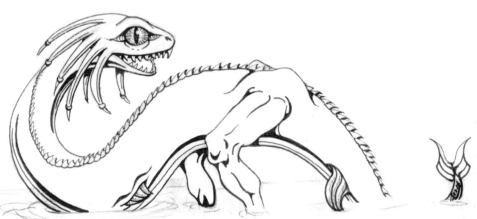

Step Eight Switching between various pen tips, I add the striped pattern on the top side of the body, as well as on the legs. This helps integrate the human parts with the beast parts. Then I deepen the tone of the water ripples, and I draw a light line along the horizon to finish the water. Next I add cast shadows from the head spikes on the neck. I draw the thin stripes on the fins. Then I darken a few areas that need it, such as inside the mouth. When the ink is dry, I remove stray pencil lines with an art gum eraser.

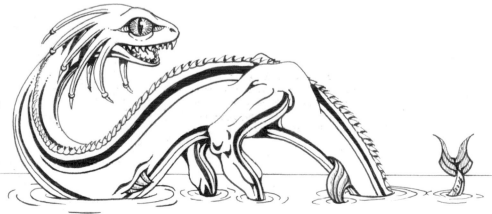

TIAMAT MESOPOTAMIAN

Tiamat is the Babylonian embodiment of salt water. Immune to all weapons, this shapeshifter is considered the mother of all that exists. After being slain by the god Marduk, the creator of humankind, Tiamat's severed corpse created heaven and earth.

Step One With a 3H pencil, I lightly sketch the basic shape of the creature. I curl the tail around the head and add a ball at the end of the tail. Then I add the large oval eye.

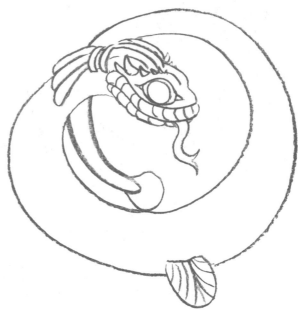

Step Two I give Tiamat a pulled-back hairstyle reminiscent of other Babylonian creatures. Then I refine the eye and add the striped jaws. I also draw a serpentine tongue and add a few horns on the head. Then I draw a dorsal fin that somewhat resembles a seashell.

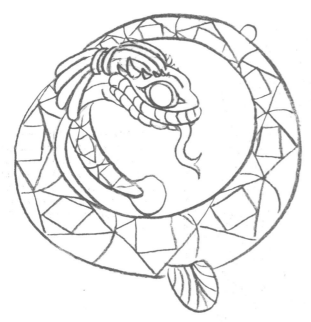

Step Three I cover the body with geometric shapes in a pattern that reminds me of stained glass. I make the shapes smaller and closer together near the end of the tail. I also add a smaller fin to the far side of the body.

Step Four To create a bold, dynamic outline for Tiamat, I use pure (undiluted) ink and a small round brush to trace over my initial pencil lines on the body and face, as shown. I darken the pupil, leaving a round white highlight. To make the hair resemble dreadlocks, I add curved lines; I also draw curved lines on the fins.

DID YOU KNOW?

- Mesopotamian mythology includes Sumerian, Akkadian, Assyrian, and Babylonian myth—Tiamat is Babylonian.
- In Babylonian mythology, the first pair of gods were born from the union of Tiamat and Apsu, the embodiment of fresh water.
- When Tiamat was killed, her tears became the source of the Tigris and Euphrates rivers, which span modern-day Turkey, Syria, Iran, and Iraq.

Step Five When the pure ink is dry, I mix some water with the ink to make a dark wash, which I apply to the underside of the body with a small round brush. Then I add even more water to the ink to lighten it; I apply the lighter wash to the top side of the body, parts of the face, and the hair, as shown.

Step Six I continue to vary the amount of water in my washes to produce different values for the serpent. I layer a darker value on the hair. Then I use a lighter tone for the geometric shapes of the scales. I thicken the body a bit to create the underside of the tail, where I add a tight striped pattern with pure ink. Then I strengthen the stripes on the jaw and the lines in the hair with pure ink.

Step Seven Again using pure ink, I reinforce the scale pattern and create shadows on the underside of the tail. I also add fine lines to the eye. I detail the three fins with smaller stripes. Finally, I dilute the ink a bit with water to add tone to the slithery tongue, as well as to areas of the tail.

CHELAN LAKE DRAGON NATIVE AMERICAN

This water dragon is believed to reside in the Chelan Lake in Washington state. According to the Chelan Indians, the dragon is known to seize fishermen or anyone else who dares to venture into its territory.

Step One First I use a 3H pencil to sketch the body of the dragon. Then I add a circle for the head and use simple shapes to block in the legs. I also draw some guidelines for placing the facial features.

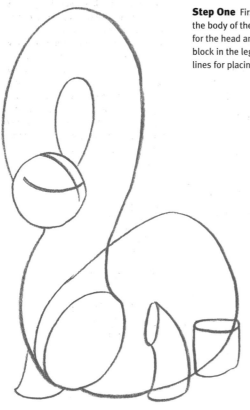

Step Two I delineate the neck with another curve, giving it form. Then I add the curled tail and the rounded haunch. I build on the head by adding two ears and a large muzzle. Next I draw the triangular nose. I also add a curved line to indicate the shape of the chest.

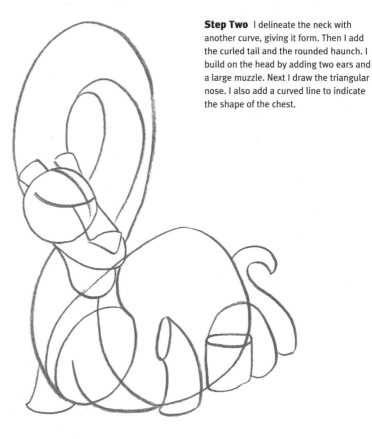

Step Three Using the foundational shapes as guides, I develop the actual form of the dragon. I add ridges and bumps to the body, erasing my construction lines as I draw. I add the eyes and open mouth, and I draw horns behind the ears. Then I transform the nose into a heart shape and add nostrils. Next I draw the deep ridges on the side of the face.

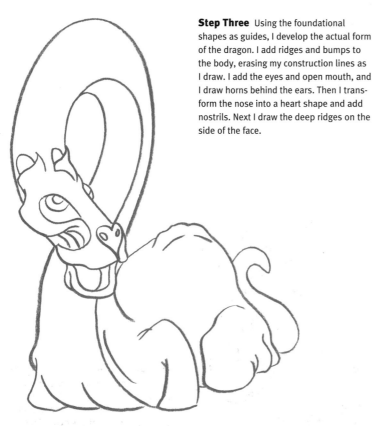

Step Four As this dragon resides in a lake, I want to give it slick, smooth skin. So after adding the sharp teeth, I use a small round brush to apply waterproof India ink over the pencil lines. I use thicker, darker strokes on the ears, around the eyes, inside the mouth, and on the ridges on the face. I darken the pupil, leaving a white highlight, and I add an arched brow.

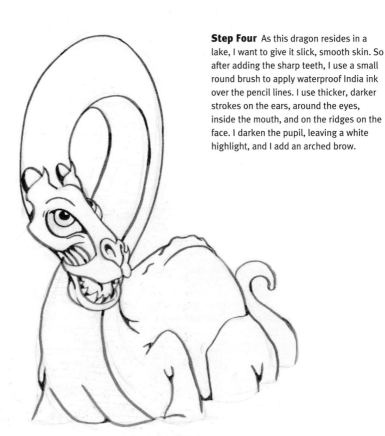

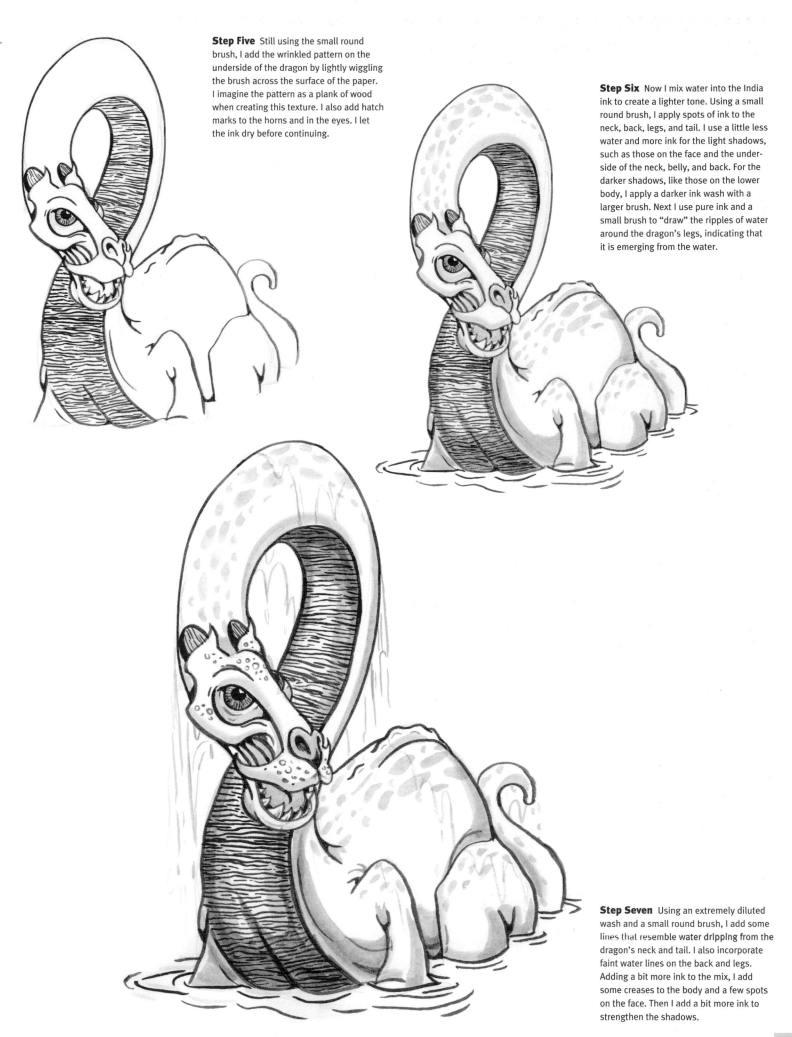

Step Five Still using the small round brush, I add the wrinkled pattern on the underside of the dragon by lightly wiggling the brush across the surface of the paper. I imagine the pattern as a plank of wood when creating this texture. I also add hatch marks to the horns and in the eyes. I let the ink dry before continuing.

Step Six Now I mix water into the India ink to create a lighter tone. Using a small round brush, I apply spots of ink to the neck, back, legs, and tail. I use a little less water and more ink for the light shadows, such as those on the face and the underside of the neck, belly, and back. For the darker shadows, like those on the lower body, I apply a darker ink wash with a larger brush. Next I use pure ink and a small brush to "draw" the ripples of water around the dragon's legs, indicating that it is emerging from the water.

Step Seven Using an extremely diluted wash and a small round brush, I add some lines that resemble water dripping from the dragon's neck and tail. I also incorporate faint water lines on the back and legs. Adding a bit more ink to the mix, I add some creases to the body and a few spots on the face. Then I add a bit more ink to strengthen the shadows.

FAFNIR NORSE

Fafnir was once a dwarf. But soon after he joined forces with his brother Regin to murder their father—the dwarf king Hreidmar—for his treasure, Fafnir decided he didn't want to share his newfound riches. Due to his greed, he was slowly transformed into a dragon. Regin then avenged his brother's selfishness by having his son, Sigurd, slay the dragon Fafnir.

Step One With a 2H pencil, I block in the basic shapes that make up the upper portion of the dragon. I draw a teardrop shape for the torso, a curved cylinder for the neck, and a small circle for the head. Then I use curved shapes that resemble swords for the wing bones.

Step Two I connect the bones of the wings with curved lines, adding small circles at the tip of each bone. Then I add the long snout and two beady eyes. I draw circles, boxes, and cylinders to block in the arms and legs, and I draw the thick tail.

Step Three Now I add some details to the head. I draw the sharp horns, the webbed fins on either side of the face, and the striped pattern that reaches from the top of the head to the forehead and from the eyes to the nose. Then I add the nostrils and the open mouth, suggesting two sharp fangs at the top of the mouth. I use a curved line to indicate the furrowed brow, and then I erase any remaining construction lines on the head.

Step Four Using the basic shapes as guides, I develop the arms, legs, hands, and feet. I add sharp claws to the feet and hands, and I draw curved lines to suggest musculature on the legs. The visible elbow gets a spike as well. Then I add the striped scales down the belly and the spikes down the neck and onto the tail. I also refine the wings and add spiked tips to each bone. Then I erase all my remaining construction lines.

Step Five To achieve darker, softer tones for this dragon, I use a black colored pencil to start rendering the details of the face. I build up the tones slowly, with a soft touch. I work with a small sharpener in hand because the colored pencil is very soft and needs constant resharpening for detailed areas.

Step Six I use light pressure to shade the wings, placing the darkest tone along the bones and near the neck, where the light is blocked. I also add nicks and tears along the outer edges of the wings, and I darken the tips of the spikes. Then I add very light veins throughout the wings. Next I apply a scale pattern to the legs and arms that reminds me of a quilted mattress. I also add tone to the feet, using the darkest value yet for the claws.

DID YOU KNOW?

- To slay Fafnir, Sigurd hid in a covered pit and stabbed the dragon as he passed by.

- In a German version of the tale, Fafnir began life as a giant rather than a dwarf.

- After slaying the dragon, Sigurd cooked and tasted Fafnir's heart, gaining the power to understand the language of birds.

- Unbeknownst to Fafnir, the stolen treasure actually was cursed.

Step Seven I continue the scale pattern onto the neck, back, and tail. I prefer working on one section of the body at a time, as it helps me keep the pattern appropriate for the area I'm working on. Once the body scales are complete, I add dark shadows where the scales intersect. Next I shade the wide scales of the belly, leaving the near side lighter to show that the light is coming from the right. I also darken the tips of the spikes along the back, and I add some round knobs to the end of the tail.

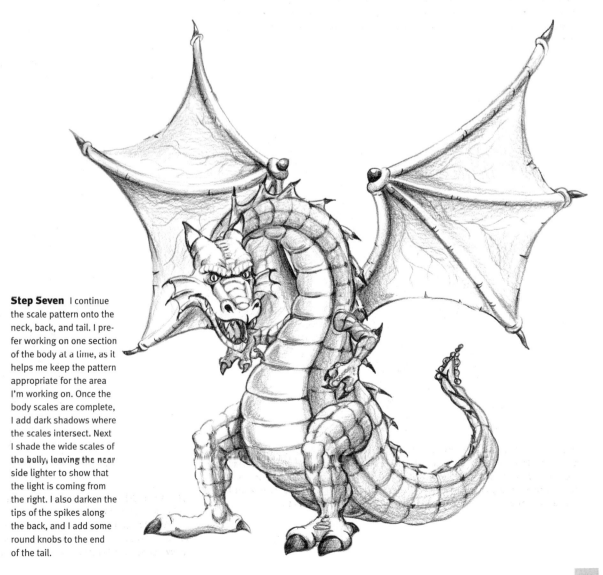

DRACHENSTEIN GERMAN

This wingless firedrake hails from German mythology. The tale comes from the same origin as Fafnir's story—but in this rendition, Drachenstein was born a dragon. He was slain for hoarding a treasure, but it was his own, not ill-gotten gains.

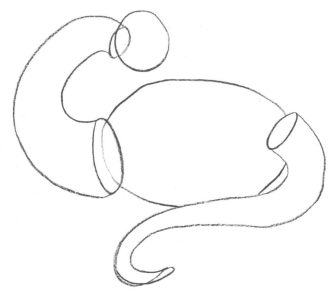

Step One I start this drake by mapping out the form of the creature's body. I use a harder pencil—a 2H—because I know most of this information is for me and will soon fall victim to the eraser.

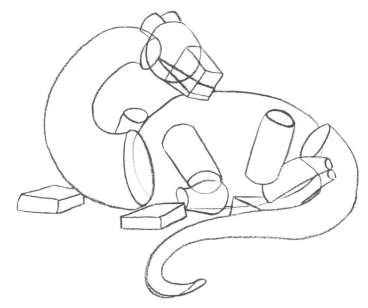

Step Two After adding a boxlike snout and the back of the head, I block in the legs and feet using boxes and cylinders.

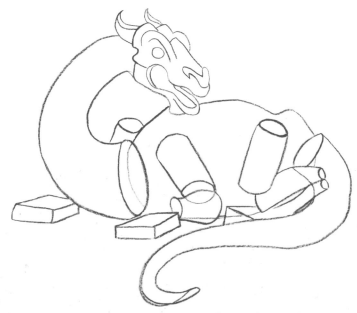

Step Three Following the form I laid out, I use an HB pencil to develop the head, which is similar to a horse's skull. The nose resembles a llama's. Next I modify the shape of the lower body by drawing a bony ridge near the tail.

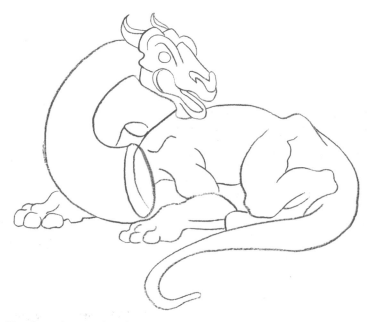

Step Four I integrate the tail into the body and develop the legs, using my basic shapes as guides. I refine the feet, making the toes appear lumpy and oversized. Before erasing my construction lines, I modify the end of the tail by thinning it out a bit.

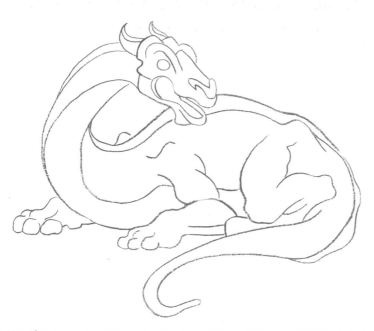

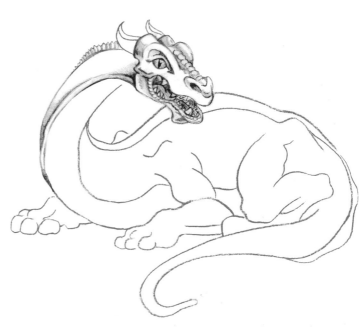

Step Five To give form to the neck, I add curved lines to represent the underside and top sections. I also draw a stripe that goes from the base of the neck to the middle of the tail to show the ridge of the back, and I refine the shoulder that is visible on the far side of the dragon's body.

Step Six I want to give this dragon a fierce personality, so I use my 2B pencil to add the sharp, jagged teeth and the small, bony plates along the back of the neck. I also detail the eye and add a ridged texture to the nose. Then I add tone to the base of the horns, the nose, inside the mouth, and along the side of the neck. The darkest values are inside the mouth and at the top of the neck, where the jaw bone casts a shadow.

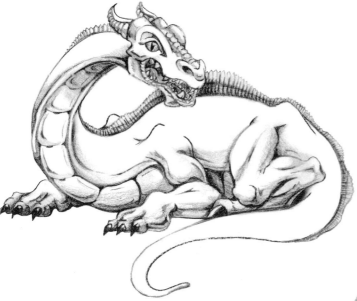

Step Seven I continue drawing bony plates along the ridge of the back, making them taller and sharper near the middle of the back. Then I add large scales on the underside of the neck and belly. I apply dark tone where the head casts a shadow onto the neck. And I add tone to the legs, creating a darker value where the body parts overlap. I shade the feet, drawing long, dark claws with a highlight on each toe. I also begin to draw ridges on the horns.

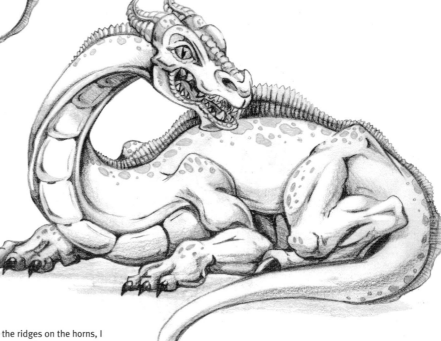

Step Eight After I finish the ridges on the horns, I add irregular spots all over the dragon's body. I shade the dragon's tail and add a shadow beneath the feet, tail, and torso to "ground" the beast into the scene.

DRAGON OF BEOWULF ANGLO-SAXON

This drake was responsible for the felling of the legendary warrior hero Beowulf. After the dragon attacked Beowulf's village to avenge being robbed, Beowulf hunted the dragon. The beast was slain—but its deadly bite resulted in Beowulf's demise!

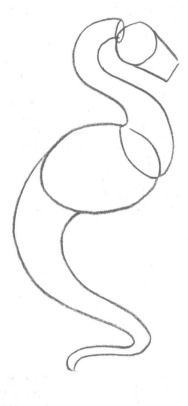

Step One With a 2H pencil, I draw the basic shapes of the dragon. I draw an egg shape for the torso and attach an S shape for the neck. I add a circle for the head and tack on a rectangular shape for the muzzle. Then I add the curved tail.

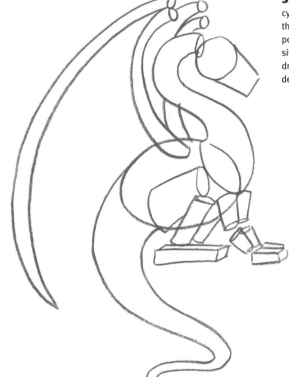

Step Two Now I add cylinders and boxes for the legs and feet. This pose reminds me of a sitting dog or cat. Next I draw long, curved cylinders for the wing bones.

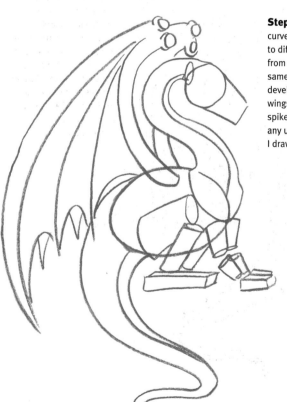

Step Three I add a curved line to the neck to differentiate the front from the back. I do the same to the tail. Then I develop the large batlike wings, with four nubby spikes at the tips. I erase any unnecessary lines as I draw.

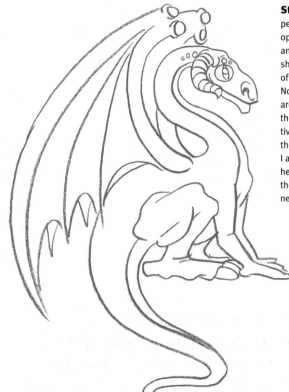

Step Four With an HB pencil, I refine and develop the dragon's head and body. I use the basic shapes to draw the forms of the chest and legs. Notice that the back feet are oversized, whereas the front feet are relatively petite. After giving the dragon a ram's horn, I add a few details to the head, such as the nostril, the spots on the head and neck, and the eye.

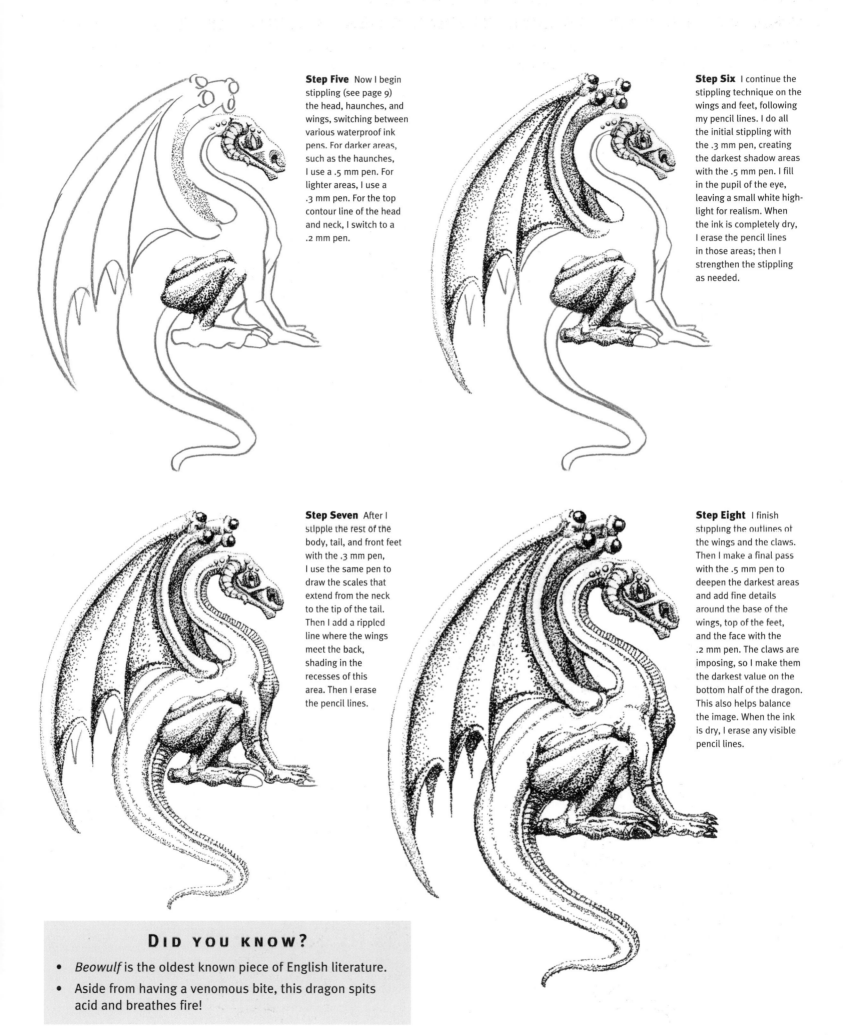

Step Five Now I begin stippling (see page 9) the head, haunches, and wings, switching between various waterproof ink pens. For darker areas, such as the haunches, I use a .5 mm pen. For lighter areas, I use a .3 mm pen. For the top contour line of the head and neck, I switch to a .2 mm pen.

Step Six I continue the stippling technique on the wings and feet, following my pencil lines. I do all the initial stippling with the .3 mm pen, creating the darkest shadow areas with the .5 mm pen. I fill in the pupil of the eye, leaving a small white highlight for realism. When the ink is completely dry, I erase the pencil lines in those areas; then I strengthen the stippling as needed.

Step Seven After I stipple the rest of the body, tail, and front feet with the .3 mm pen, I use the same pen to draw the scales that extend from the neck to the tip of the tail. Then I add a rippled line where the wings meet the back, shading in the recesses of this area. Then I erase the pencil lines.

Step Eight I finish stippling the outlines of the wings and the claws. Then I make a final pass with the .5 mm pen to deepen the darkest areas and add fine details around the base of the wings, top of the feet, and the face with the .2 mm pen. The claws are imposing, so I make them the darkest value on the bottom half of the dragon. This also helps balance the image. When the ink is dry, I erase any visible pencil lines.

DID YOU KNOW?

- *Beowulf* is the oldest known piece of English literature.
- Aside from having a venomous bite, this dragon spits acid and breathes fire!

DRAGON OF ST. GEORGE ENGLISH

St. George was a Roman cavalry officer who liberated the town of Cappadocia from a marauding dragon—the Dragon of St. George. The town had been pacifying the dragon by sacrificing sheep; when they ran out of sheep, they sacrificed children!

Step One I start by using a 2H pencil to block in the basic shapes. I connect a long oval shape to a small circle with two curving lines. These shapes represent the dragon's head, neck, and torso. Then I add a curved line down the center of the torso.

Step Two I draw the scale pattern on the dragon's torso, which is divided in two parts by the curved vertical line from step one. Then I add the long tail, curving it to resemble a hook.

Step Three I extend the head to include the long snout, the horn, and the fin. I block in the eye, nose, and mouth. At this point, the head sort of resembles that of a dog. Next I use basic shapes to draw the legs and feet. I continue the scale pattern up the neck and down the tail. Then I add a diamond shape at the end of the tail.

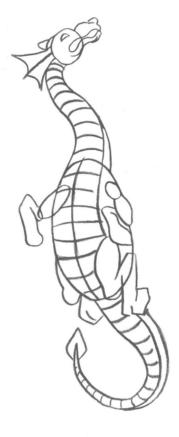

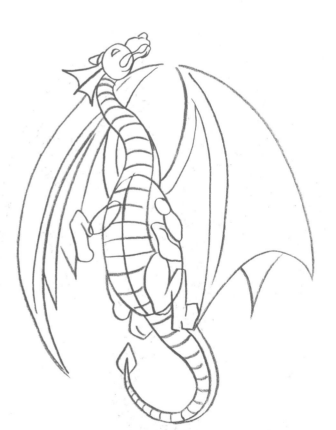

Step Four Next I draw the large, batlike wings. I start with the large bones coming from the dragon's back, then add the skin around them.

DID YOU KNOW?

- St. George killed the dragon by running a lance through its body from horseback.

- The dragon went from eating two sheep a day to one child a day—his fee for not poisoning the entire city.

- St. George arrived just in time to prevent the king's daughter from becoming the dragon's next meal.

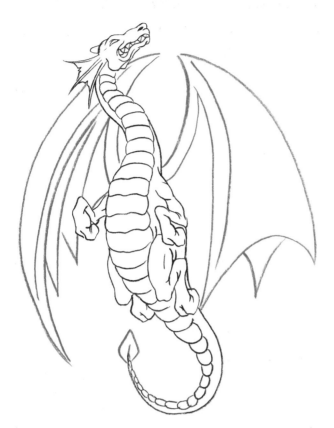

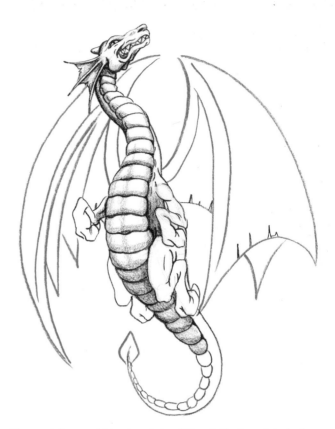

Step Five Switching to a sharp 2B pencil, I retrace the pencil lines on the body (everywhere except the wings). Then I refine the shape of the fin; add the sharp, clenched teeth; and fill in the nostril. Then I refine the shapes of the legs. Next I use curved, rippling lines to give form to the scales. I erase pencil lines as needed.

Step Six I apply loose, quick hatch marks to add tone to the dragon's body. For areas of shadow, such as the lower section of the tail, under the forelegs, and below the neck, I change to rough crosshatching.

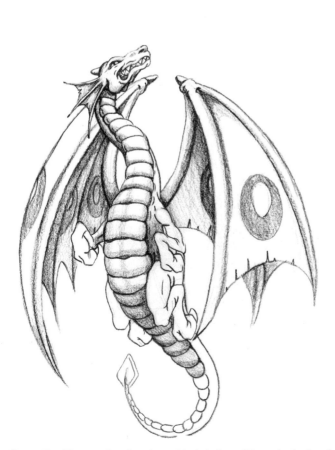

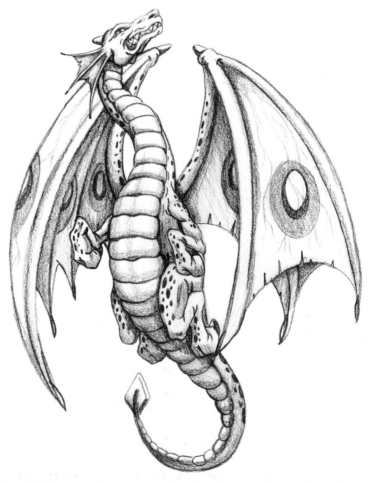

Step Seven Now I focus on the wings. I use a blunted 2B pencil to emphasize the wing bones, shading around them to create their forms. I draw a spike at the top of each wing and then add the "eye" pattern, as shown.

Step Eight I finish adding tone to the tail and then draw spots all over the dragon's body. Finally, I add light veins to finish both wings.

APOCALYPTIC BEAST MESOPOTAMIAN

In the Bible, the seven-headed beast of the Apocalypse has a lion's mouth, a bear's paws, and a leopard's body. The 10 crowns on the beast's 10 horns represent the kingdoms that unite with the beast to become a world-dominating empire.

Step One Using a 2H pencil, I block in the outline of the beast's head and body. I add the legs, haunches, paws, and tail; then I add facial guidelines to the head.

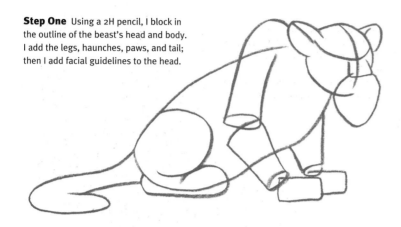

Step Two I draw a striped pattern that travels from the tip of the tail to the beast's right foreleg. Then I refine the huge bearlike paws, giving them sharp claws.

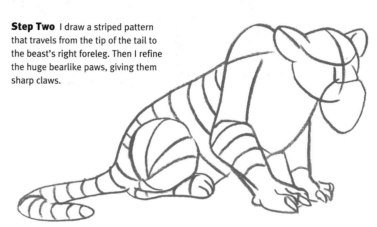

Step Three Now I focus on the main head. I render a lion's face, complete with an underbite and a wide nose. I add a tuft of spiky hair on the head before creating the 10 long horns. Then I draw wavy lines that extend from the side of the main face, sketching small heads at the end of the lines. At this point, only four small heads are visible. I also continue the striped pattern up the beast's right shoulder.

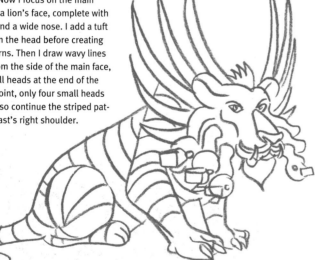

Step Four After adding four spikes at the end of the tail, I use a black colored pencil to begin shading the tail, as well as the underside of the beast and parts of the forelegs. I choose to apply black colored pencil because I want to achieve a dark value for this dark creature.

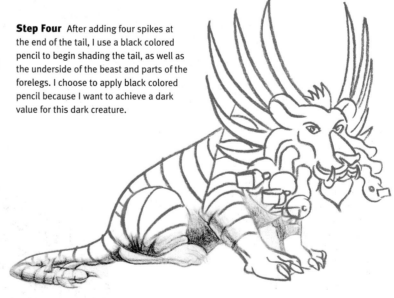

DID YOU KNOW?

- The word "apocalypse" translates in Greek to "revelation."
- In English, "apocalypse" refers to the end of the world.
- The beast of the Apocalypse appears in the Book of Revelation, the last book of the Christian New Testament.
- In the Book of Revelation, one of the beast's heads seems to be mortally wounded but then heals itself.

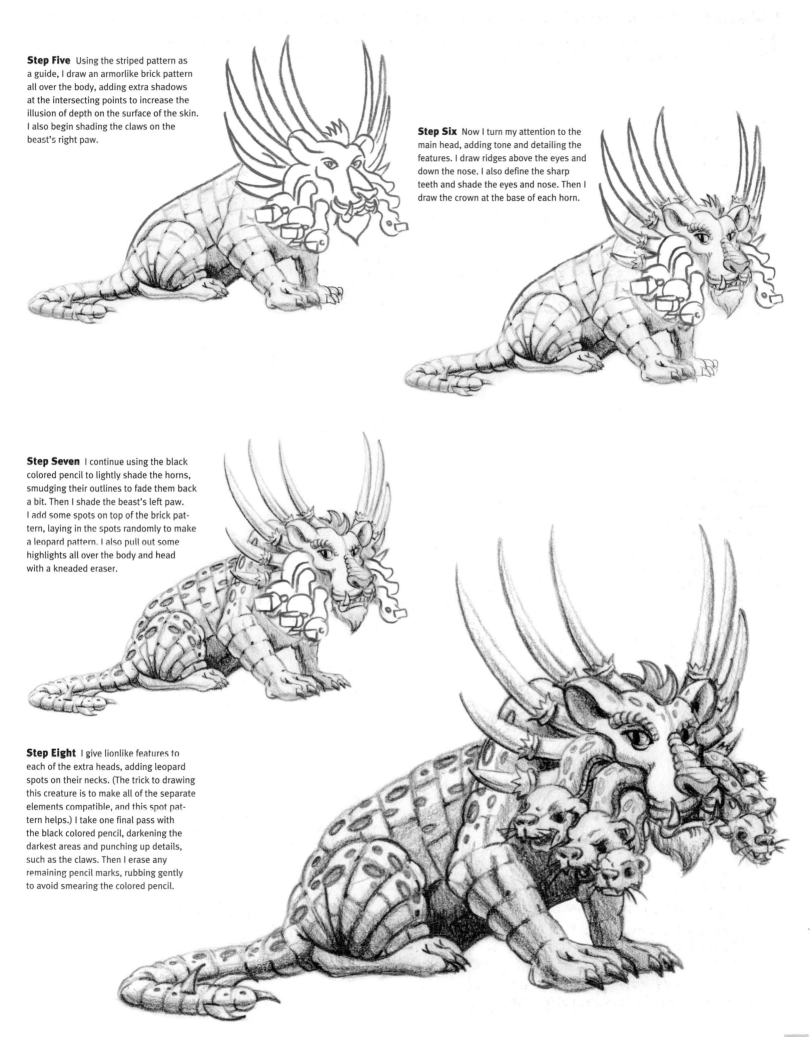

Step Five Using the striped pattern as a guide, I draw an armorlike brick pattern all over the body, adding extra shadows at the intersecting points to increase the illusion of depth on the surface of the skin. I also begin shading the claws on the beast's right paw.

Step Six Now I turn my attention to the main head, adding tone and detailing the features. I draw ridges above the eyes and down the nose. I also define the sharp teeth and shade the eyes and nose. Then I draw the crown at the base of each horn.

Step Seven I continue using the black colored pencil to lightly shade the horns, smudging their outlines to fade them back a bit. Then I shade the beast's left paw. I add some spots on top of the brick pattern, laying in the spots randomly to make a leopard pattern. I also pull out some highlights all over the body and head with a kneaded eraser.

Step Eight I give lionlike features to each of the extra heads, adding leopard spots on their necks. (The trick to drawing this creature is to make all of the separate elements compatible, and this spot pattern helps.) I take one final pass with the black colored pencil, darkening the darkest areas and punching up details, such as the claws. Then I erase any remaining pencil marks, rubbing gently to avoid smearing the colored pencil.

LADON GREEK

In Greek mythology, Ladon guarded the golden apples in the garden of the Hesperides, four nymph sisters. One of Heracles' Twelve Labors (performed to satisfy the Oracle) is to slay Ladon with an arrow shot from over a wall, which he does. Ladon, a hydra, was the spawn of Echidna (see page 81) and her mate, Typhon, a 100-headed sea god.

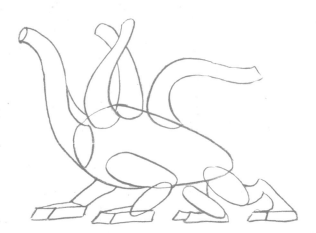

Step One Ladon is a beast with 100 heads—he will need a stout body to support all those necks, so I suggest a large body with an oval shape. Then I block in four legs with boxy feet. Now I start laying out a few necks. (I won't draw all 100 necks, as I assume that all those heads cannot be seen from any one vantage point.) This can be a knotty mess, so I need to be sure I know which neck leads to which head.

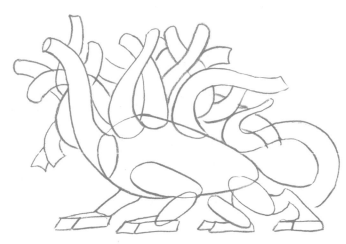

Step Two As I continue adding necks, I make sure that most of them have a visible end—although you can't really tell where they all begin. Then I add the strong, curling tail (which kind of looks like yet another neck).

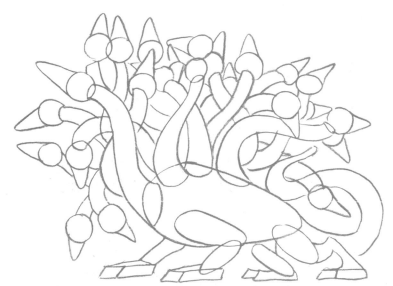

Step Three I block in the heads and add even more necks. I try to keep track of each head and neck, but it's okay if some of them get "lost."

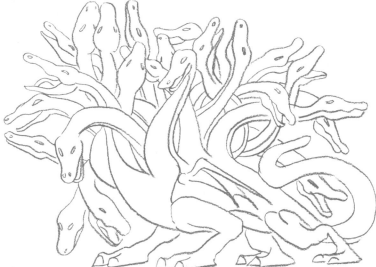

Step Four Now I begin to refine the shapes, erasing any pencil lines I no longer need as I work. I draw dinosaurlike feet, with two claws on each foot, as well as a wing just above the dragon's left front leg. Next I concentrate on the heads, which are based on an alligator. I make some of the mouths open and others closed. Sometimes the tongue is visible; sometimes it isn't. I also draw lines that travel up the undersides of some of the necks. These lines lead directly to the jaw lines and determine the position of each head.

DID YOU KNOW?

- Ladon's heads spoke with a multitude of voices and in many different languages.
- Hera, Queen of the Heavens, appointed Ladon to guard the golden apples.
- Ladon guarded the apple tree by coiling himself around it.
- When Ladon was slain, Hera placed his body in the heavens so that it coiled around the North Pole.

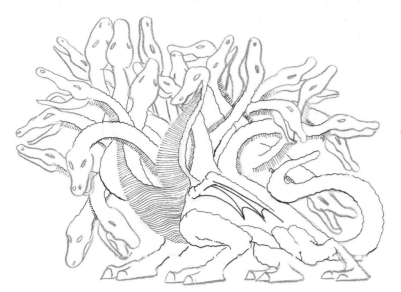

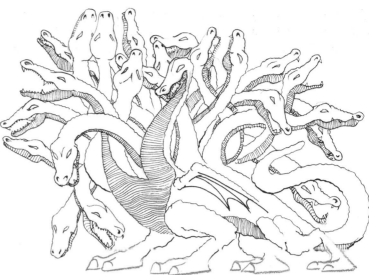

Step Five To draw the ridged lines on the belly, torso, and on the undersides of some of the necks, I use a .2 mm ink pen. I pay careful attention to where I place these ridges. If I lay them in haphazardly, it will show in the final work. I switch to a .5 mm pen to outline some of the necks, as well as the wing, tail, and upper portions of the limbs.

Step Six I continue the ridged pattern with the .2 mm ink pen, extending the pattern to the undersides of the jaws. I also finish outlining the necks and heads, adding ridges along the necks and on the tops of the heads. Then I outline the eyes, nostrils, and brows, where applicable. I also add small, sharp teeth to the open mouths.

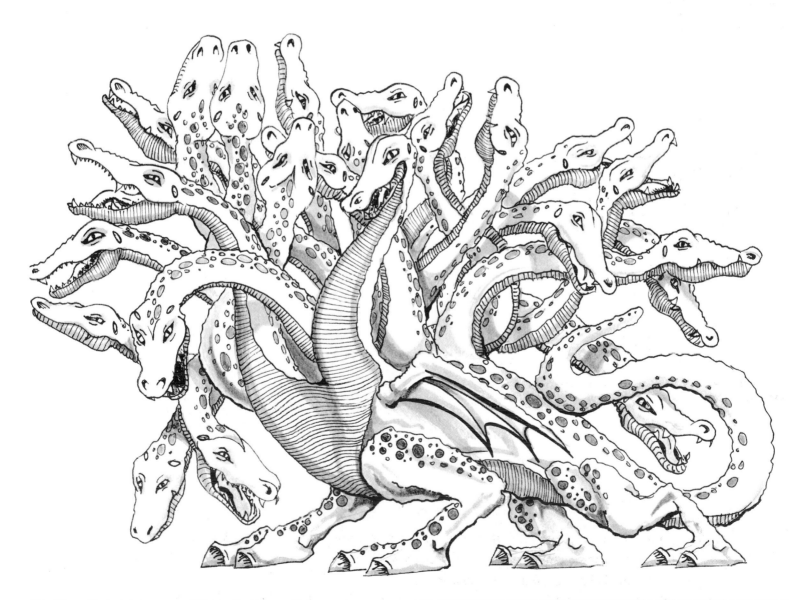

Step Seven I lay in darker areas around the mouths and eyes with the .5 mm pen, and I refine the feet and claws. Then I add a slew of spots with the .2 mm pen. Once the ink is dry, I thin some India ink with water. With this wash and a small round brush, I add areas of tone wherever I want to suggest a shadow. Finally, I erase any pencil lines that still show.

AZHI DAHAKA Persian

This evil, three-headed monster wished to destroy all the people in the world. Fredon, a boy with divine gifts, feared that the poisonous creatures that would emerge from Azhi Dahaka's wounds would wreak havoc—so instead of slaying him, he tied up the beast on a mountain. At the end of the world, the beast will break free and kill one third of all humans and livestock.

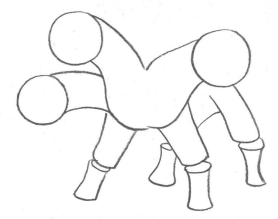

Step One I rough in the general body shapes with a 2H pencil. I draw the body of a stout canine and place it in a pose that reflects a readiness for action. Then I add three circles to place the heads.

Step Two I add circles below each of the four legs to block in the paws. The dragon's right paws get four circles, whereas the left paws get three (the fourth toes on the right paws are less prominent from this angle). Then I add facial guidelines on the heads, as well as lines to show the curvature of the necks.

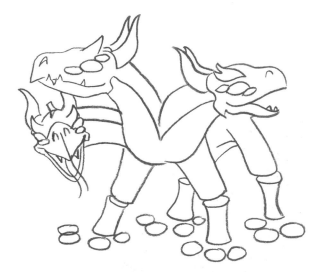

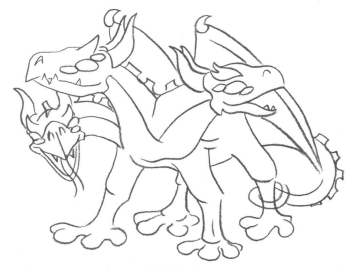

Step Three Now I develop all three heads. Then I begin rendering facial features, such as the noses, mouths, and eyes. Each head has three sets of eyes. I also add a pair of curved horns to each head.

Step Four I use the small circles to refine the feet, keeping their rounded shapes. After I draw the two large wings, I add spikes to the tips of each. I also draw the tail, which wraps around the dragon's back left leg. I make square ridges along the tail, as well as along the backs of the necks. I erase any construction lines that remain to clean up my drawing.

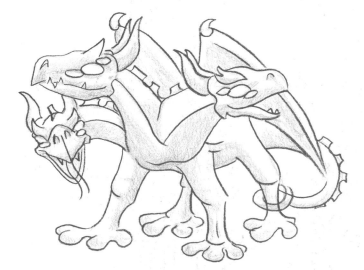

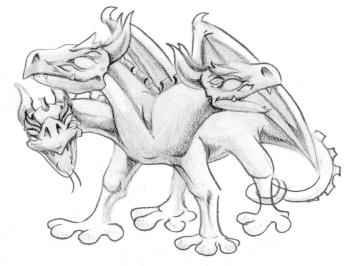

Step Five I begin shading the body and the wings with a black colored pencil. This is just a very light, initial layer of tone.

Step Six I continue building up the image slowly, adding darker tones to the faces, necks, and wings. I also shade in between some of the ridges on the backs of the necks. A nice aspect of colored pencil is that it doesn't smudge easily—but it's difficult to erase, so I take my time to avoid making mistakes.

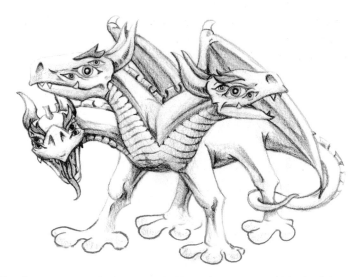

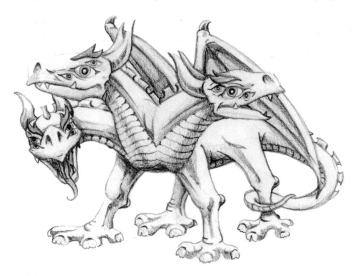

Step Seven Moving to the faces, I use the black colored pencil to add the details in the eyes. I also fill in the eyebrows, the mouths, the tongue, and the six horns. Then I add shading on the tail, tapering the tip a bit more than it originally was. Next I draw scales on the chest and up the necks. I also shade the underside of the dragon and the upper legs.

Step Eight Now I concentrate on the paws. I picture the dragon's toes to be a cross between those of a tree frog and an elephant, so I draw them this way. I make rough, ragged nails to contrast with the orderly, streamlined design of the rest of the body.

Step Nine Finally, I use the colored pencil to darken the shadows and refine the figure as needed. I add tone to the toenails and pull some highlights out in the chest scales. When I'm satisfied, my drawing is complete!

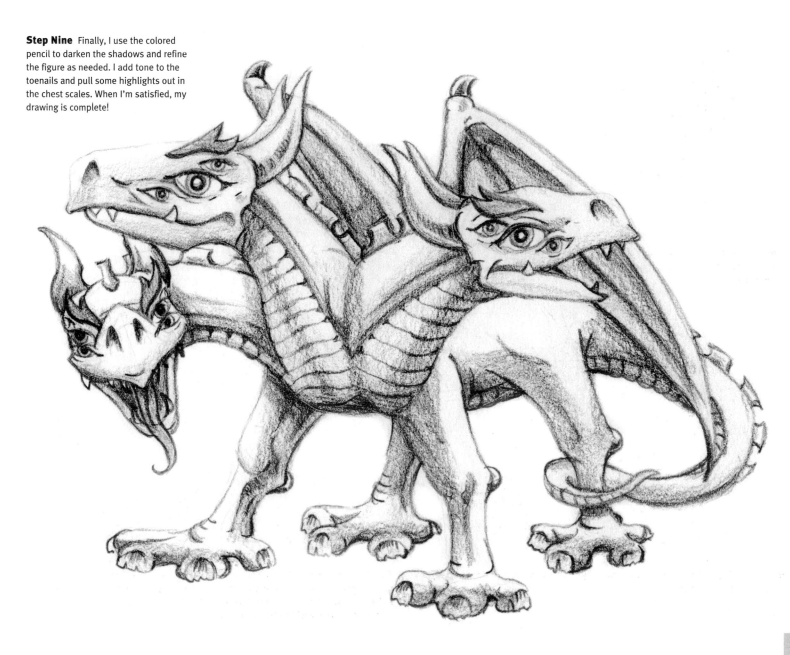

SUI-RIU JAPANESE

Dragons are rare in Japanese mythology. When they do appear, they are benevolent and generally are associated with water. Sui-Riu is the Japanese dragon king of rain. Like all Japanese dragons, it has three claws on each foot.

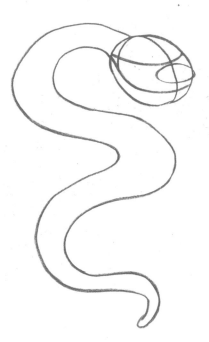

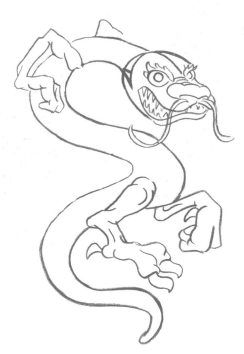

Step One I use a 3H pencil to draw a simple S shape with an extra tail for the body. Then I add an oval for the head. Next I draw curved facial guidelines and then add an oval for the long nose.

Step Two Changing to a 3B pencil, I add large eyes, a toothy mouth, bushy eyebrows, and long whiskers. Then I refine the nose and add scrawny forelegs. The hind legs and feet are oversized, with long, sharp claws.

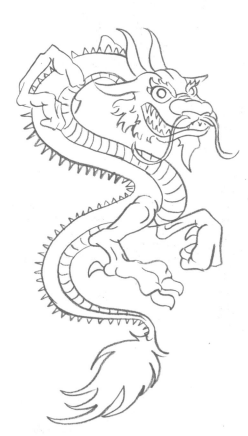

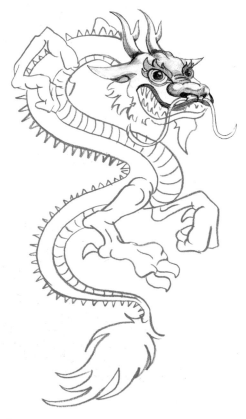

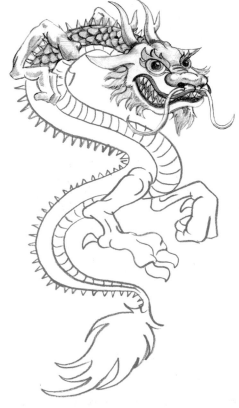

Step Three I add two curved horns, the pointy ears, facial hair, and a bushy tuft of hair on the tail. I add a striped pattern on the underside of the body and spikes on the back of the body.

Step Four To begin adding tone to the head, I start with the horns and work my way down to the mouth. I place the darkest values at the bottoms of the horns, along the upper lip, and along the nostrils.

Step Five Continuing down the face, I shade the rest of the mouth, as well as the whiskers and hair. Then I begin adding a scale pattern down the dragon's back with a 3B pencil. These scales appear fishlike and shimmery.

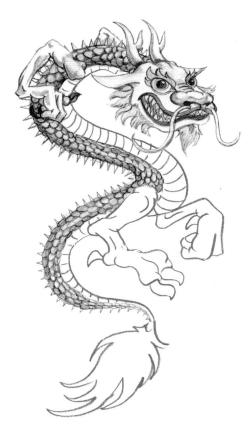

Step Six I continue adding scales along the body of the dragon. I also darken the claws on the front right foot. Because the soft lead of the 3B wears down rather quickly, I keep a sharpener handy so I can draw the thin lines of the scales.

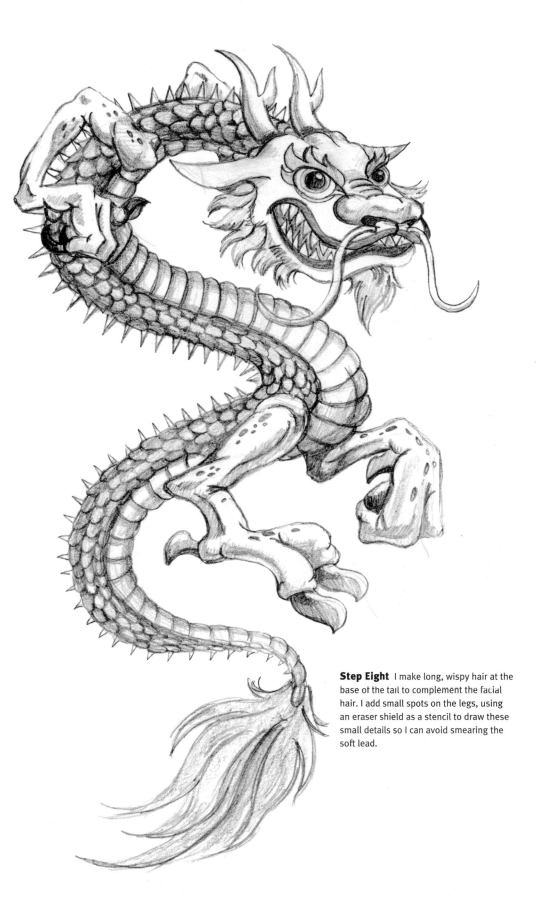

Step Eight I make long, wispy hair at the base of the tail to complement the facial hair. I add small spots on the legs, using an eraser shield as a stencil to draw these small details so I can avoid smearing the soft lead.

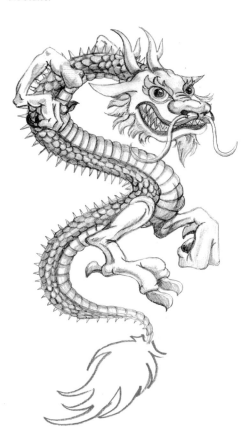

Step Seven I create the smoother, ridged texture of the dragon's belly, starting at the foreleg and ending at the tip of the tail. This pattern nicely contrasts with the scaly, fish-like back. I add tone to the hind legs and feet, saving the darkest tones for the claws.

71

T'IEN LUNG CHINESE

This extremely powerful Celestial Dragon guards the heavens and the palace of the gods in Chinese mythology. Although totally deaf, this water dragon has the power to control lightning and thunder. The power rests in the dragon's pearl.

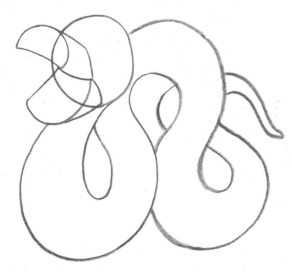

Step One I begin by creating an outline of the dragon's body and head with a 2H pencil. I draw the large, open mouth and indicate the tapered tail.

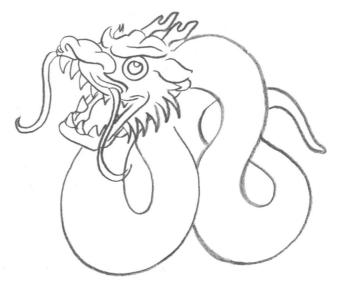

Step Two Using my basic shapes as a guide, I render the head. I draw the large, round eye, the wide nose, the open mouth, and the antlers. I add a pointed ear, sharp teeth, two curled whiskers, and some bushy hair. I also add the pupil with a round highlight at the top.

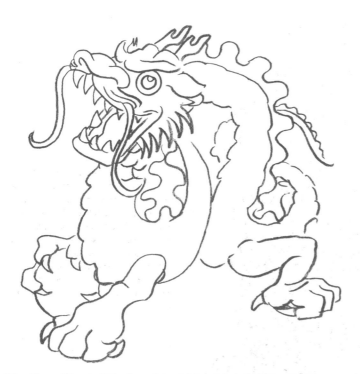

Step Three When I add the dragon's two left legs, I draw the toes so that they are curled in. I indicate a few long claws, and then I draw the dragon's front right paw clutching the round pearl. I develop the shape of the body, making the edges rougher. I also add a scalloped ridge on the dragon's back; the ridge decreases in size as it nears the tail.

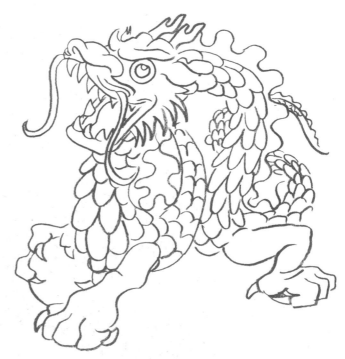

Step Four I add scales all over the body. The scales curve within the body's form. This pattern is larger and more open than the scale pattern on Sui-Riu. Notice the way the scales become smaller as they approach the tail.

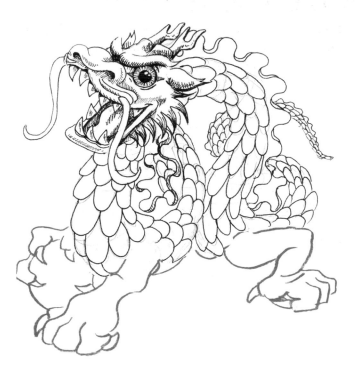

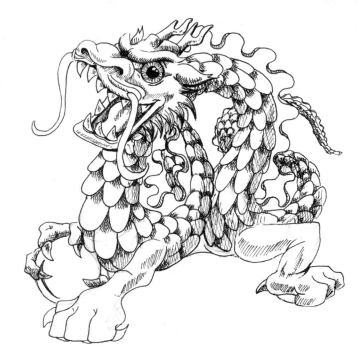

Step Five Using a .3 mm ink pen and steady strokes, I outline the scales and add details on the face. With the same pen and short, rapid hatch marks, I shade the face. I use cross-hatching for darker shading. I erase the pencil lines as I finish each area.

Step Six I use the same method for the legs: outlining with smooth, even-flowing strokes and shading with rapid hatch marks. I fill in shadowed areas on the scales to give them depth, and I add darker values to the claws. I also shade the ridges on the dragon's back to give them form.

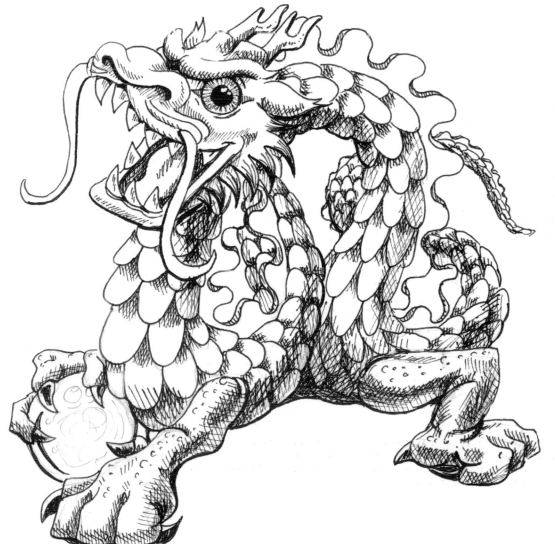

Step Seven I continue to add texture to the limbs, also strengthening the contour line on the underside of the figure with repeated, careful strokes. I do the same to enhance details around the face. I darken the claws, leaving a stark highlight on each. Lastly, I draw some light swirls on the pearl, as well as a dark, curved line to show a reflection. When the ink is completely dry, I erase any visible pencil marks.

HYDRUS EGYPTIAN

Also called "Idrus," Hydrus is a many-headed dragon that lives on the Nile River in Egypt. A natural enemy of the crocodile, Hydrus tricks the reptile into swallowing it so Hydrus can destroy the crocodile, eating it from the inside out!

Step One With a 3H pencil, I lightly sketch the outline of the dragon, which is shaped like a pretzel. At this point, I draw only one snakelike head.

Step Two I add the other two heads, wrapping them around the first head with a shared neck.

Step Three For the second and third heads, I make a thicker body shape. Then I begin adding the lines for the mouths and the nostrils on all three heads. I also lengthen the eye on each head.

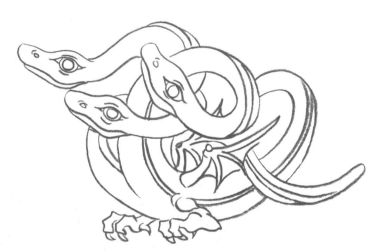

Step Four I add the feet, drawing them so that they appear to be clutching something in their sharp claws. Next I add more lines to separate the necks and to delineate the front from the back. I also draw a small pair of wings at the base of the main body. Finally, I add a pupil in each eye and draw details around them.

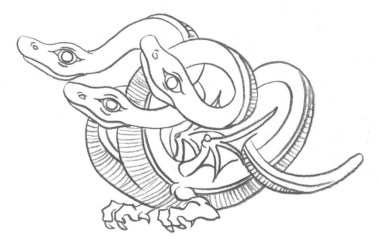

Step Five To add texture, I draw tight lines on the underside of the necks. These lines continue on the middle section of the body and down the underside of the tail.

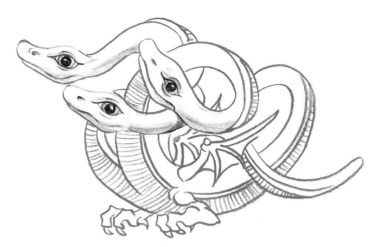

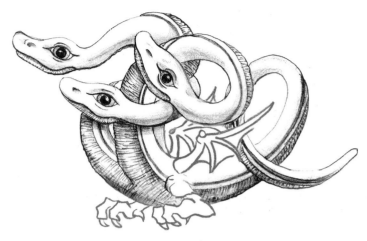

Step Six I press harder with the pencil to shade inside the eyes. I am careful to leave a white highlight in each pupil. I also shade the nostrils and the mouths. Then I add some light tone on each neck.

Step Seven Switching to a .5 mm ink pen, I trace over the underside outline of the dragon. I use a .3 mm pen to trace the upper outline. I use a .2 mm pen to create texture on the belly and the underside of the tail. I use my pencil lines as a guide to refine these lines, allowing the ink lines to break and fade.

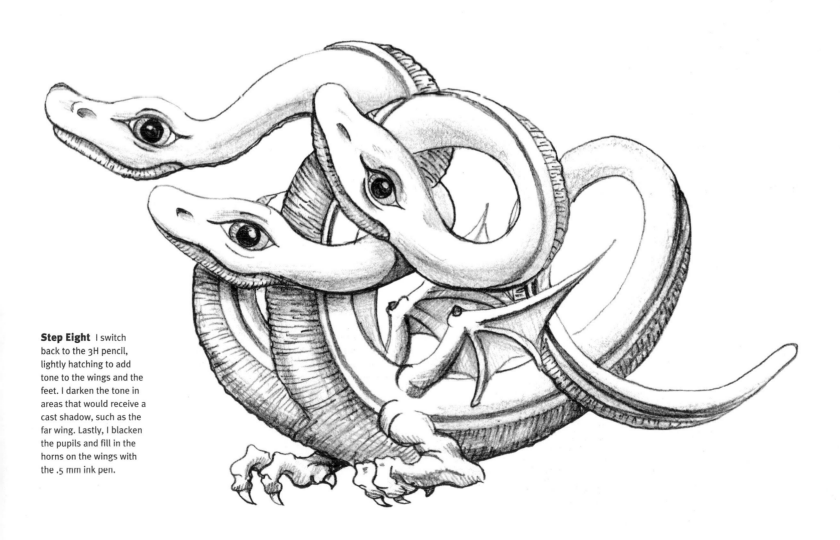

Step Eight I switch back to the 3H pencil, lightly hatching to add tone to the wings and the feet. I darken the tone in areas that would receive a cast shadow, such as the far wing. Lastly, I blacken the pupils and fill in the horns on the wings with the .5 mm ink pen.

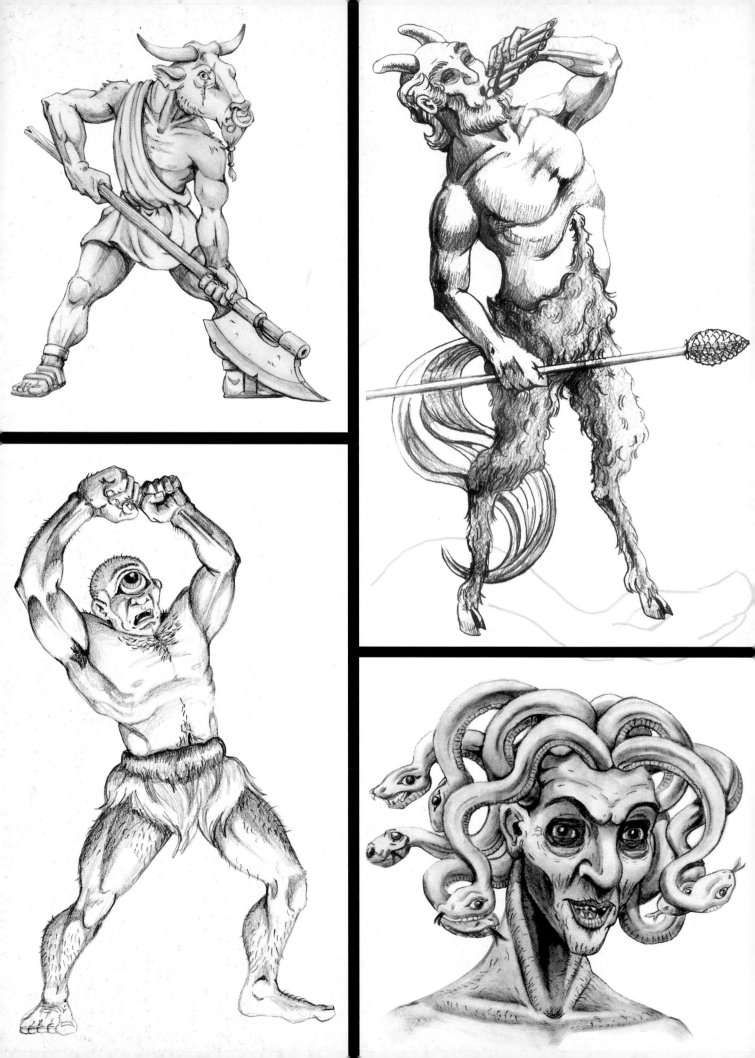

Mythological Beasts

Every culture has its own mythology, and many of these myths feature mystical creatures. Here you'll find a small sampling of my personal favorites. You will see that I gravitated toward the Greek characters—which may be due to my own interest in the topic or to the fact that many Greek monsters were incorporated into other regions' mythologies as the Greeks conquered most of the known world at the time. But aside from the Greek beings, you'll discover magical creatures from a few other regions. Mythological beasts come in all shapes and sizes, and each has a fascinating backstory of its own. So pick up your pencil and start capturing these fanciful figures!

HUWAWA MESOPOTAMIAN

Huwawa (also called "Humbaba") was the celestial forest guardian in Mesopotamian mythology. As the story goes, the god of sky and wind, Enlil, bestowed Huwawa seven "radiances" and appointed him protector of the Cedar Forest, home of the gods. Huwawa eventually was hunted and slain by Gilgamesh, a distracted king looking for adventure.

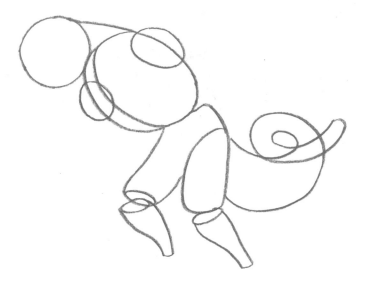

Step One I block in the main body structure with a 2H pencil. I start with an oval for the chest and a circle for the head. Then I use basic shapes to block in the neck, shoulders, upper legs, and tail.

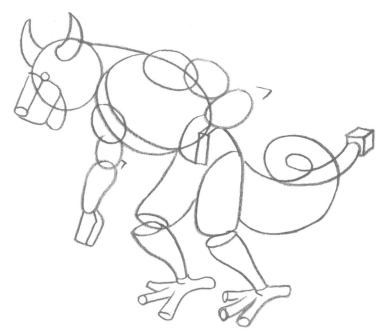

Step Two I continue building up the figure, adding the arms, lower legs, and feet, as well as the muzzle and horns.

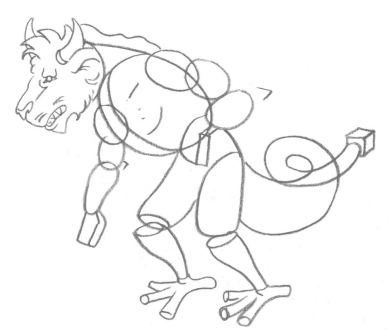

Step Three I use my basic shapes to refine the head. Huwawa has a lion's face, complete with a catlike nose, sharp teeth, and the beginning of a mane. I also refine the horns.

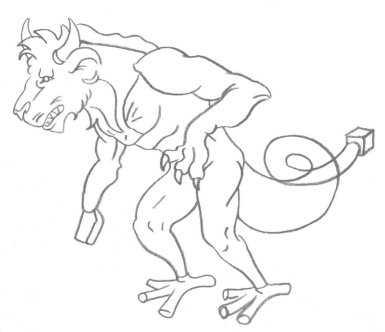

Step Four As I refine the shapes of the torso, arms, and legs, I suggest humanlike musculature. I erase the construction lines as I no longer need them. Next I add three sharp claws on the creature's left hand. Then I thicken the mane around the front of the chest.

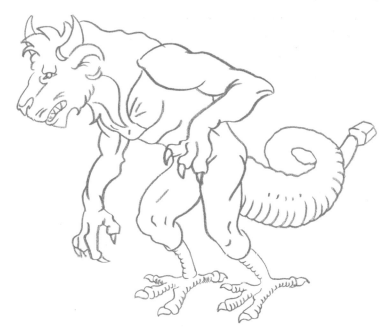

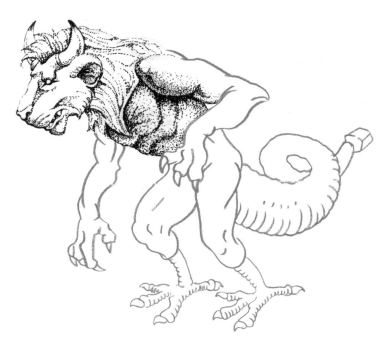

Step Five I refine the beast's right hand to match the left. Then I develop the tail and feet. I use short, curved strokes to add texture on the legs, feet, and tail. Next I draw sharp talons on the feet.

Step Six Using a .2 mm waterproof ink pen, I begin tracing over my pencil lines with stippling. I stipple dots on the head, mane, and torso. By increasing the number of dots in an area, you can achieve very dark values. Notice how the stippling is denser at the base of the hair than at the end. Besides increasing the amount of dots in a certain area, you can increase your black tones by making bigger dots. To achieve the darkest tones, I switch to a larger .5 mm pen.

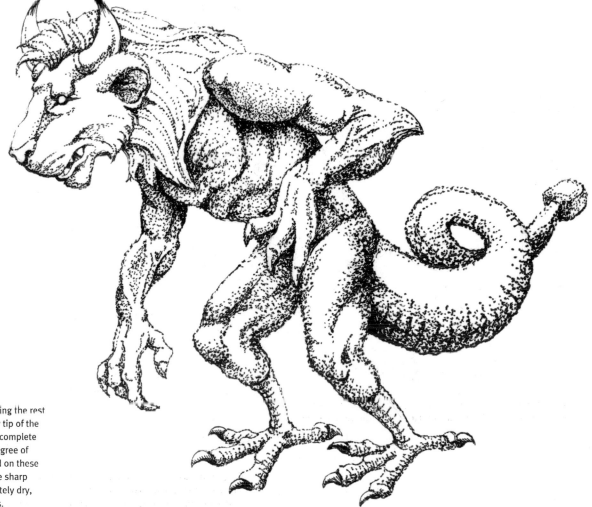

Step Seven I continue stippling the rest of the body, including the boxy tip of the tail. I use my .2 mm ink pen to complete the hands and feet. I want a degree of delicate control to be exercised on these extremities. Lastly, I darken the sharp talons. When the ink is completely dry, I erase any visible pencil marks.

GARM NORSE

Garm guards Hel, the land of the dead, in Norse mythology. This canine lives in a cave called "Gnipahellir." Garm's mortal enemy is the god of war and justice, Tyr—they will destroy each other at Ragnarök (the end of time).

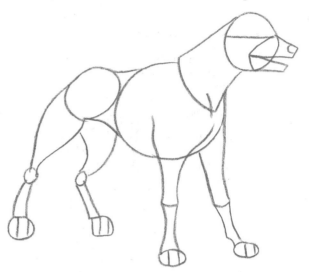

Step One Starting with a 2H pencil, I block in the basic shapes of our canine friend. I use simple circles and cylinders to establish the proper anatomical proportions and to establish the pose and attitude.

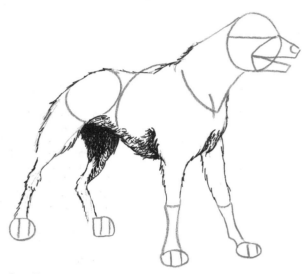

Step Two I start right in with .5 mm waterproof ink pen, using short strokes to draw the fur outline that defines the edges of the figure.

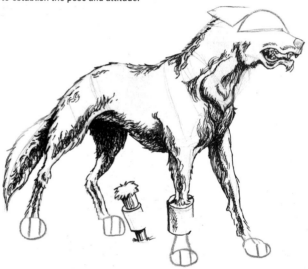

Step Three Using loose strokes of the pen, I continue to add areas of shadow and texture for an unkempt look. Then I add the wooden post in the ground. I draw manacles around the post and Garm's front right leg, using straight hatch marks to create the texture. Next I use a .3 mm pen to detail the mouth and further develop Garm's coat.

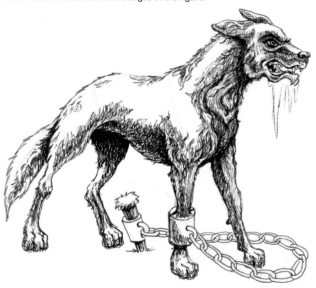

Step Four I refine all four paws, continuing the loose strokes for the fur. I also continue the fur pattern up the neck, darkening areas of shadow. Then I draw the chain that encircles Garm's left foreleg. Next I draw the ears and add the eye, brow, and nose. With a .2 mm pen, I lightly hatch the entire face and draw some drool.

Step Five I shade the chain with the .2 mm pen. Then I finish refining the drool, and I erase any visible pencil lines.

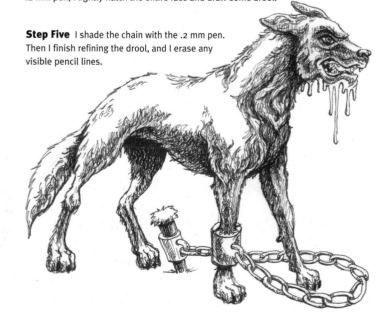

DID YOU KNOW?

- The giant Hraesvelgr (whose name translates to "corpse swallower" in English) guards Hel along with Garm.
- Some versions of the myth say that Garm's chest and neck are perpetually bloody.
- Garm is the name of a talking dog in J.R.R. Tolkien's short fairy tale, "Farmer Giles of Ham."

ECHIDNA Greek

Echidna is the mother of all Greek monsters, including Cerberus, Chimera, Ladon, hydra, and the sphynx. Because Echidna was half nymph, she did not age—she also was half serpent. Argus, the hundred-eyed giant, killed Echidna in her sleep.

Step One I begin blocking in Echidna's body with a 2H pencil. I use simple shapes, such as cylinders, circles, and boxes to work out the general proportions. The construction lines on the face indicate the location of the features.

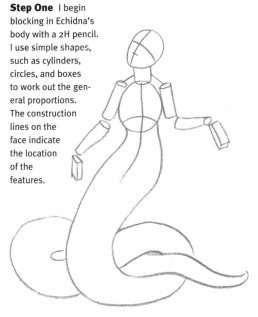

Step Two Using my 2B pencil, I add Echidna's long, flowing hair. Then I use my basic shapes to refine the arms and hands, creating long, sinewy fingers. I draw shell-like plates on her torso, adding a short crescent stroke on each plate for texture.

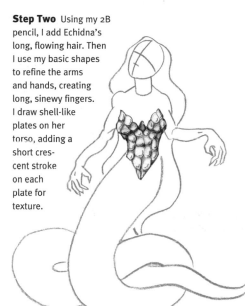

Step Three I draw the facial features, creating a ghastly expression. Then I shade the sunken cheek, hollow eyes, and bony neck. I refine her hair, making long, loose strokes that follow the direction of growth. And I shade the arms to make them look muscular.

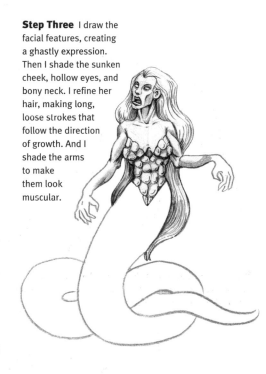

Step Four On the serpentine portion of the figure, I create a simple texture using uneven scribble strokes that follow the snakelike form. I add a tonal gradation to the outer edges of the body and a cast shadow where the tail overlaps itself.

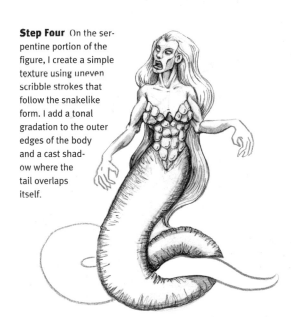

Step Five As I continue shading the body, I increase the length and thickness of the strokes in the shadow areas. Her hands are so laden with sharp claws that it seems she can barely hold them up. I don't add a lot of detail to the hands but allow the silhouette to do most of the work. I use my trusty vinyl eraser to erase any stray marks or smudges.

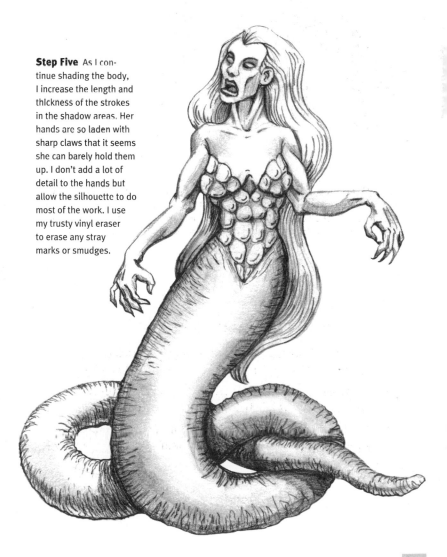

DID YOU KNOW?

- Echidna staged an attack on the gods of Olympus but failed.
- She had three children with Greek strongman Heracles.
- Echidna shares her name with an unusual mammal, also known as a "spiny anteater."

CHIMERA GREEK

Chimera, daughter of Echidna and Typhon, had two heads—one of a goat and the other of a lion—the body of a goat, and the tail of a dragon. She terrorized Lycia (now the coast of Turkey) before being murdered by the Greek hero Bellerophon.

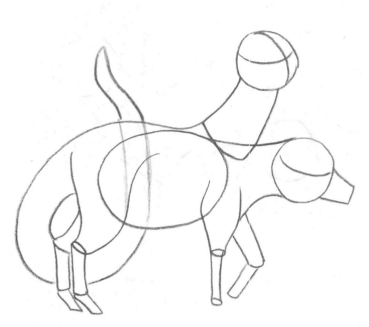

Step One First I block in the basic shapes of the beast with a 2H pencil. This step helps me work out the proportions before adding any details. I "draw through" the body to establish the placement of the tail.

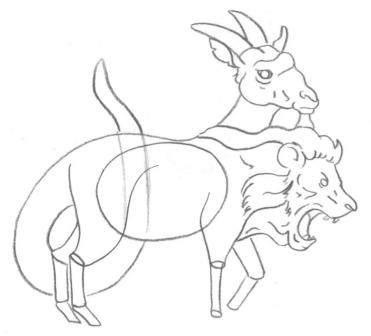

Step Two I start with the lion's head, developing the blocky shape and adding the features, including the thick mane. Then I build the goat's head, emphasizing the horns, the strong brow, and the large ears. (The Chimera is female but has male heads.)

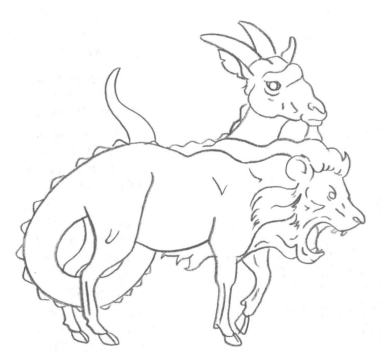

Step Three I refine the body, including the goatlike torso and legs. I give the beast a long, spiked dragon's tail. I continue the lion's mane on the chest. Then I erase any unnecessary pencil lines.

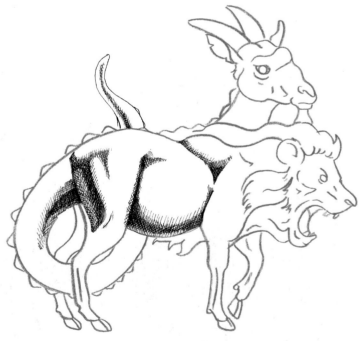

Step Four With a .2 mm waterproof ink pen, I begin adding tone with crosshatching. I let my darkest crosshatching gravitate toward the underside of the body. This tone starts to create the illusion of form on the body.

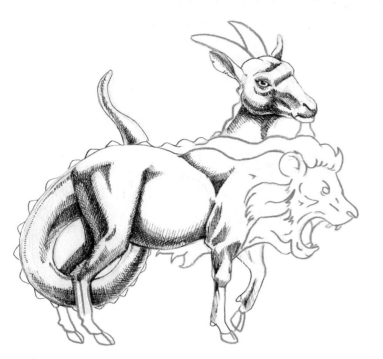

Step Five To establish different levels of tone on the body, I continue crosshatching as well as hatching on the tail and legs. I ink over the outline of the tail to help it pop forward from the background. Then I begin crosshatching on the goat's face, placing the darkest tones on the side of the jaw, on the brow, and along the neck. I darken the pupil, leaving a white highlight. Next I shade the ears.

Step Six I outline the goat's horns and add tone with rough scribble-hatching. Then I shade the fur on the lion's mane with simple lines that follow the direction of growth. I begin adding tone on the lion's face: I shade inside the mouth, outline the teeth, and hatch over the nose and inside the ear. Then I outline the hooves and the part of the mane that hangs down from the belly.

Step Seven As I continue adding darker tones to the lion, I also fill in its pupil and add long whiskers. Then I darken the spikes on the tail. I darken the legs and hooves with simple line work, giving weight and depth to the lower legs with strong, thick crosshatching. I also enhance the shadows by darkening the hatching areas under the torso and within the mane. When the ink is dry, I erase any pencil marks.

SPHYNX GREEK

A sphynx has the body of a lion and the head of a human, ram, or bird. Egyptian sphynx typically are male statues—but in Greek mythology, the sphynx was winged with the head of a woman. She terrorized the city of Thebes and would strangle anyone who could not answer her riddle. When her riddle was solved by Oedipus, he became king and she committed suicide.

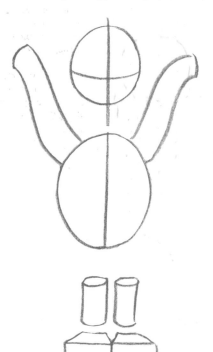

Step One I draw simple shapes for the head, torso, wings, and forelegs using a 2H pencil. I use circles, cylinders, and boxes, and I add guidelines for the face and torso.

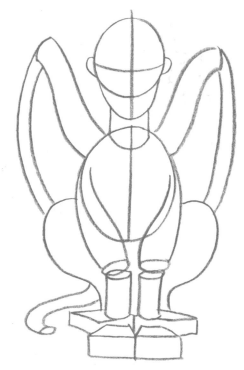

Step Two I add the upper forelegs and the outline of the wings. Then I draw the haunches and tail with simple curves. I draw boxes for the back feet, angling them slightly outward. I also add a few lines to indicate the ears, jaw, and neck.

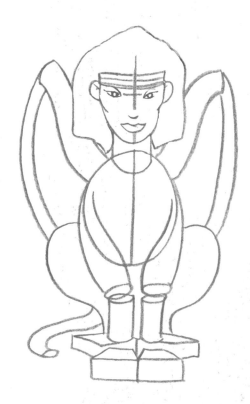

Step Three Following my guidelines, I place the eyes, nose, and lips. I also draw the headpiece, including the horizontal band across the forehead. I erase any unneeded lines as I draw.

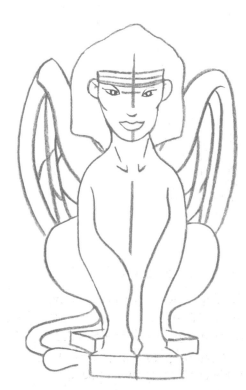

Step Four To refine the neck and shoulders, I draw gracefully sloping curves, continuing onto the upper and lower cylinders of the forelegs. I indicate the rows of feathers in the wings. Then I add a teardrop shape to the end of the tail.

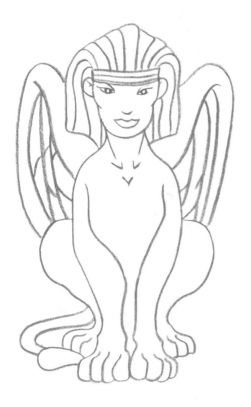

Step Five After I establish the stripes on the headpiece, I refine the paws, drawing the individual toes. I clean up my construction marks with an art gum eraser.

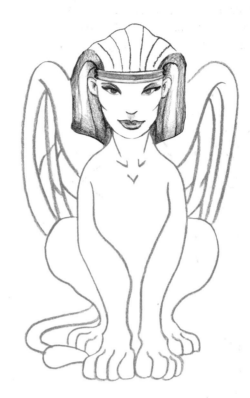

Step Six With a 2B pencil, I refine and shade the facial features. I give the upper eyeline a heavy, dark stroke, with a soft shadow above. I place some tone on the lips, and then I begin differentiating the stripes on the headpiece.

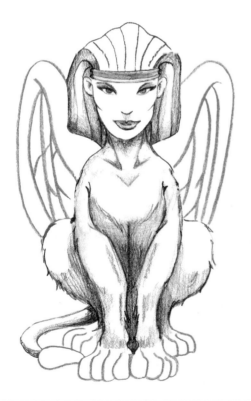

Step Seven I render shadows on the neck, torso, and legs, making the area where the legs cast a shadow onto the center of the torso the darkest. Then I use short, wispy lines to create a furry texture on the torso, legs, and tail.

DID YOU KNOW?

- The Greek word "sphingo" means "to strangle," and it's the origin of the name "sphynx."

- The Greek sphynx had a given name, as well—Phix!

- The parents of the Greek sphynx are alternately listed as Typhon and Echidna or Orthrus and Chimera.

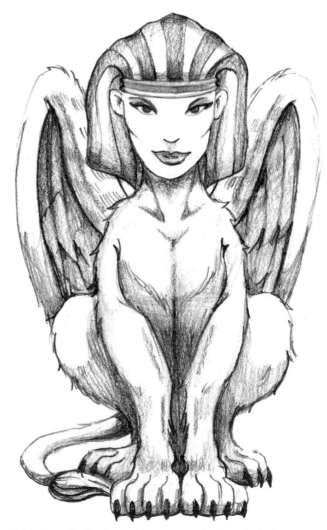

Step Eight I finish shading the headpiece stripes and indicate the feathers in the wings by varying the shadows. I add tone to the long tuft of hair at the end of the tail. Then I use the darkest tone to render the razor-sharp claws.

CERBERUS Greek

Another offspring of Echidna and Typhon, Cerberus is the guardian of the gates to Hades, allowing only dead spirits to enter—and none to leave. Although Cerberus holds a high position, he is not infallible—a few heroes, including Heracles, Orpheus, and Hermes, were able to sneak past him at one time or another.

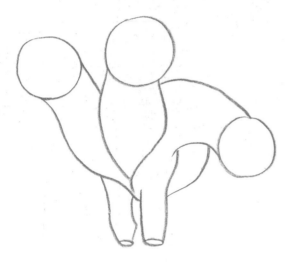

Step One I use a 2H pencil to lay in the basic shapes of the creature, indicating the way in which the three heads will emerge from one torso. It is much easier to plan out your drawing using simple shapes like these.

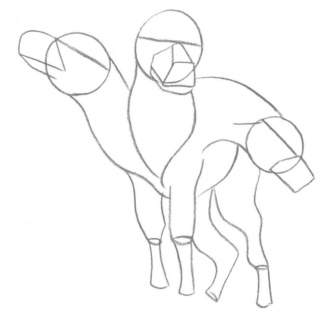

Step Two I add boxy muzzles to all three heads and construct the legs with simple cylinders. I make sure I'm happy with the proportions before adding anything else.

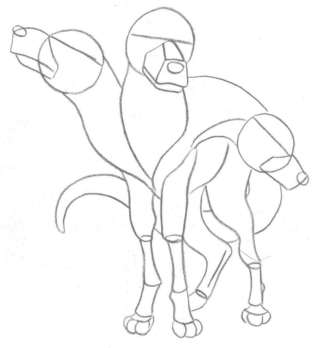

Step Three Now I finish the legs and add the tail. Then I draw the noses and paws. The basic foundation is complete, so I can gain an overall sense of the beast's general proportions.

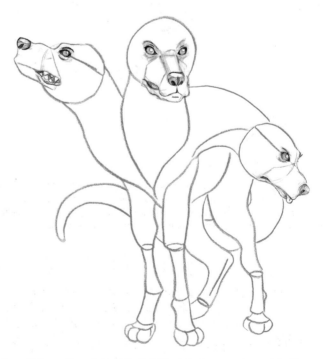

Step Four Using a 2B pencil, I add the facial features. I want to give each head a different personality, so I vary the features a bit. The head on the right is baring its teeth, whereas the head in the middle appears to be growling, and the head on the left has its tongue sticking out a bit. I shade the eyes, noses, and mouths. Notice how intense the dark area is around the eyes.

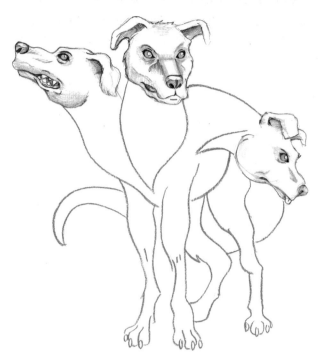

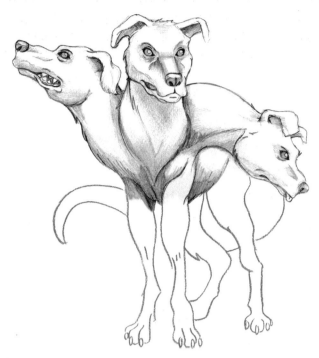

Step Five Still using a 2B pencil, I continue shading the heads, adding the ears and making jagged lines around the heads to create fur. Then I refine the legs, adding claws on the toes and more fur around the knees.

Step Six I carry the shading down the necks and onto the body. I place more pressure on the pencil to make the outlines and shadows heavier and blacker. This will enhance the illusion of depth and form.

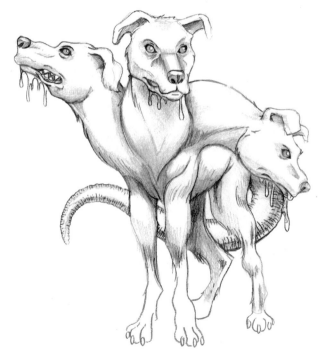

Step Seven At this point, each head gets a liberal dose of drool. Then I turn my attention to the tail. The tail is scaly, so I want to make it as different from the fur as I can. I sharpen my 2B and use short, uneven strokes to draw a scaly pattern along the edges of the tail. Note how hard these lines are compared with the wispier strokes in the fur.

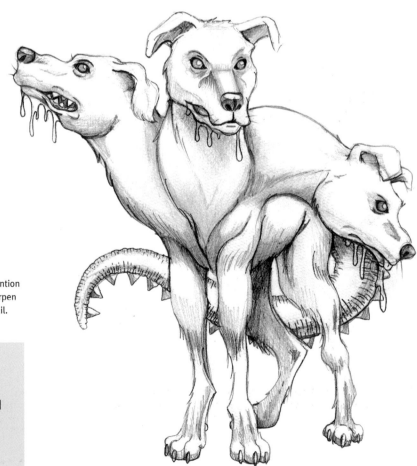

DID YOU KNOW?

- The twelfth (and final) labor of Heracles was to capture Cerberus. Hades and his mistress, Persephone, allowed Heracles to take Cerberus, as long as Heracles didn't harm the hound.
- Cerberus sometimes is portrayed with 50–100 heads.
- In Greek, Cerberus also is called "Kerberos."

Step Eight I finish shading the legs; then I darken the claws and add sharp spikes to the tail. I touch up the faces, adding darker tones where needed. Finally, I add a few whiskers on each head.

GERYON & ORTHRUS Greek

Geryon has three upper bodies—but only one pair of legs! Geryon was a Titan, one of the principle gods of Greek myth (best known for their war against the Olympian gods).

He was a giant who lived on the island of Erytheia in the west Mediterranean Sea. Geryon's two-headed dog, Orthrus, guarded Geryon's prized herd of red cattle.

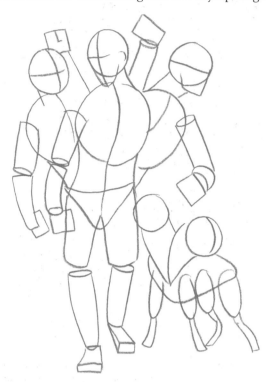

Step One With a 2H pencil, I use basic shapes to block in the three torsos, three heads, five arms, and two legs. Then I draw basic shapes for Geryon's two-headed dog, Orthrus. This layout is vital because it's very easy to run out of room for an arm or even a head.

Step Two Still using a 2H pencil, I refine the torso and face of the figure on the left, adding a large shield in his right hand. Then I switch to a 2B pencil to add tone to the torso, face, shield, and helmet. I build up the tones slowly, making darker areas to show transitions between flesh and metal, such as where the neck meets the helmet or where the shield overlaps the arm. Then I begin refining the face, helmet, right arm, and torso of the central figure. I add wristbands on the arm and use light, vertical lines to draw the skirt.

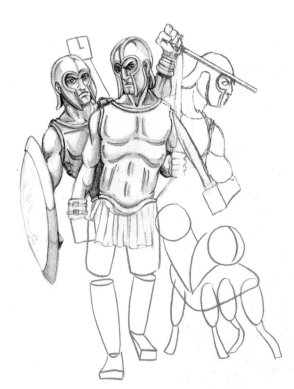

Step Three With a 2H pencil, I develop the raised left arm of the figure on the left, adding wristbands and the handle of a weapon. Then I add the left hand of the figure in the center, which holds a long handle that overlaps the raised hand of the figure on the left. I rough in the facial features and helmet of the figure on the right, developing the muscled arm and adding a sword in his left hand. Switching to a 2B pencil, I shade the center figure's face, helmet, chest, and right arm.

Step Four Still using a 2B pencil, I refine the right hand of the figure on the right, which holds a braided whip. Then I refine the left hand of the figure on the right, also detailing the sword it holds. Next I shade the face, helmet, torso, and arm of the figure on the right. I also finish drawing the weapon that the left-hand figure holds, and I add tone to the weapon in the center figure's hand. To make each figure distinct and independent (to some extent), I vary the tones of each figure, keeping the center figure the lightest in value.

Step Five With a 2B pencil, I use my original shapes to refine the warrior's legs and feet, casting a shadow onto the legs from the skirt, to which I add more tone. Then I finish the weapons, including the spear, the whip, and the trident. I also add a net to the center figure's right hand, placing more pressure on the pencil to create darker tones. With a 2H pencil, I develop Orthrus's body and heads.

Step Six Now I focus on Orthrus. With a 2B pencil, I use short, curved lines to start rendering the fur. I create the darkest values on the underside. I leave some areas completely white—I don't have to render every individual strand of hair.

DID YOU KNOW?

- Heracles's tenth labor was to steal the cattle of Geryon. Heracles slew Geryon and Orthrus in the process.

- In Dante's *Divine Comedy,* Geryon is a winged beast with the tail of a scorpion and the face of a man.

- Orthrus is Cerberus's brother (see page 86).

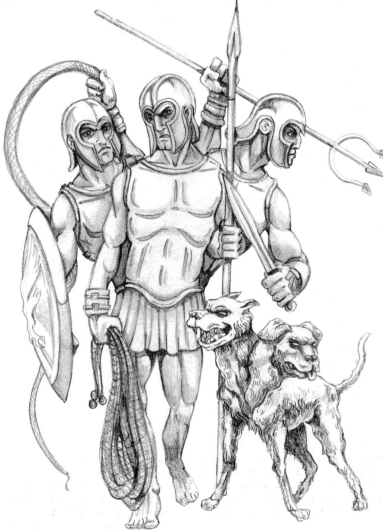

Step Seven I continue adding Orthrus's fur, and then I draw the facial features. Note that the two heads are quite distinct—one has small, pointed ears; the other has large, floppy ears.

GRENDEL ANGLO-SAXON

Grendel is one of the antagonists in the epic poem *Beowulf*. In the poem, Grendel regularly invaded the Danish king's great hall. But hero Beowulf saved the kingdom—he killed Grendel in the hall one night by ripping off Grendel's arms.

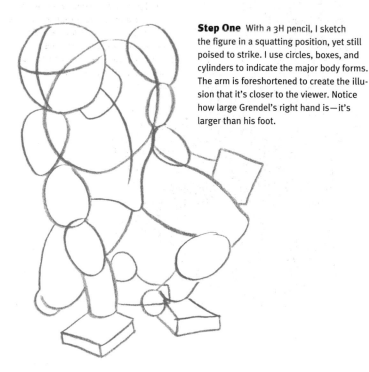

Step One With a 3H pencil, I sketch the figure in a squatting position, yet still poised to strike. I use circles, boxes, and cylinders to indicate the major body forms. The arm is foreshortened to create the illusion that it's closer to the viewer. Notice how large Grendel's right hand is—it's larger than his foot.

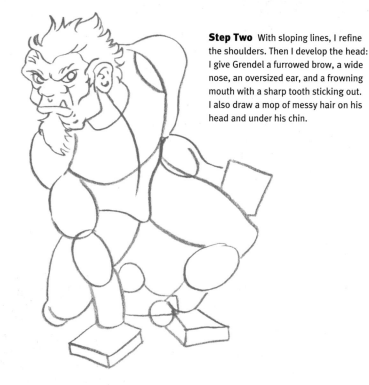

Step Two With sloping lines, I refine the shoulders. Then I develop the head: I give Grendel a furrowed brow, a wide nose, an oversized ear, and a frowning mouth with a sharp tooth sticking out. I also draw a mop of messy hair on his head and under his chin.

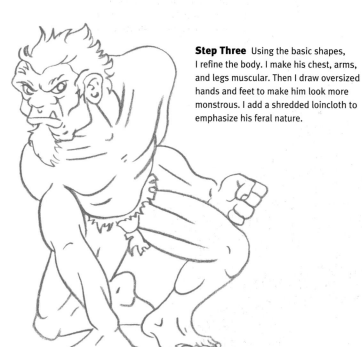

Step Three Using the basic shapes, I refine the body. I make his chest, arms, and legs muscular. Then I draw oversized hands and feet to make him look more monstrous. I add a shredded loincloth to emphasize his feral nature.

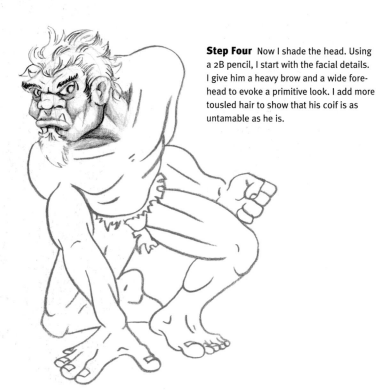

Step Four Now I shade the head. Using a 2B pencil, I start with the facial details. I give him a heavy brow and a wide forehead to evoke a primitive look. I add more tousled hair to show that his coif is as untamable as he is.

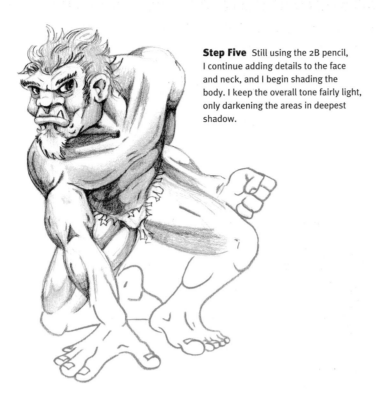

Step Five Still using the 2B pencil, I continue adding details to the face and neck, and I begin shading the body. I keep the overall tone fairly light, only darkening the areas in deepest shadow.

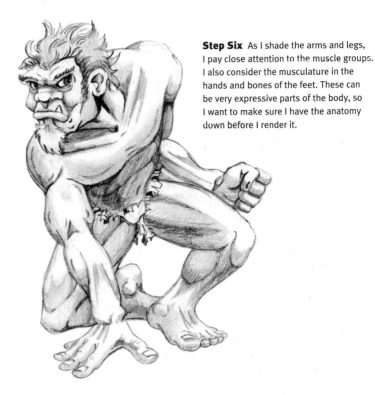

Step Six As I shade the arms and legs, I pay close attention to the muscle groups. I also consider the musculature in the hands and bones of the feet. These can be very expressive parts of the body, so I want to make sure I have the anatomy down before I render it.

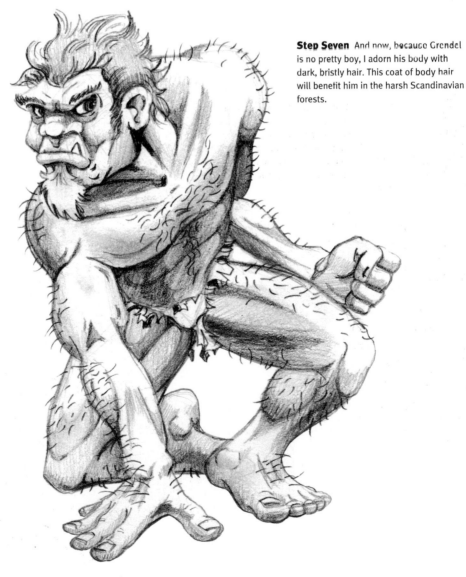

Step Seven And now, because Grendel is no pretty boy, I adorn his body with dark, bristly hair. This coat of body hair will benefit him in the harsh Scandinavian forests.

DID YOU KNOW?

- No one really knows what Grendel is. He sometimes is called a troll, an ogre, or a giant.

- Grendel's mother also is a beastly figure, and she is just as tough as Grendel. She tries to avenge her son's death but fails.

- Grendel Is a descendent of the Biblical figure Cain.

MINOTAUR GREEK

The Minotaur has the body of a man and the head of a bull. He was born of the Crete king Minos's wife and a bull Minos took from the sea god, Poseidon. To keep the Minotaur from destroying the island of Crete, Minos had a labyrinth built where the beast was imprisoned until he was killed by the Greek hero Theseus, a suitor of Minos's daughter.

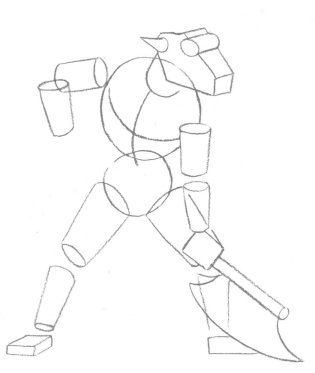

Step One The Minotaur is a big, action-oriented beast, like a hockey player at face-off, so I choose a pose that evokes this, placing an axe in his hands instead of a hockey stick. I construct the body with a 2H pencil, using circles, boxes, and cylinders.

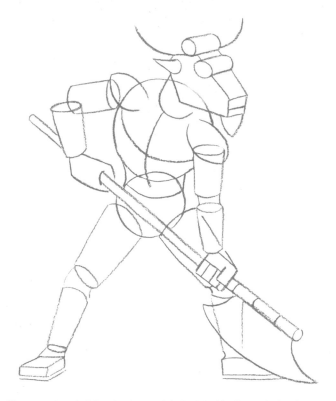

Step Two I continue building the shapes of the body by blocking in the hands, shoulders, and the rest of the axe. I also add a cylinder on top of his head and a triangular shape below his chin. Then I draw a curved line at the top of the head for the horns. I connect the chest to the hips and the feet to the legs.

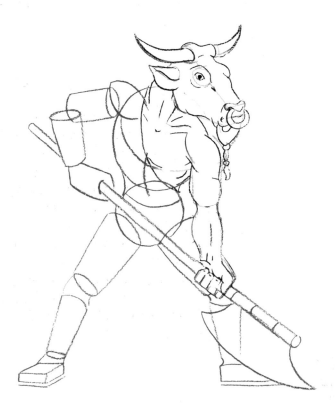

Step Three Now I refine the shapes of the head to draw a bull's face, complete with a nose ring and a long goatee. I use a photo reference of a bull to help me in this process. I begin to shape the beast's muscular chest, as well as his left shoulder, arm, and hand.

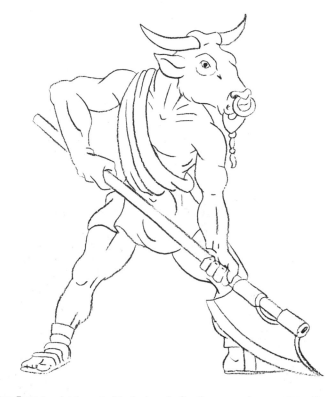

Step Four I sculpt the rest of the body and refine the axe, erasing any unnecessary pencil lines. The Minotaur has the body of a man, so I dress him in a simple toga and sandals. He gets an axe because he wants the axe—I certainly wouldn't try to take it from him!

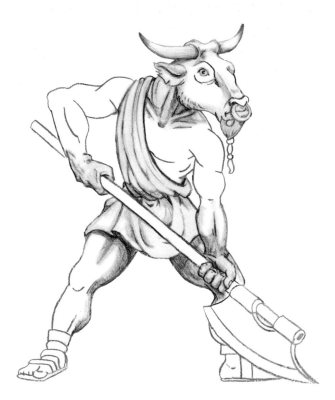

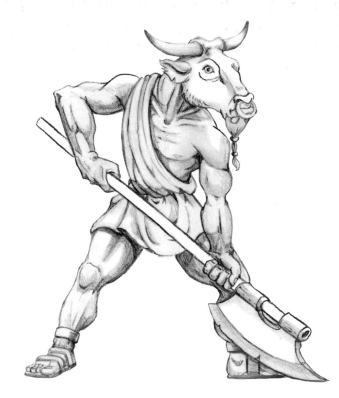

Step Five Using a 2B pencil, I build up shading around the head, hands, and legs. I shade the neck, making it look strained and raised. Then I begin shading the toga, taking care to make the drapes and folds convincing. I add dark tone to the upper legs where the toga and the arm cast shadows.

Step Six I continue shading the rest of the body, including the shoulders, arms, legs, and feet. I add tone to the head of the axe, creating nicks and dings in the metal. I like the way this looks, so I decide to add some rougher qualities all around to illustrate that the Minotaur's weapon is not just for looks!

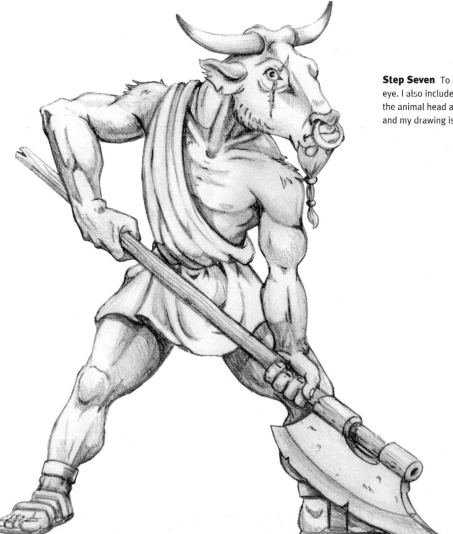

Step Seven To show that this character means business, I add a long, jagged scar to the eye. I also include a bit of hair on the shoulder area to break up the stark contrast between the animal head and the human body. I create a wooden texture on the handle of the axe, and my drawing is complete.

DID YOU KNOW?

- The ancient Minotaur sometimes is represented with the body of a bull and the head of a man.
- The Minotaur lived for years in the labyrinth on Crete, snacking on captured Greek youths.
- King Minos asked the architect Daedalus to build the Minotaur's labyrinth.
- Some say the Minotaur's proper name was Asterius, which means "the starry one."

CENTAUR GREEK

The centaur of Greek tradition is a part-human, part-horse race; it is untamed and ill behaved because its animal nature conflicts with its human side. When offended, Zeus, the leader of the Olympian gods, unleashes this wild creature on gods and mortals alike as punishment. Centaurus, one of the god Apollo's sons, is believed to be the founder of the Centaur race.

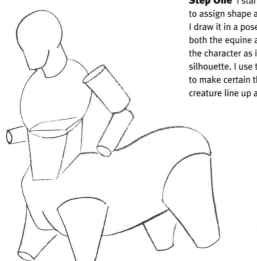

Step One I start by using a 2H pencil to assign shape and form to the centaur. I draw it in a pose that plainly represents both the equine and human aspects of the character as it creates a recognizable silhouette. I use these underlying forms to make certain that the two parts of the creature line up appropriately.

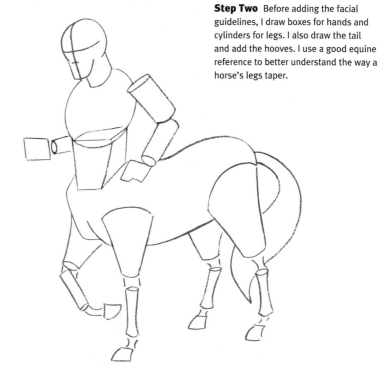

Step Two Before adding the facial guidelines, I draw boxes for hands and cylinders for legs. I also draw the tail and add the hooves. I use a good equine reference to better understand the way a horse's legs taper.

Step Three Using the simple shapes as guidelines, I begin to refine the forms of the creature. I start with the beast's left shoulder and move down to the right hand and the forelegs. Then I refine the rear, including the tail.

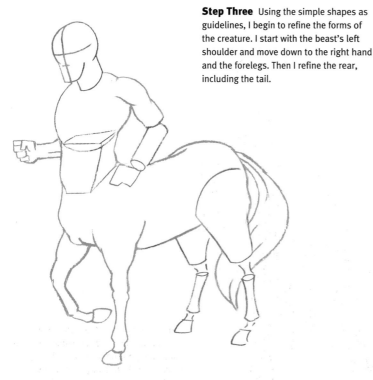

Step Four I continue building the body, including the beast's left arm, chest, torso, and rear legs. Although centaurs aren't real, horses and people are, so I use plenty of good reference material to make a convincing creature. Following the facial guidelines, I add the features. Then I draw the hair and beard.

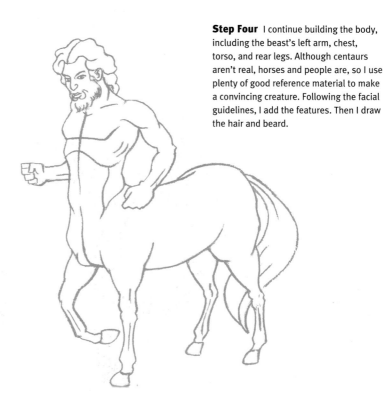

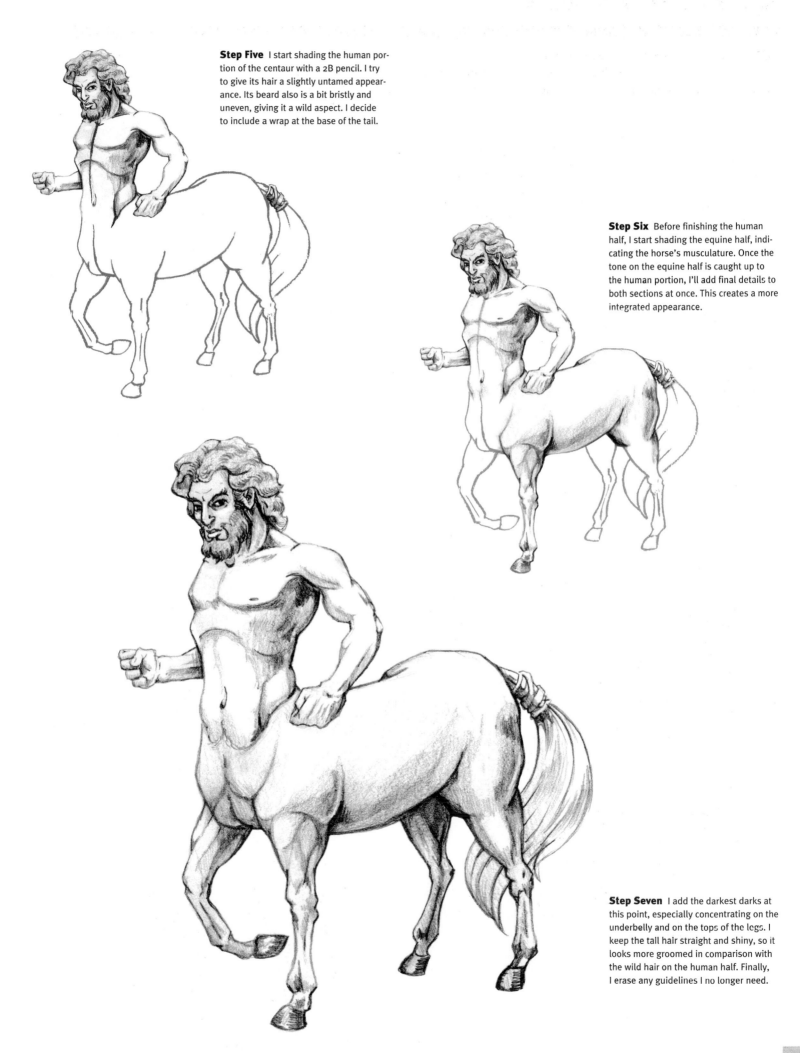

Step Five I start shading the human portion of the centaur with a 2B pencil. I try to give its hair a slightly untamed appearance. Its beard also is a bit bristly and uneven, giving it a wild aspect. I decide to include a wrap at the base of the tail.

Step Six Before finishing the human half, I start shading the equine half, indicating the horse's musculature. Once the tone on the equine half is caught up to the human portion, I'll add final details to both sections at once. This creates a more integrated appearance.

Step Seven I add the darkest darks at this point, especially concentrating on the underbelly and on the tops of the legs. I keep the tail hair straight and shiny, so it looks more groomed in comparison with the wild hair on the human half. Finally, I erase any guidelines I no longer need.

SATYR GREEK

The satyr is the companion of Dionysus, the Greek god of wine. It has the upper half of a man, the rear and horns of a goat, and the tail of a horse. A satyr often carries a thyrsus, which is the staff of Dionysus and a symbol of fertility.

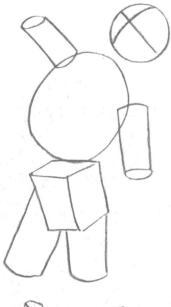

Step One Using a 2H pencil, I sketch the basic shapes of the satyr. I use a circle for the head, an oval for the chest, cylinders for the arms and legs, and a curved box for the hips. I also add the facial guidelines.

Step Two I draw additional cylinders and boxes to block in the arms and legs.

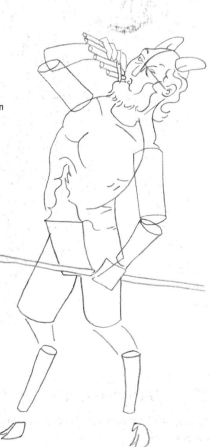

Step Three I add human details to the chest, then start the fur pattern that will cover the lower torso and legs. Moving to the head, I add the horns, hair, and beard. Then I add the eye, nose, mouth, and ears. The facial features are small with little detail. I draw the cloven hooves, then add the pipes and a staff that resembles an oversized cotton swab.

Step Four Using short, wispy strokes, I draw the furry outline of the lower body. By alternating the direction of my strokes, I can make the hair rough and wild. In contrast, I use long, softly curved lines to represent the tail. I erase any guidelines as they're no longer needed.

Step Five Switching to a 2B pencil, I begin shading the satyr's head. I want to create the appearance of frontal, overhead lighting, so the heaviest shadows are at the back of the head and on the neck. I lightly shade the creature's right arm, as well as the pipes in his right hand and the tip of the spear in his left hand.

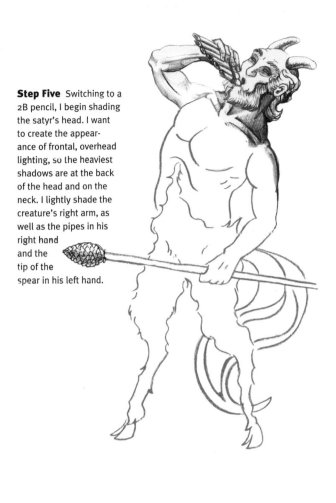

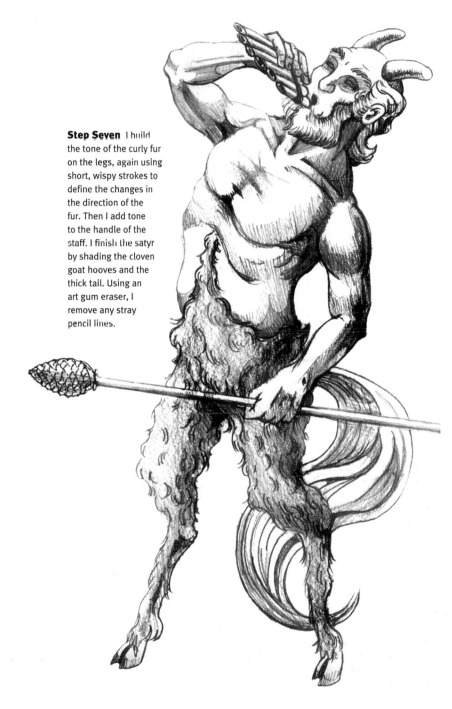

Step Seven I build the tone of the curly fur on the legs, again using short, wispy strokes to define the changes in the direction of the fur. Then I add tone to the handle of the staff. I finish the satyr by shading the cloven goat hooves and the thick tail. Using an art gum eraser, I remove any stray pencil lines.

Step Six I continue building tone on the rest of the upper body, creating the darkest tones on the satyr's left arm.

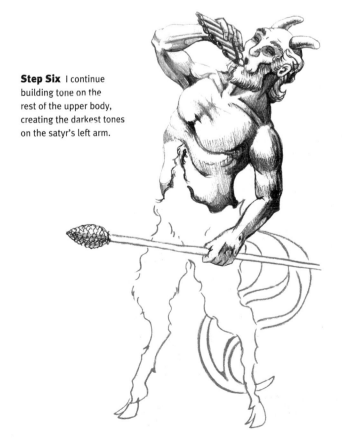

DID YOU KNOW?

- Satyrs are not immortal creatures, so they are depicted at all ages.
- Satyrs travel to the music of pipes.
- Older satyrs are known as "sileni," and younger satyrs are called "satyrisci."

CYCLOPS GREEK

Cyclops, a giant with a single eye in the middle of its forehead, originates from Greek mythology. In Homer's epic poem *The Odyssey,* the cyclopes live as a community of shepherds and blacksmiths in what is now Sicily.

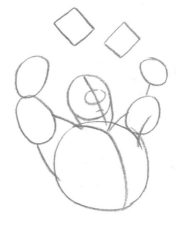

Step One With a 2H pencil, I draw the basic shapes of the figure's torso, head, and arms, which are raised above the head.

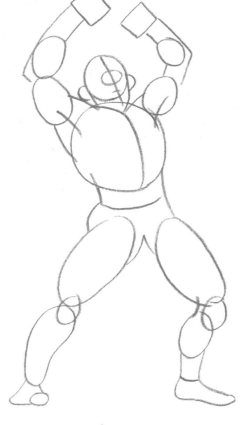

Step Two To convey a sense of power, I block in the legs with a wide stance.

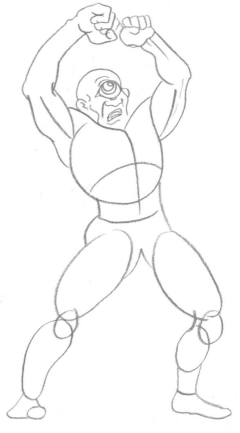

Step Three I add a guideline across the chest to suggest curvature. Then I refine the arms and hands, making them large and beefy. At this point, I switch to a softer HB pencil to add the facial features. I make the nose extra wide to balance the oversized eye.

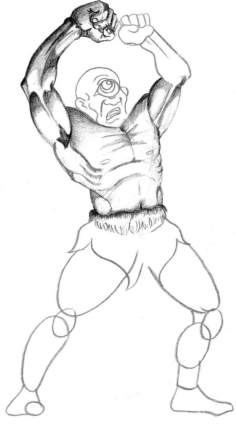

Step Four Still working with an HB pencil, I draw the outline of the loincloth, which barely covers the muscular thighs. Then I add the furry band at the top, using short, curved strokes. Now I begin shading the upper portion of the cyclops with a 2B pencil. I define the muscle groups of the beast's right arm, shading them so they appear to be lit from below. I progress to the torso, keeping the darker tones in the upper portions of each interior body shape.

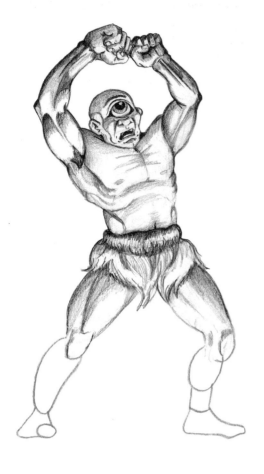

Step Five With the 2B pencil, I shade and detail the face, saving the darkest values for the curving eyebrow and the large pupil. Then I continue to add tone to the rest of the body. I make the shadows on the upper body darker than those on the lower body, which is closer to the light source. Using a very sharp point, I render long, wispy hair on the loincloth, curving around the thighs.

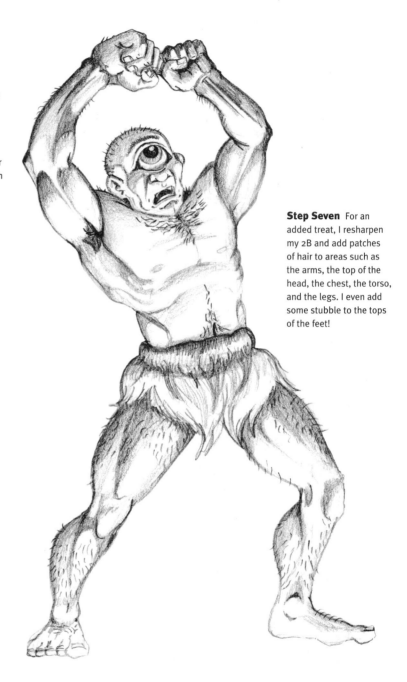

Step Seven For an added treat, I resharpen my 2B and add patches of hair to areas such as the arms, the top of the head, the chest, the torso, and the legs. I even add some stubble to the tops of the feet!

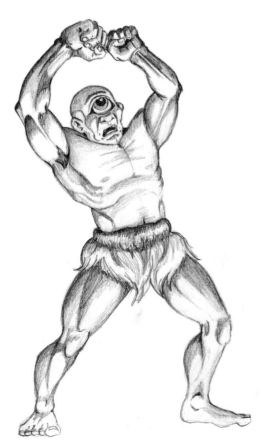

Step Six Now I refine the bottoms of the legs and the feet. I separate the toes and draw large toenails. I add curved shadows on the calves to make them bulge. Then I add tone to the tops of the feet.

DID YOU KNOW?

- Cyclopes is the plural of cyclops.
- There are two races of cyclopes in Greek mythology—another group of cyclopes lives on Earth, on the Isle of Cyclops. Greek hero Odysseus encountered one of these (Polyphemus) on his way home from the Trojan War.
- In addition to Zeus's thunderbolts, the cyclopes also fabricated Artemis's bow, Poseidon's trident, and Perseus's helmet.

SIREN GREEK

Sirens is the collective name given to a group of Greek sea nymphs who live on a rocky island and lure sailors to their doom with their singing. The song of these sisters promised knowledge and spiritual elation. In later stories, the siren was depicted with a seductive body to match its voice—this is why the siren sometimes is depicted as a mermaid.

Step One With a 3H pencil, I block in the simple shapes that will become the head and torso of the siren. I try to keep these shapes light for construction purposes.

Step Two Building on the simple shapes, I draw a human profile and a bird's body, with the beginnings of human arms. Most small song birds lack the long, graceful necks of swans or flamingos, so I draw a small, curved neck. I also start suggesting wings and the tops of the legs.

Step Three I add the swooping shape of the hair, as well as the facial features. The siren has a small, upturned nose and full lips. I draw feathers on the chest and stripes on the wings, and I make the tail a bit more pointy. I rough in the hands and add the huge, taloned feet. For the scales, I draw a ring pattern that runs down the legs and onto the feet.

Step Four To bring out the soft, sleek body, I use a medium black charcoal pencil to add tone to the wings, tail, and neck. With a craft knife, I whittle a fine point on the pencil to sketch in details on the collar bone and the chest plumage.

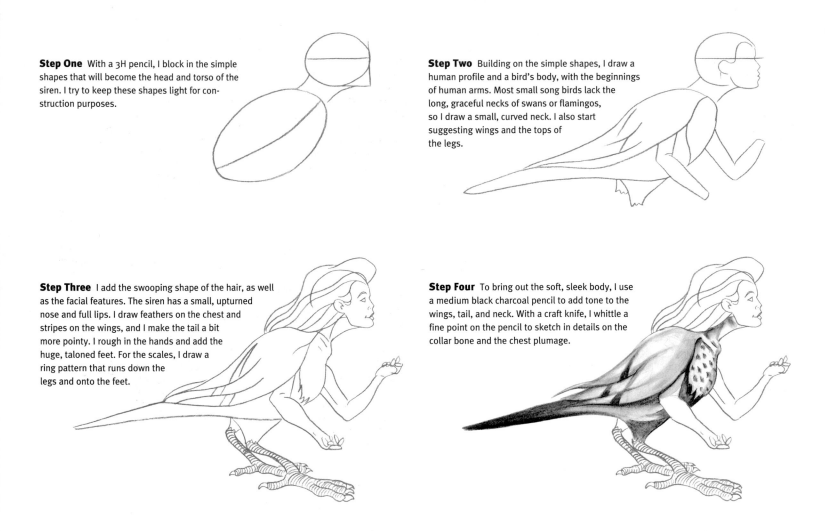

Step Five With a fine point on my charcoal pencil, I draw waves in the hair. I continue using the sharp-pointed charcoal pencil for the arm and hands, making them appear withered and gnarled. With the tip of the charcoal worn down, I shade the legs to give them form. I allow my strokes to be a bit softer here, as to not distract from the rest of the drawing. I add tone to the talons, making them larger and more curved than before. Then I lightly shade the face with charcoal, smudging a bit of tone on the cheek with a color blender. I darken the shadows on the underside of the beast near the tops of the legs; then I add more variation of tones in the hair. I erase any smudges using a vinyl eraser. To access tight areas and corners, I shave the eraser into a tapered edge.

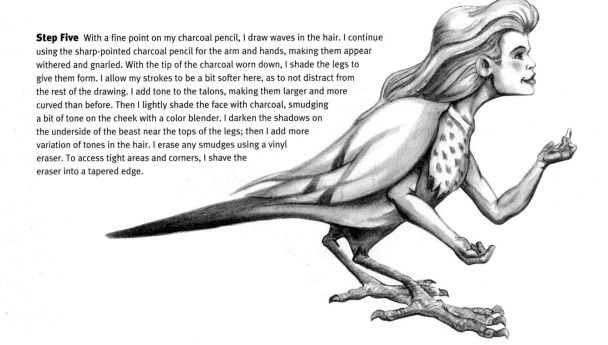

Harpy Greek

Originally conceived as a beautiful woman with wings, the harpy later became known as a cruel, ugly, disease-spreading creature—a winged monster. It takes people to the underworld, where it tortures them with its sharp claws.

Step One With a 2H pencil, I establish the general shapes of the figure. These simple circles and cylinders help me get a sense of the spatial relationships of the harpy's body mass.

Step Two I connect the simple shapes and begin to construct the wings, tail, and claws. Then I add the chin and neck. The main focus here is finding a plausible way to incorporate the animal and human parts into one another.

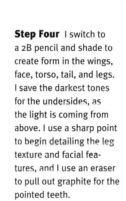

Step Three Using an HB pencil, I draw the facial details, including sharp cheekbones and skeletal eye sockets. I also add windswept hair. Then I draw curved lines in the wings to begin the feather pattern. Next I refine the feet and claws.

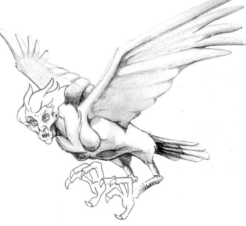

Step Four I switch to a 2B pencil and shade to create form in the wings, face, torso, tail, and legs. I save the darkest tones for the undersides, as the light is coming from above. I use a sharp point to begin detailing the leg texture and facial features, and I use an eraser to pull out graphite for the pointed teeth.

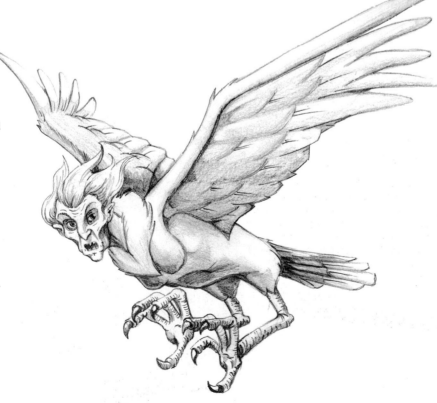

Step Five I use a 2B pencil to continue the lines onto the feet, and I add tone to the sharp claws. Then I sharpen my pencil and add light, fine lines to the wings to represent feathers. I switch back to an HB to add some soft lines to establish the direction of the hair. Lastly, I punch up the dark areas of the face, especially in the recesses of the cheekbone and around the eyes.

Did you know?

- Zeus sent harpies to torture Phineas, the King of Thrace. Phineas's hunger could never be satiated—even though he had ample provisions—because the harpies perpetually stole or befouled his food at the last minute.

- The harpies most likely represented storm winds.

GORGON GREEK

The gorgon is a vicious and powerful female figure—Medusa is the most recognized gorgon. Like her sisters, she would turn anyone who looked directly at her to stone. Gorgon images often adorned the shields of Greek soldiers to avert evil.

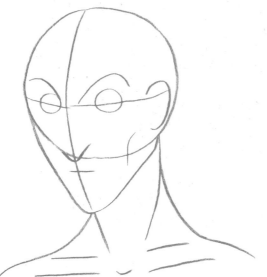

Step One I begin by drawing basic shapes and guidelines with a 2H pencil. I start the head with a simple circle, with the eye line at the approximate center. Then I add the jaw line and indicate the curved lines of the neck, shoulders, and collarbone.

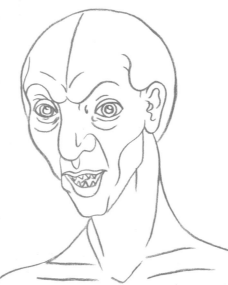

Step Two Still using the 2H pencil, I outline the eyes, nose, mouth, and ear. To create a less human appearance, I add extremely sharp cheekbones and make the chin more boxy. I also add curved lines to the face for wrinkles. I erase the guidelines from step one as I draw.

Step Three Because this character is extremely dark in nature, I decide to add tone with a medium charcoal pencil. Starting with the face, I lay in a thick area of charcoal, smudging it with a color blender. I create very dark areas of tone on the eyebrows and eyelids, in the hollows of the cheek and forehead, and underneath the nose.

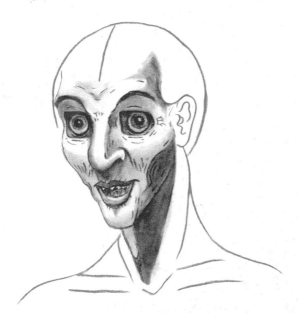

Step Four After darkening the iris, pupils, and mouth, I sand a fine point on the charcoal pencil and add some wrinkles and creases to the face. Then I continue blending a large, wedge-shaped shadow on the neck. I stand back and realize that the face appears much too pleasant. I'll make adjustments in the next step.

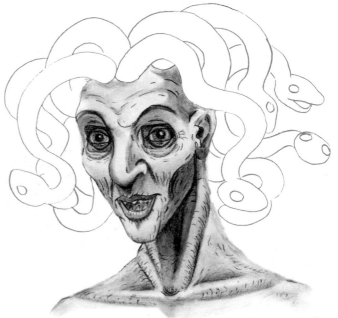

Step Five To relieve the gorgon of her pleasant appearance, I draw a ridge between the eyebrows to make them seem furrowed, and I add upper and lower eyelids. I also darken the area around the eyes and add more creases to the face. I continue adding tone to the neck and shoulders with the charcoal pencil. I add ridges that represent straining neck tendons; then I cover the neck and shoulders with creases that match those on the face. Next I retrieve my 2H pencil to draw the outlines of the snakes that adorn her head.

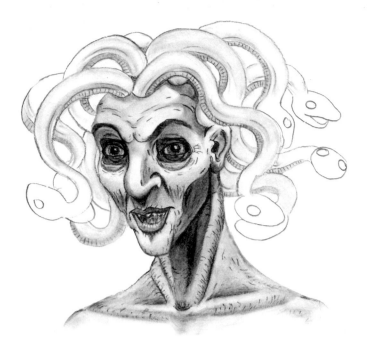

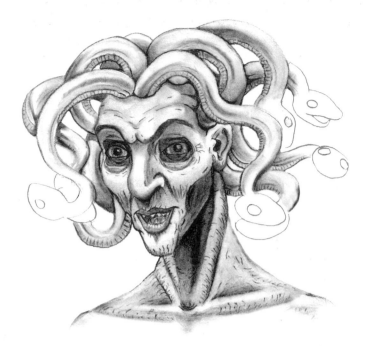

Step Six Using the charcoal pencil, I start adding tone to the snakes, also establishing the belly texture.

Step Seven I use a color blender to spread the charcoal tones over the snakes' bodies, darkening the areas where the snakes overlap.

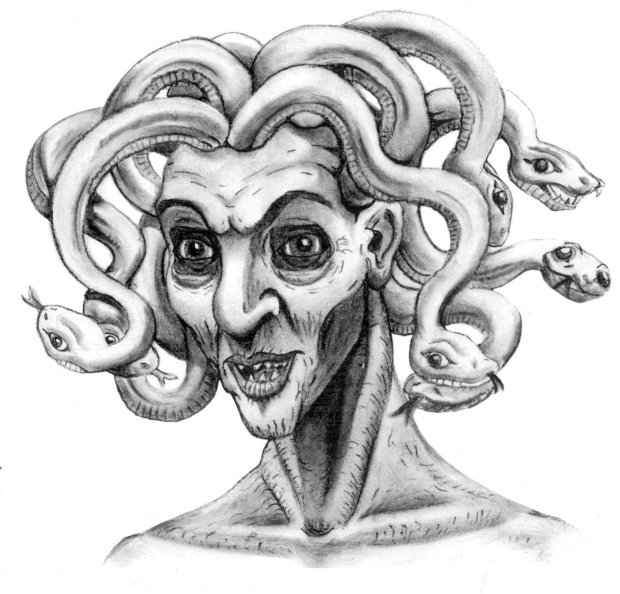

Step Eight I add facial features to some of the snakes, including forked tongues. For final touches, I darken the inside of the mouth and strengthen the shadows on the neck and collar bone. I apply white chalk to bring out the highlights in all the eyes and teeth. Finally, I erase any stray marks with a vinyl eraser.

PEGASUS Greek

Pegasus is the offspring of Medusa and Poseidon. When Medusa was slain, Pegasus emerged from her pregnant body.

Eventually, the flying horse ascended to the heavens, becoming a constellation of stars.

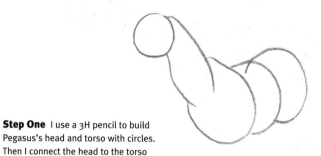

Step One I use a 3H pencil to build Pegasus's head and torso with circles. Then I connect the head to the torso with two curving lines.

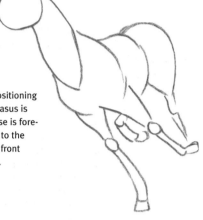

Step Two I add the four legs, positioning them so it appears as though Pegasus is about to take off in flight. This pose is foreshortened (the front end is closer to the viewer than the back end), so the front legs are larger than the back legs.

Step Three Now I add the huge wings and the long, curling tail. I also add a guideline for the eye and block in the shapes of the muzzle and the ears. Then I add a wavy line to indicate the flowing mane.

Step Four I refine the shape of the head, then add the eyes, nostrils, mouth, and a line for the cheekbone. Next I draw the lines for the feathers in the wings. I erase my construction lines as I draw.

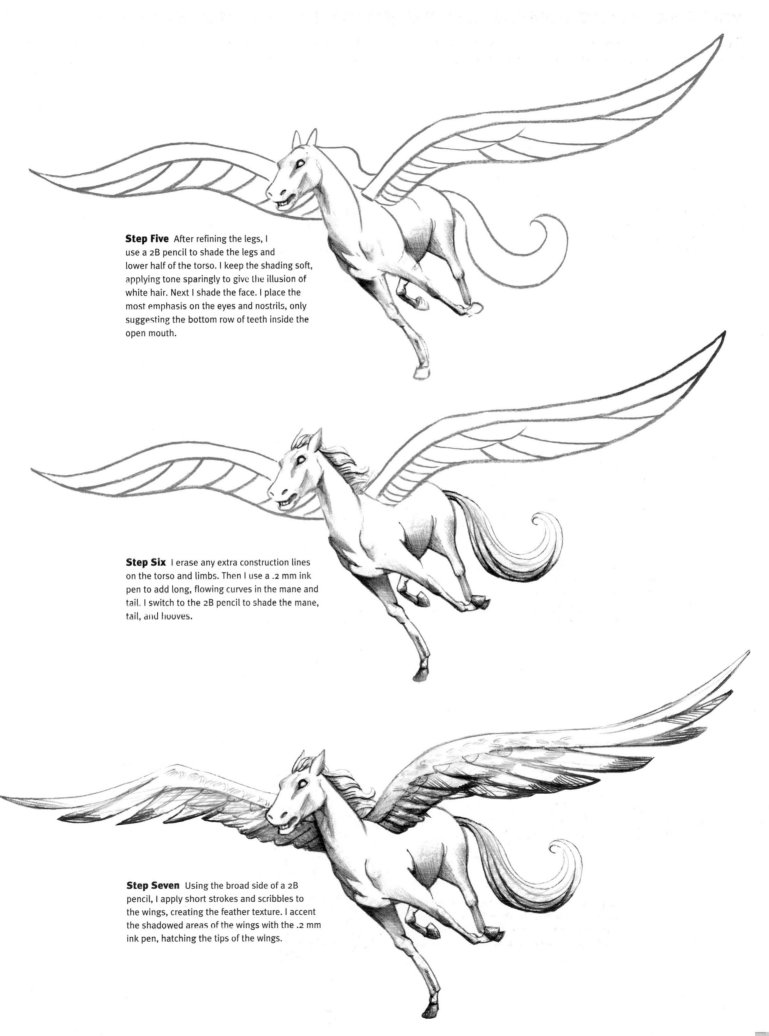

Step Five After refining the legs, I use a 2B pencil to shade the legs and lower half of the torso. I keep the shading soft, applying tone sparingly to give the illusion of white hair. Next I shade the face. I place the most emphasis on the eyes and nostrils, only suggesting the bottom row of teeth inside the open mouth.

Step Six I erase any extra construction lines on the torso and limbs. Then I use a .2 mm ink pen to add long, flowing curves in the mane and tail. I switch to the 2B pencil to shade the mane, tail, and hooves.

Step Seven Using the broad side of a 2B pencil, I apply short strokes and scribbles to the wings, creating the feather texture. I accent the shadowed areas of the wings with the .2 mm ink pen, hatching the tips of the wings.

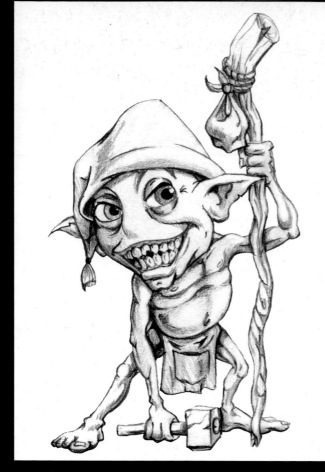

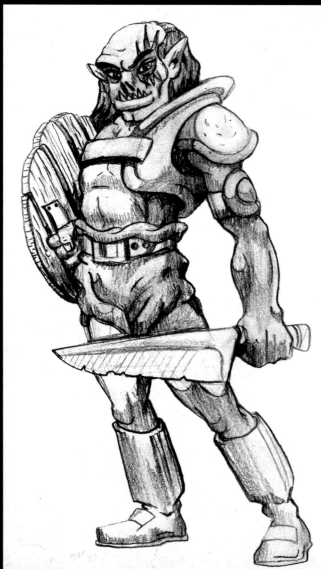

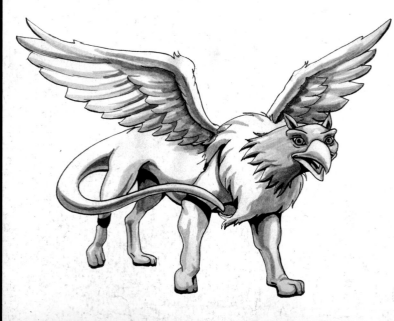

FANTASY CREATURES

From pixies and goblins to orcs and ettins, the figures on the next few pages are classified as fantasy creatures. Many of them share the same lore and origin as the mythological creatures in this book. You may ask, then, what is the difference? These characters aren't limited to one or two appearances in a regional myth; rather, they've infiltrated fairy tales and other stories. Read on to discover the subtle differences between goblins and hobgoblins, as well as the characteristics that differentiate fairies from pixies. There's always the possibility of encountering one and struggling to define the creature to your awe-stricken friends!

LEPRECHAUN

The leprechaun is a male creature from Irish folklore who keeps his riches hidden. Humans can acquire the treasure by capturing a leprechaun—but it isn't easy, as the leprechaun will vanish if one's eyes are taken off him, even for an instant!

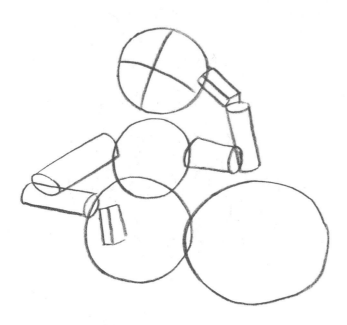

Step One With a 3H pencil, I draw three large circles reminiscent of a snowman for the figure, accompanied by a larger, overlapping circle for the kettle. Then I add cylinders for arms and boxes for hands. I also add the facial guidelines.

Step Two I continue adding simple shapes to the figure until the pose is more complete. Then I add the hat, the rounded shoes, and the lip of the kettle.

Step Three Using the facial guidelines, I place lines for the eyebrows and eyes, then add a bulbous nose and shaggy beard. I also draw a curved pipe in the leprechaun's hand.

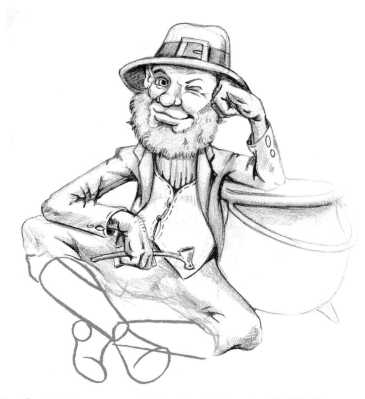

Step Four As I progress, I erase any guidelines I no longer need. With a 2B pencil, I begin refining and shading the face: I add a grinning mouth, a pointed ear, and a winking eye; I leave the other eye alone for now. I pull out a highlight on the tip of the nose to make it appear round. Then I add tone to the hat, creating a wide buckle. I add dark tones to the underside of the hat and create the cast shadow on the leprechaun's forehead. Then I add a layer of shading and several short, curved lines to the beard.

Step Five I detail the open eye, add darker tones to the beard, and finish the hat. Then I refine the arms and hands, adding some hair to the top of the right hand. I draw the handle on the kettle, also shading the lip and top section. Next I concentrate on the clothes: Following the forms of my initial sketch, I draw dark lines where the elbow bends to suggest folds; add buttons to the arms and a light-colored vest; and use simple, vertical lines to create the texture of the shirt beneath the vest. Then I begin refining the top of the pants. I also shade the pipe.

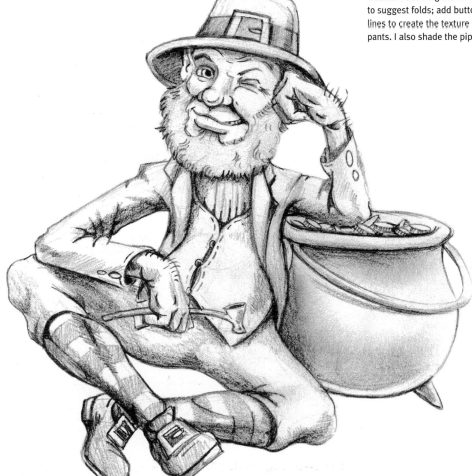

Step Six I finish the legs, adding the striped socks and buckled shoes. I draw a cast shadow where the arm rests on the leg, and I add a few sprouting hairs to the leprechaun's left hand. I finish rendering the kettle, adding some fluted coins inside. I also add a cast shadow from the handle for realism. Finally, I darken the shadowed undersides of the limbs and add a wee bit of teeth to the corner of his smile for personality.

BANSHEE

It's Irish tradition to have a wailing woman sing a lament at a funeral. Legend has it that several Irish families had a fairy sing that lament instead of a human—and that fairy came to be known as a banshee. Outside of the funeral setting, hearing a banshee's wail foretells a death in the family, and seeing a banshee is an omen of one's own death.

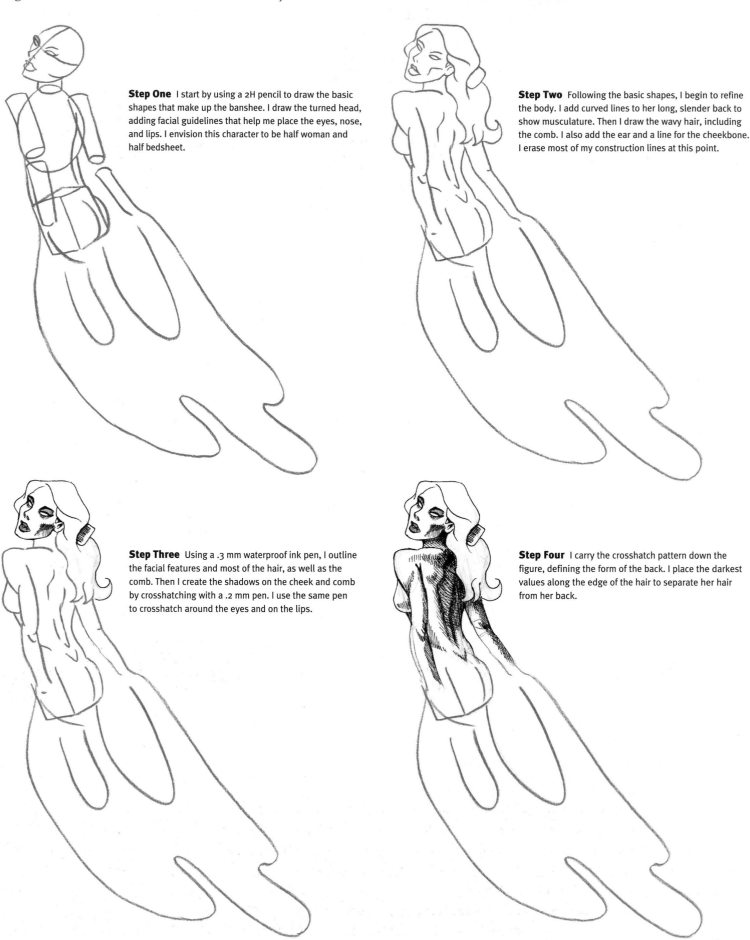

Step One I start by using a 2H pencil to draw the basic shapes that make up the banshee. I draw the turned head, adding facial guidelines that help me place the eyes, nose, and lips. I envision this character to be half woman and half bedsheet.

Step Two Following the basic shapes, I begin to refine the body. I add curved lines to her long, slender back to show musculature. Then I draw the wavy hair, including the comb. I also add the ear and a line for the cheekbone. I erase most of my construction lines at this point.

Step Three Using a .3 mm waterproof ink pen, I outline the facial features and most of the hair, as well as the comb. Then I create the shadows on the cheek and comb by crosshatching with a .2 mm pen. I use the same pen to crosshatch around the eyes and on the lips.

Step Four I carry the crosshatch pattern down the figure, defining the form of the back. I place the darkest values along the edge of the hair to separate her hair from her back.

Step Five Now I move down the body and add shading to indicate separations between fingers, making it appear as though the hands are part of the gown. I add dark tone to the V shape where the back flows into the gown. Then I outline the gown and begin adding shadows with single hatch marks to keep the tone light and soft.

Step Six With a .5 mm ink pen, I thicken the contours of the arms and the gown. I also draw wavy lines in the hair, keeping them simple to avoid overpowering the rest of the head. As a finishing touch, I extend the banshee's left hip so that it is visible behind her left arm; this creates a more convincing, balanced look.

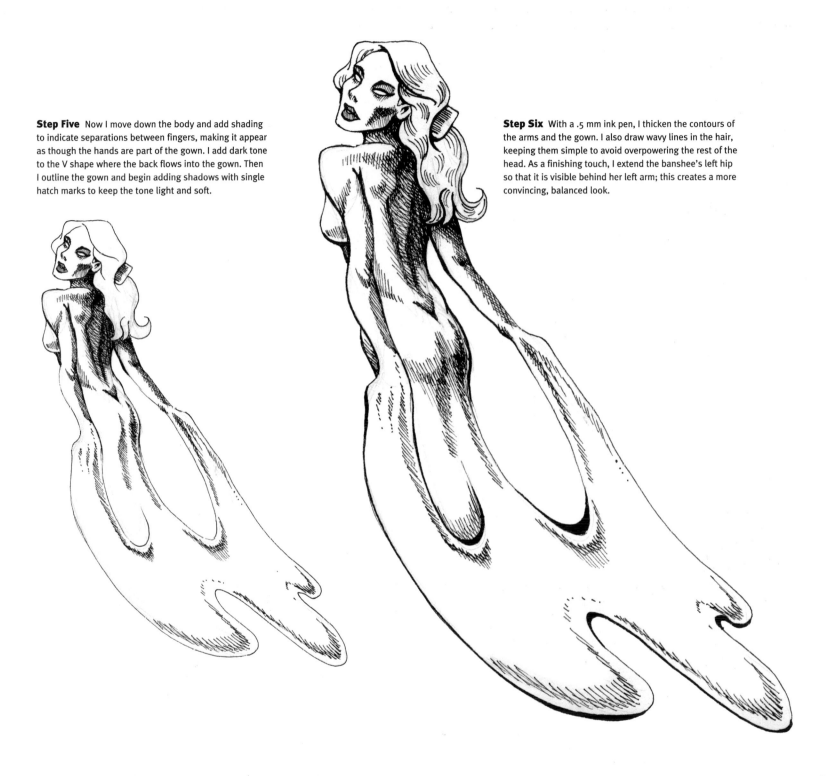

DID YOU KNOW?

- The banshee has long, flowing hair that she brushes with a silver comb.
- If you see a silver comb on the ground in Ireland and pick it up, you will be spirited away by a banshee.
- The women who sang laments at Irish funerals were referred to as "keeners."
- Banshees frequently are dressed in white, although some stories portray them as being dressed in green or black, with a gray cloak.
- In Scottish mythology, the banshee is known as "bean nighe."

TROLL

Originating in Scandinavian folklore, the troll is imposing but dim-witted and easily duped. Because it is unpleasant to be around, other creatures usually avoid the troll. Commonly found living in caves or under bridges, the troll is adept at fortune-telling and shape-shifting.

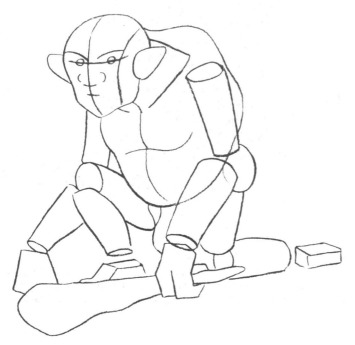

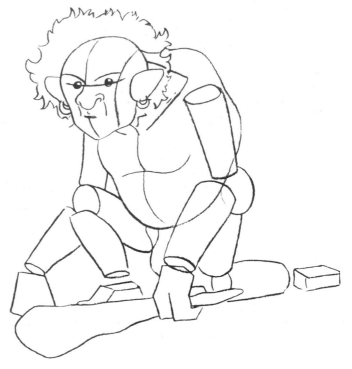

Step One Using a 2H pencil, I block in the geometric shapes that make up this crouching troll. Considering the troll's large size, I draw a big, misshapen torso, large hands, oversized feet, and a big head. I whittle down the troll's upper arms and legs to make him appear oddly shaped and unbalanced. I also add a huge club in his left hand.

Step Two To give the troll a little character, I start refining his facial features. I fill in the beady eyes, add a bulbous nose, accessorize the ears, and draw a mop of unruly hair. I am trying to create the appearance of a stupid brute, not a ravenous monster.

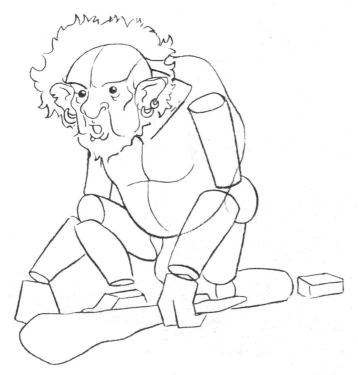

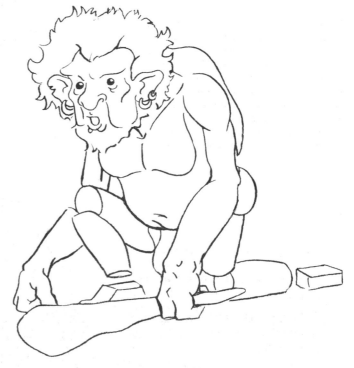

Step Three I modify the ears a bit, creating a few nicks in one and adding a second earring in the other. I draw the small, open mouth and curved lines for the drooping chin. Then I add the beard, using the same types of strokes I used for the hair.

Step Four I refine the shapes of the chest, back, arms, and hands. Then I erase the remaining construction lines on these areas and the face. Next I extend the hair over the forehead and adjust the brow ridge.

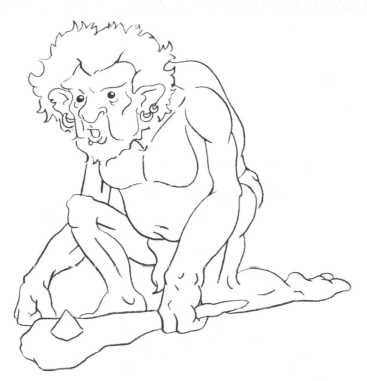

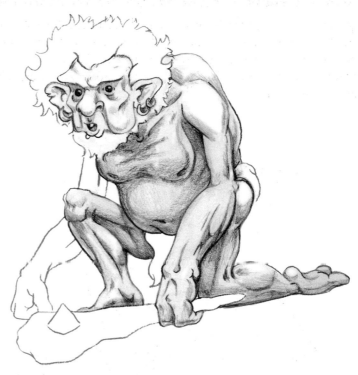

Step Five To finish refining the body, I follow the same simple recipe that I used on the arms. I make the legs full and round, but knobby and angular at the joints. This means that the lines tend to change direction a lot more around the wrists, ankles, elbows, and knees. I also refine the club, adding a sharp spike on the tip.

Step Six I create depth on the troll's body by building tone with a 2B pencil. I approach the image in sections. For instance, I shade the face until it is done; then I move on to an arm, then a leg, and so on. I find this is beneficial in keeping the anatomy clear and distinct.

Step Seven After adding a few warts to the face, I use short strokes that follow a radial pattern to achieve the hair's curly texture. By alternating between a series of clockwise and counterclockwise strokes, I produce an unkempt look. I repeat this pattern in the beard and the loincloth, although I make the beard a bit darker. I continue shading the rest of the body, remembering to add cast shadows where body parts overlap. Then I create the wooden texture of the club using curved, broken lines. I give form to the spike, creating a faceted appearance.

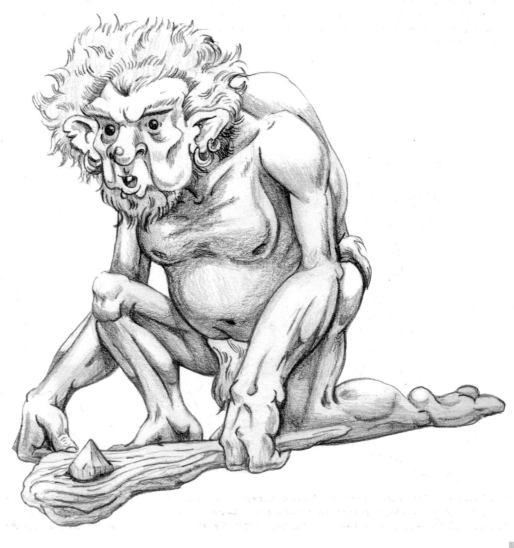

DID YOU KNOW?

- Trolls are very fond of eating humans!

- Although it is brutish and frightening, the troll usually isn't malicious.

- In direct sunlight, a troll will turn into stone.

OGRE

The ogre is a cruel, monstrous creature. This beast eats human flesh and can change into an animal or object at will. Large, but shorter than a giant, the ogre usually is depicted with a muscular body, large amounts of hair, and a huge belly.

Step One I start by drawing large, round shapes for the body and limbs using a 2H pencil. I want my ogre to be a strong, massive creature, so my construction lines reflect that. I add guidelines to the face that indicate a three-quarter view.

Step Two Now I start to convert the circles from step one into the more refined shapes of the arms, hands, and torso. I suggest the musculature with curved lines, and I make the hands larger than the head to suggest the ogre's massive size.

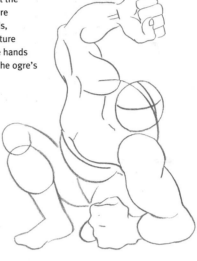

Step Three After creating the angular shape of the head, I draw the features, cramming them into the small head area. I allow the mouth to consume a great portion of the face, giving the ogre a sense of rage. I also add a tangled mess of hair to the sides of the head and the chin, leaving the top of the head bald and the forehead creased.

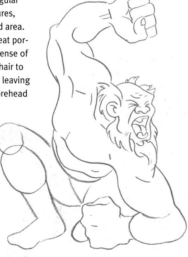

Step Four I draw a giant sword with several nicks and a ridged handle and place it in the ogre's right hand. I also add a studded wristband to the ogre's left arm, drawing the studs in curved, vertical paths that reflect the roundness of the arm underneath.

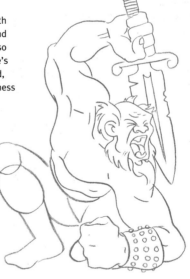

Step Five Next I refine the ogre's right leg, maintaining the roundness of the bulging calf. I use a vinyl eraser to remove any construction lines that remain.

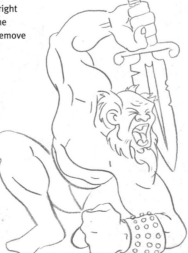

Step Six I draw a spiked kneepad on the giant's right knee. The kneepad looks like a tortoise's shell, and the spike reminds me of a faceted rhino horn.

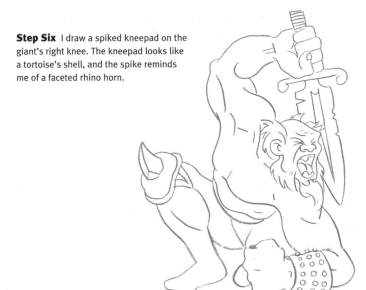

Step Seven I add some lines to the chest and leg to help define the form, and then I refine the visible foot by adding large toenails and a studded sandal. I also develop the ragged loincloth. I add a circle to the end of the sword and incorporate more studs. I don't want to draw an exceptionally ornate weapon because it might draw focus away from the character, which should be the main point of interest.

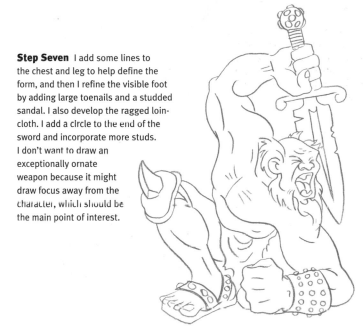

Step Eight Now I'm ready to add tone. Using a 2B pencil, I tackle one small area (such as the fist, face, or sword) at a time, completing it before moving to the next section. Working this way helps prevent unwanted smudges. I add sharp lines to the hair, and I draw some sprouts of hair at the top of the otherwise bald head. I also shade the visible thumbnail, giving it dark, rough edges.

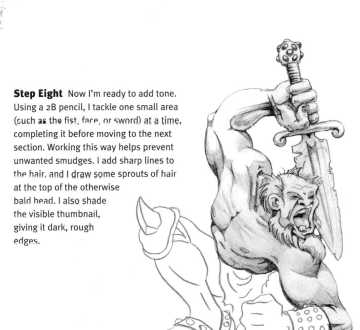

Step Nine I continue to shade the body, keeping the darkest shadows toward the core of the character, particularly around the edges of the loincloth. I shade the spike and add texture to the kneepad, giving it a shell pattern and a ridged edge. Then I add tone to the sandal and wristband, shading around the studs to make them pop forward. Finally, I shade the toenails, making the largest one appear torn.

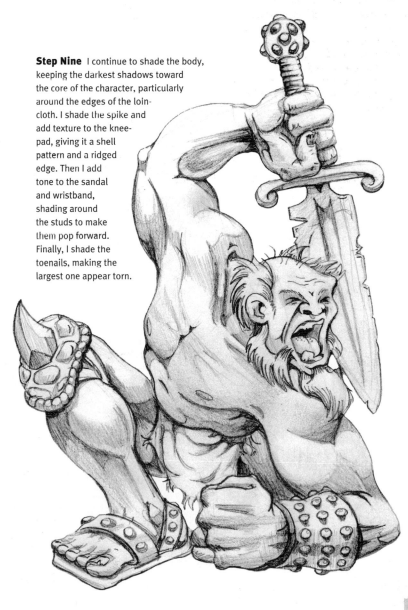

DID YOU KNOW?

- A female ogre is called an "ogress" and generally is associated with water.

- The ogre isn't very intelligent—this lack of mental agility makes it easy for humans to defeat it.

- In the fairy tale "Puss in Boots," a cat defeats a shape-changing ogre.

- In Scandinavian folklore, the word "ogre" is not used; instead, ogrelike creatures are referred to as "trolls." These trolls are said to inhabit castles in the wilderness, where they hoard treasure.

ETTIN

An ettin is a large humanoid that usually bears two or three heads. It is giant and unpredictable. Violent, sharp-eyed, and alert, the ettin makes an excellent hunter.

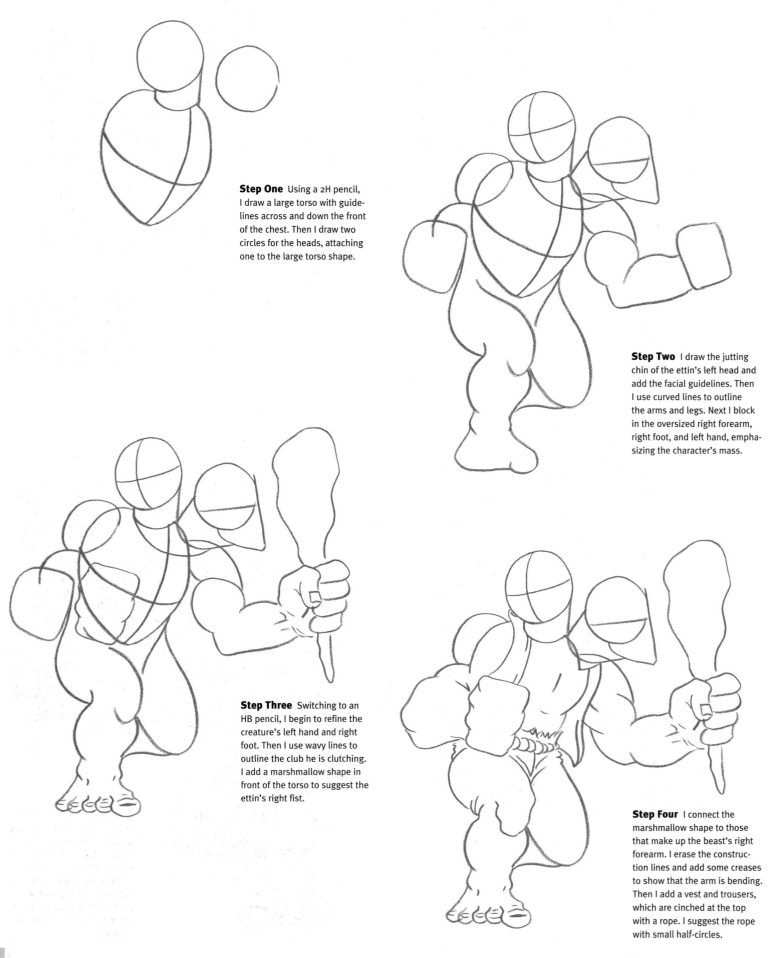

Step One Using a 2H pencil, I draw a large torso with guidelines across and down the front of the chest. Then I draw two circles for the heads, attaching one to the large torso shape.

Step Two I draw the jutting chin of the ettin's left head and add the facial guidelines. Then I use curved lines to outline the arms and legs. Next I block in the oversized right forearm, right foot, and left hand, emphasizing the character's mass.

Step Three Switching to an HB pencil, I begin to refine the creature's left hand and right foot. Then I use wavy lines to outline the club he is clutching. I add a marshmallow shape in front of the torso to suggest the ettin's right fist.

Step Four I connect the marshmallow shape to those that make up the beast's right forearm. I erase the construction lines and add some creases to show that the arm is bending. Then I add a vest and trousers, which are cinched at the top with a rope. I suggest the rope with small half-circles.

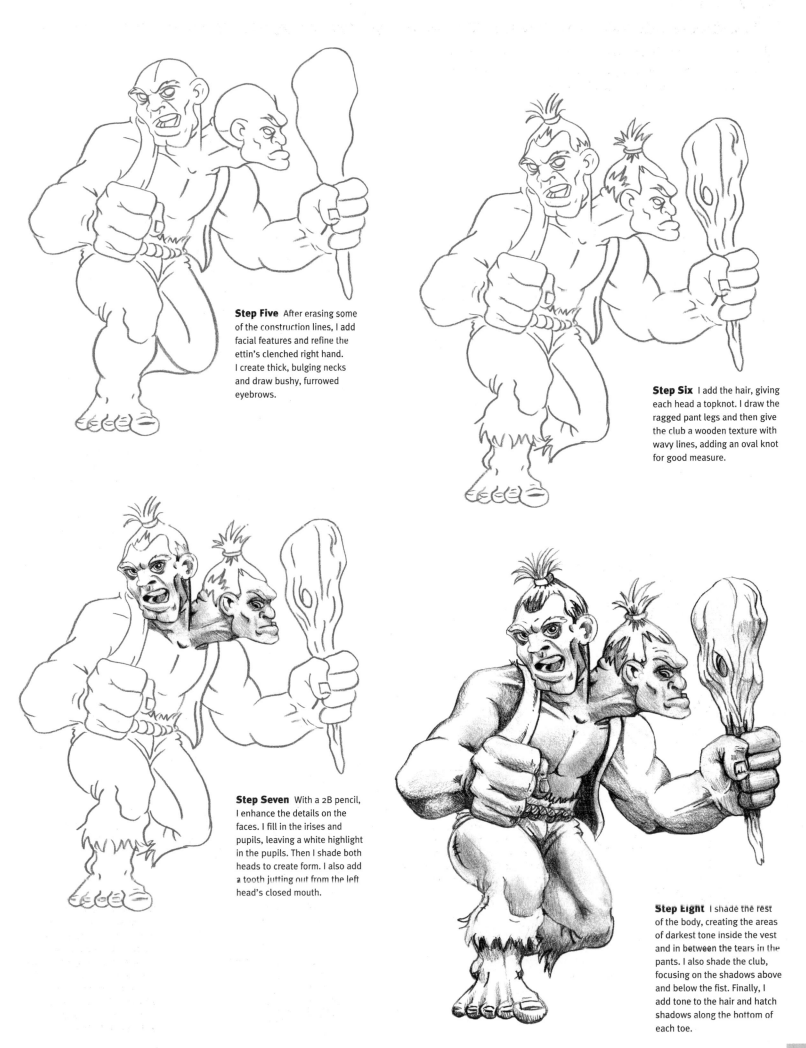

Step Five After erasing some of the construction lines, I add facial features and refine the ettin's clenched right hand. I create thick, bulging necks and draw bushy, furrowed eyebrows.

Step Six I add the hair, giving each head a topknot. I draw the ragged pant legs and then give the club a wooden texture with wavy lines, adding an oval knot for good measure.

Step Seven With a 2B pencil, I enhance the details on the faces. I fill in the irises and pupils, leaving a white highlight in the pupils. Then I shade both heads to create form. I also add a tooth jutting out from the left head's closed mouth.

Step Eight I shade the rest of the body, creating the areas of darkest tone inside the vest and in between the tears in the pants. I also shade the club, focusing on the shadows above and below the fist. Finally, I add tone to the hair and hatch shadows along the bottom of each toe.

ORC

The orc usually is portrayed as a brutal, warmongering humanoid. The word "orc" comes from Orcus, the Roman god of the underworld. Cowardly yet tough and sadistic, the orc's ugly, filthy appearance is a good match to its personality.

Step One Using simple ovals and boxes, I lay out a map of the figure with a 2H pencil, placing guidelines over the face and chest. I want to give the orc some warrior characteristics right from the start: I draw the head and torso so that the orc seems to be puffing out its chest, even with its head tucked in. This pose shows aggressive defiance; the orc won't leave its neck exposed to attack.

Step Two With an HB pencil, I refine the head and add the facial features. I draw the square jaw and angular cheekbones. Then I add the protruding bottom lip, sharp teeth, and sloping brow. I also add a piglike snout and pointed ears. I want the orc to look like it means business. I leave the forehead bald but use wavy lines to suggest the long hair in the back.

Step Three I draw the hair on the right side of the orc's head. Then I refine the torso, drawing an armor plate over the chest. The curve of the collar and the way the shell wraps around the back of the character help define the shape of the body beneath.

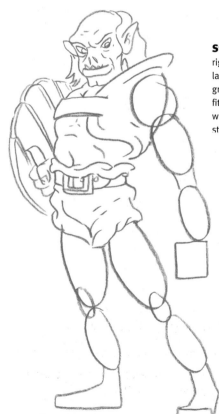

Step Four I draw the orc's right hand before drawing the large, wooden shield that it grasps. Then I draw the loose-fitting shorts that are cinched with a wide belt, erasing construction lines as necessary.

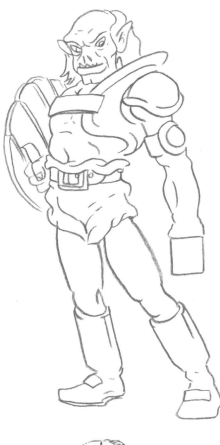

Step Five I adorn the orc's left shoulder with a plate of armor that looks like a turtle shell. Then I refine the rest of the arm, adding a band and a curved, bulging forearm. I add some details to the belt and give the orc a pair of sturdy boots. The tops of the boots are stiff and inhibit the viewer from seeing the curves of the lower leg and calf. The ankle area is much softer, allowing you to see the taper of the leg.

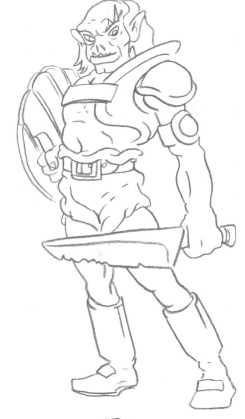

Step Six After I complete the orc's left hand, I draw the huge butcher knife, complete with nicks. I also put a decorative tattoo around the orc's left eye. This tattoo could be seen as an intimidating trait or perhaps as a mark to show the orc's loyalty to its clan.

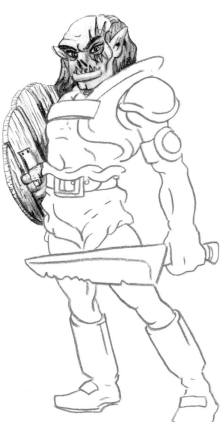

Step Seven Using a soft 2B pencil, I apply tone on the face. I make the nostrils and eyebrows very dark, and I detail the irises and pupils. I also add tone to the hair and the shield, using long, vertical strokes to suggest the grain of the wooden shield. I put some very deep shadows along the lower portion of the shield to show that it is blocking the light.

Step Eight I continue shading the rest of the body, making the chest armor and the knife the lightest values. This suggests that light is reflecting off these areas. The darkest areas of tone are along the right side of the orc's body as it turns away from the light source and the area under the band of armor on the chest. I use dark lines on the shorts to show the creases and folds. Then I shade the legs and boots, giving the boots a shiny surface by leaving some of the paper white.

DID YOU KNOW?

- The Irish homophone "ork" means "swine."
- The most well-known orcs are those that appear in J.R.R. Tolkien's *The Lord of the Rings* trilogy.

GNOME

Small and dwarflike, the gnome lives underground, where it guards its treasure. According to myth, the gnome also guards secret knowledge—which is why its name is taken from the Greek "gnosis," meaning "knowledge."

Step One Using a 2H pencil, I draw two circles for the head and torso of the gnome.

Step Two I indicate the facial guidelines and draw a line through the body to suggest its curvature. I draw a few more lines to find the position of the arms and shoulders.

Step Three Building on the guidelines, I add the round eyes, wide nose, and slightly frowning mouth. Then I draw the small ears and the full beard, breaking up the line along the gnome's left cheek. I also draw thick eyebrows and indicate the line of the hat across the forehead. Then I add very faint hatch marks above the line of the hat and within the beard for subtle shadows.

Step Four When I draw the conical hat, I make it flop over at the top. I make the base of the hat rounded to indicate the shape of the head underneath.

Step Five Following my guidelines, I draw the gnome's shoulders and crossed arms.

Step Six I extend the coat down the hips and toward the legs, curving the lines to follow the gnome's bulging contours. Then I draw the legs, adding lines near the ankles to indicate creases in the bunched fabric.

Step Seven After lightly hatching the hat, arms, jacket, and pants, I add pinstripes to the pants and draw pockets, an elbow patch, and lapels on the jacket. The pinstripes curve where the pants gather at the ankle.

Step Eight I add a pair of oversized wooden clogs to complete the gnome's ensemble. Again, I use light hatch marks to define the form.

Step Nine Using a .2 mm ink pen, I trace over all my pencil lines. When the ink has dried, I go over the drawing with an art gum eraser. Then, with a .5 mm pen, I retrace the exterior contour lines of the character and the hatch marks to give the gnome a more dynamic appearance. Again, I erase my pencil lines when the ink is dry.

DID YOU KNOW?

- The gnome is an excellent guardsman, which is why people often use garden gnome statues to protect their gardens.
- If exposed to daylight, the gnome will turn to stone.
- The gnome loves animals and is the caretaker of wildlife.
- In Iceland, gnomes are so respected that roads are re-routed around areas said to be inhabited by them.

GOBLIN

A type of gnome, the goblin is a small creature that is at once playful and evil. Its mischievous tricks include inserting nightmares into the ears of humans and kidnapping women and children. A goblin's laugh sours milk; its smile curdles blood!

Step One Using a series of circles and ovals, I block in the basic pose of the goblin. The curved line running through the torso is the *line of action*—a line that indicates the main thrust of the movement. In this case, the line shows that the character will be bending forward.

Step Two I connect the circles and ovals with lines to create a more comprehensive foundation. Then I add the facial guidelines to the head.

Step Three Following my facial guidelines, I establish the position of the eyes and nose. I use a 2B pencil for these details, and I eliminate the construction lines as I draw.

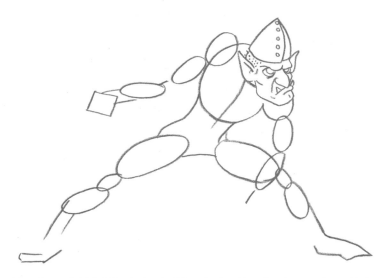

Step Four I finish building the head, adding a jutting chin, pointed ears, and a studded cap. I also indicate the frowning lip, two sharp teeth, and a heavy brow. Then I draw small dots and a few spikes of hair along the right side of his head.

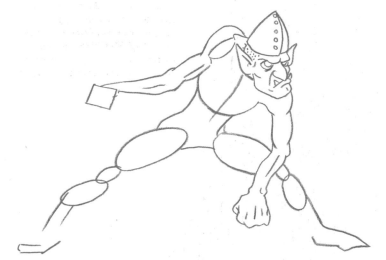

Step Five I begin refining the shapes of the arms and the goblin's left hand, which is curled in a fist. I erase any unneeded construction lines along the way.

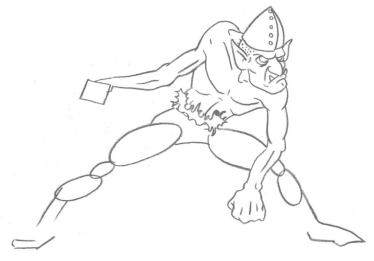

Step Six Curved lines suggest the musculature of the torso. Next I add tattered fabric around the goblin's waist. The short, jagged strokes make an interesting contrast to the long, lean lines of the rest of the goblin's body.

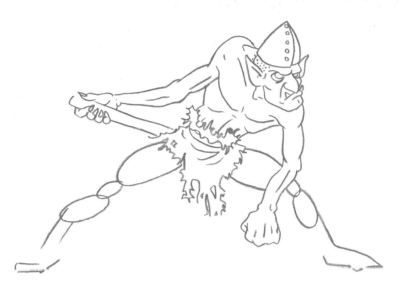

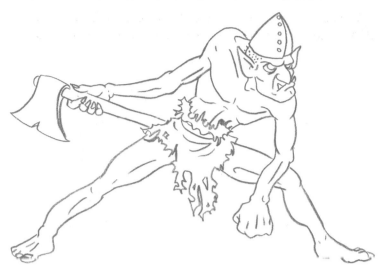

Step Seven I complete the shredded loincloth, and I refine the rest of the right arm and hand. I add long, pointed fingernails to the right hand and draw the handle of the goblin's weapon.

Step Eight To draw the thin legs and the bare feet, I build on my construction circles. I use curved lines to indicate the leg muscles. Then I begin drawing the head of the axe, which features a ding that echoes the goblin's tattered clothing.

DID YOU KNOW?

- A goblin's height can range from 2'–5'.
- A baby goblin is called a "changeling."
- Female goblins are referred to as "hags" or "crones."
- A group of goblins is called a "horde."
- Goblins usually are invisible to the human eye.
- If a horse is rearing, it is said that a goblin is trying to "borrow" it.

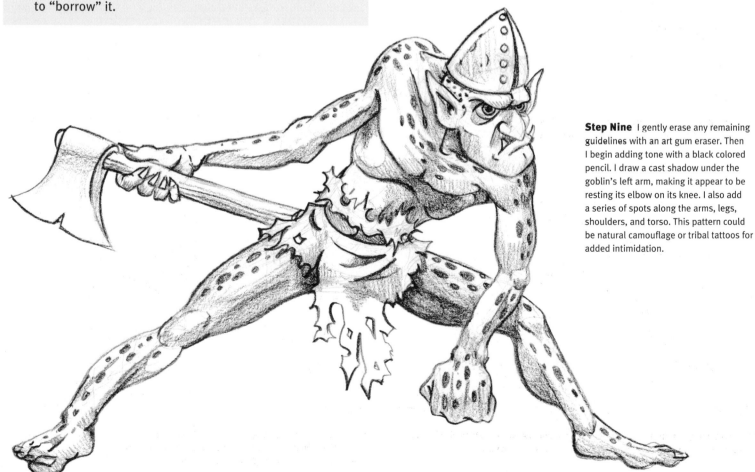

Step Nine I gently erase any remaining guidelines with an art gum eraser. Then I begin adding tone with a black colored pencil. I draw a cast shadow under the goblin's left arm, making it appear to be resting its elbow on its knee. I also add a series of spots along the arms, legs, shoulders, and torso. This pattern could be natural camouflage or tribal tattoos for added intimidation.

HOBGOBLIN

A hobgoblin is the same as a boogeyman. It's a type of goblin, so it's ugly and mischievous, but it is friendlier and more good-humored than most goblins. If it becomes annoyed, however, things can turn nasty.

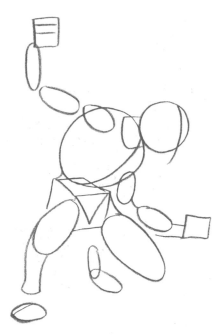

Step One To begin this drawing, I map out the figure's pose with a 3H pencil. I use spheres, ovals, boxes, and cylinders to give the hobgoblin its generally humanoid appearance.

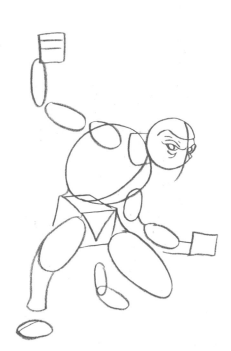

Step Two Switching to a slightly softer HB pencil, I begin to draw the face, starting with the eyes and the brow ridge.

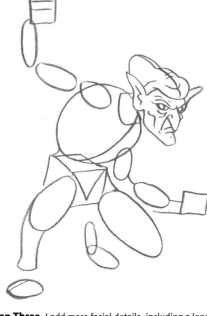

Step Three I add more facial details, including a long chin, pointed ears, and a long, hooked nose. I erase my facial guideline and add a cap to the top of the head.

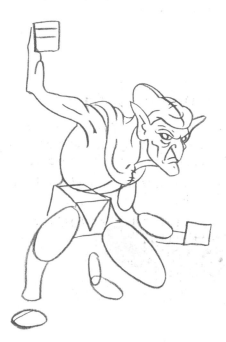

Step Four I extend the hat down the back and over the shoulders, transforming it into a hood. I create the illusion of draping fabric by adding curving lines and ripples. I also refine the scrawny, raised arm.

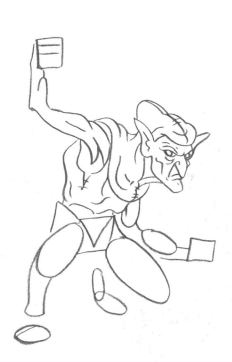

Step Five I add the oversized armhole of the hobgoblin's tunic, drawing some stitches where the fabric might have ripped. I also reshape the outline of the creature's back to include a large hump. I add a few more wavy lines to the tunic to give it form and movement, erasing guidelines as I draw.

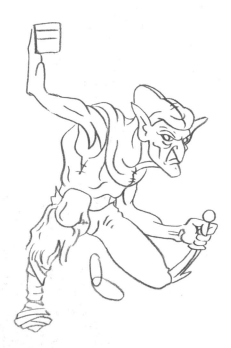

Step Six Using the construction circles to define the bulges of the muscles, I complete the figure's left arm. Then I refine the top of the left leg, which is foreshortened because it is bending toward the viewer. I draw the top of the sword and blade, which disappears behind the leg. Next I use wavy lines to create the furry texture on the right pant leg, and I draw the bandages that cover the lower half of the leg. I also add a pouch to the waist.

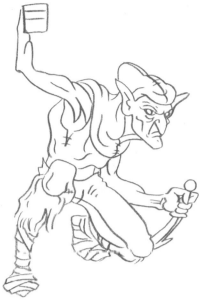

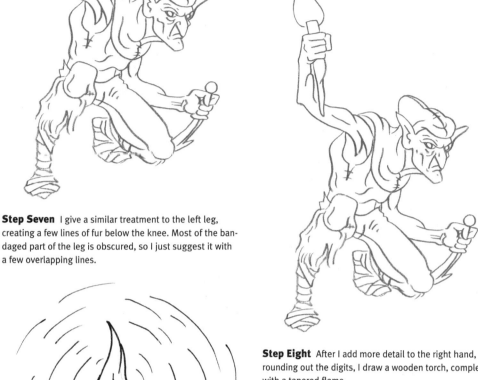

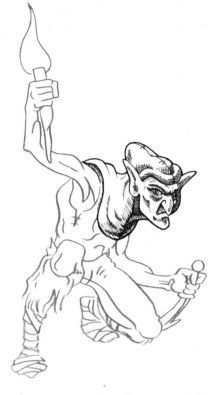

Step Seven I give a similar treatment to the left leg, creating a few lines of fur below the knee. Most of the bandaged part of the leg is obscured, so I just suggest it with a few overlapping lines.

Step Eight After I add more detail to the right hand, rounding out the digits, I draw a wooden torch, complete with a tapered flame.

Step Nine Using a .5 mm ink pen, I retrace the head and hood; then I hatch and crosshatch using a .3 mm ink pen to give form to the face and hood. I use a single hatch on lighter areas of the face and hood, and I crosshatch to make the darkest shadows. The densest area of hatching is the left side of the creature's face, which is almost entirely in shadow.

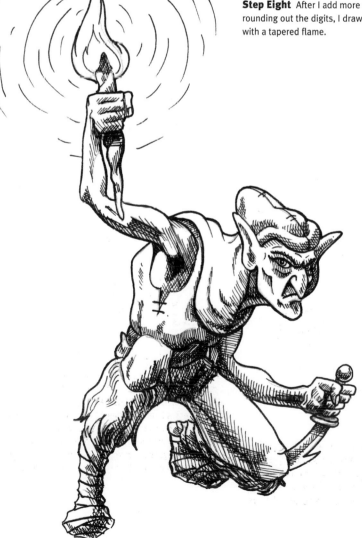

DID YOU KNOW?

- J.R.R. Tolkien's *The Hobbit* describes hobgoblins as the bigger, stronger type of goblin.

- Hobgoblins have superior night vision.

- It is said that hobgoblins live by firelight and rarely go outside.

- Hobgoblins often dwell in swamps.

Step Ten I outline the rest of the body using the .5 mm pen. Then I switch to the .3 mm pen to hatch along the body. I crosshatch areas of the figure that I want to be very dark, such as the middle of the torso and the area underneath the hobgoblin's right hand where the torch casts a shadow. I also shade the creature's weapon and torch, hatching and crosshatching to create form. Then I add curved lines all around the flame, suggesting bright light. When all the ink is dry, I drag an art gum eraser over the image to remove any visible pencil lines.

GREMLIN

Once upon a time, it was the gremlin's goal to aid humans. The gremlin helped with mechanics and inventions but got upset when humans took all the credit. For revenge, the gremlin began dismantling mechanical devices whenever possible.

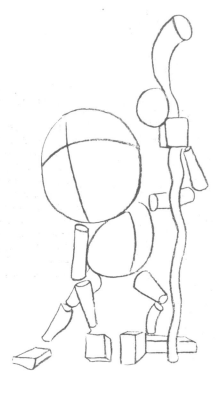

Step One I sketch this gremlin with a 2H pencil, using basic cylinders, circles, and boxes. By giving my creature an oversized cranium, I emphasize its diminutive stature. To avoid making the gremlin seem child-like, I give it a stout torso and gangly limbs. I draw a curved staff, adding the shape of the hand that grips it afterward, and I draw the square head of the hammer next to the other hand.

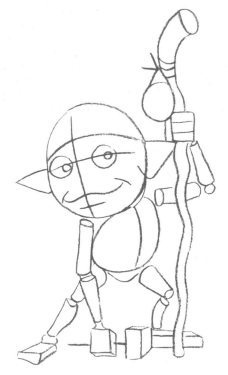

Step Two As I begin to block in the facial features, I include the round eyes, pointy ears, and curved mouth. I draw a line to indicate the handle of the hammer, separate the fingers on the gremlin's left hand, and connect the circle to the staff to suggest a sack. I also add a triangular shape below the torso.

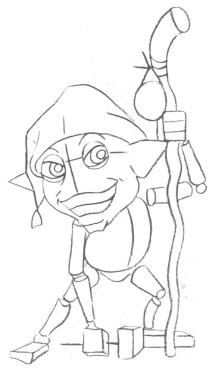

Step Three I start detailing the facial features by adding thick eyelids, round irises and pupils, and arched eyebrows. Then I extend the mouth and draw the protruding chin. I draw a semi-circle extending from the right eye to suggest the flat, almost nonexistent nose. I also add two rows of teeth. I draw the hat, which folds over and flops to the side. I erase the guidelines around the mouth and inside the eyes.

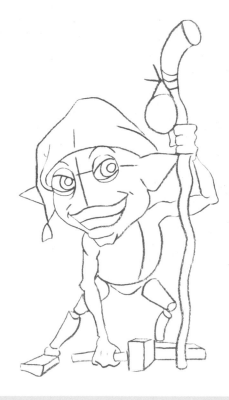

Step Four Using the simple shapes as a guide, I start to refine the gangly arms and hands. I use curved lines to suggest a little musculature. I block in a thicker shape for the handle of the hammer, erasing the original guideline.

DID YOU KNOW?

- The gremlin myth originated during World War II, when airmen of Britain's Royal Airforce joked that gremlins were responsible for every technical malfunction, including unexplained aircraft crashes.
- Children's author Roald Dahl experienced an accidental crash-landing when he served in the Royal Airforce. Years later, he wrote *The Gremlins,* in which he described male gremlins as "widgets" and females as "fifinellas."

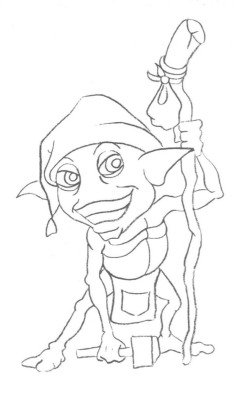

Step Five I continue refining the chest, legs, and feet, and I begin separating the toes on the gremlin's right foot. I refine the shape of the sack and tie before honing the shape of the ears. Then I add the apron at the waist.

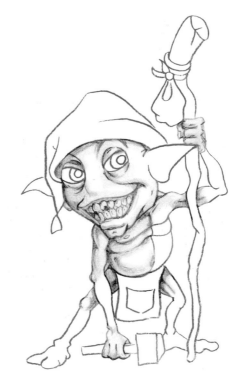

Step Six With a 2B pencil, I begin giving form to the facial features, wiping away the sweet smile by adding chipped, broken teeth. Then I start shading the chest, arms, legs, and hands. I place more pressure on my pencil to create a darker tone on the upper portions of the legs, where the apron casts a shadow. I also add darker tone where the staff casts a shadow onto the arm.

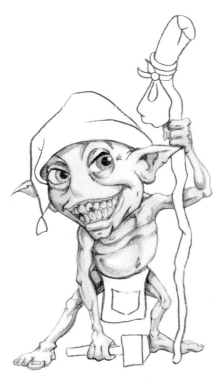

Step Seven Varying the pressure on my pencil, I emphasize the curves of the figure, from the robust stomach to the knobby knees. I also add tone to the eyes, the ears, and the bottoms of the legs. I refine the feet, defining the toes and toenails, and then I add nicks in the ears.

Step Eight I add tone to the hat and the tassel, using vertical strokes to create the tassel's texture. Then I develop the knotted, wooden texture of the staff and shade the sack and tie. I also add tone to the apron, making it appear creased and draping with a few curved lines. After shading the tool, I create the chipped texture with craggy lines.

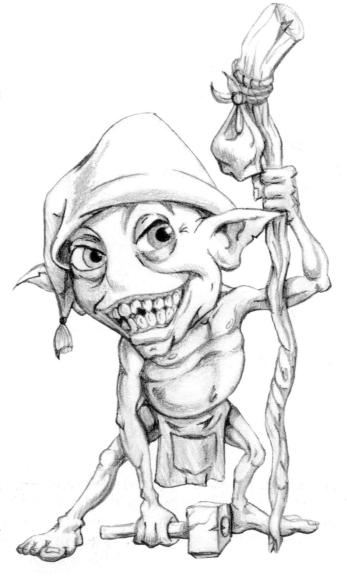

GARGOYLE

In architecture, the gargoyle is a carved water spout that directs excess water off rooftops. The gargoyle's grotesque features keep away evil spirits. In modern fiction, the gargoyle is a winged humanoid with characteristics similar to the carvings.

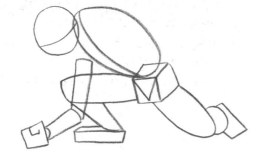

Step One Using a 2H pencil, I map out the position of the figure. I start with the basic structure of a crouching human, using circles, ovals, cylinders, and boxes where appropriate. I also add the curved center guideline for the face.

Step Two I use basic shapes to outline the wing bones and the figure's left arm. I make the left hand appear huge compared with the right hand. This is another example of foreshortening (see page 16). Then I draw the vertical guideline for the face, extending the line so that it almost reaches the leg below.

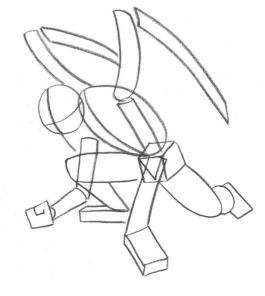

Step Three With an HB pencil, I draw the details of the wings, including the scalloped tips and a spike at the top of each wing.

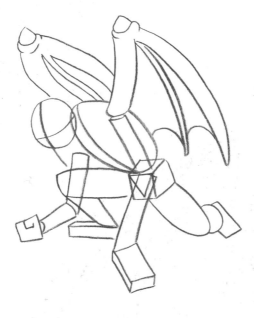

Step Four At this point, I refine the shape of the head, extending the chin to the end of my vertical guideline. I draw the pointy ear and the sunken cheek, as well as the eyes, nose, and open mouth. Then I add sharp fangs and erase any unneeded guidelines.

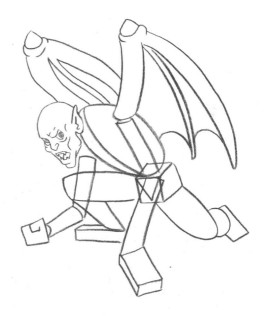

Step Five I add the horns on the forehead that match the spikes on the wings. I refine the shape of the chest and back, adding curved lines to indicate two small humps. Then I draw the scale pattern on the neck, back, and wings, continuing along the arms.

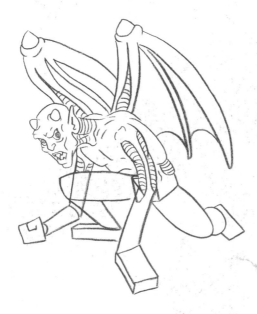

Step Six I continue the pattern of scales on the creature's right arm, avoiding the area that will be covered by the leg. Then I draw the long, clawlike hands, curling the fingers of the right hand into the palm. I also draw the long, sharp fingernails.

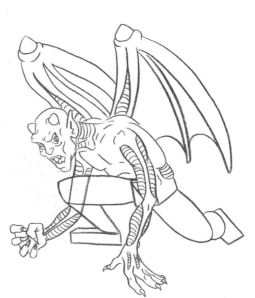

DID YOU KNOW?

- In Egypt, gargoylelike spouts ejected the water used in washing sacred vessels, a ritual that was performed on the flat roofs of temples.

- Gargoyle-esque sculptures that do not function as rainspouts are called "grotesques."

- In French, "gargouille" means "throat."

Step Seven I refine the contours of the legs, adding sections of scales, as shown. I erase my construction lines as I draw.

Step Eight I refine the feet, adding scaling and a sharp claw on each foot. The clawlike toes allow the gargoyle to cling to the sides of buildings.

Step Nine I want to give the gargoyle a dark tone to complement his evil-looking features, so I use a black colored pencil to heavily darken the most recessed areas of the character, such as around the eyes and inside the mouth. I lightly shade the rest of the body and wings, suggesting light veins over the thin skin of the wings. I place an extra layer of shading on the scaled sections to differentiate them from the rest of the body. I also add very dark tone where the figure's left arm casts a shadow onto the middle section.

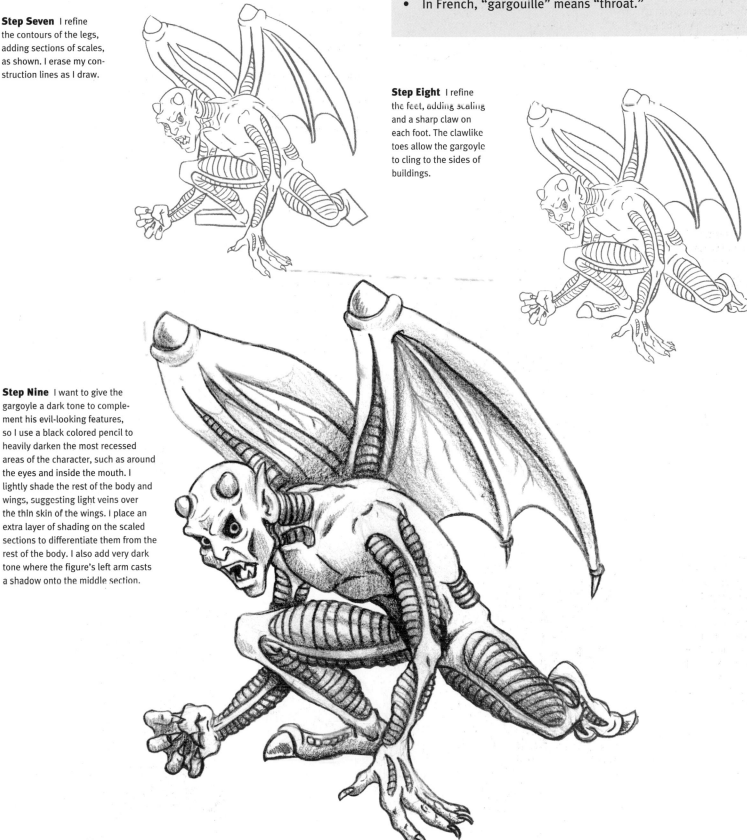

Manticore

The manticore has the head of a man and the body of a lion. Its spiny tail houses poisonous darts, and its sharp fangs are made of iron. The manticore lives in the jungle or forest and is known in Persia as the "eater of people." It stalks the land for prey; when it finds a human, it fires the darts from its tail and devours the person whole—bones, clothes, possessions, and all!

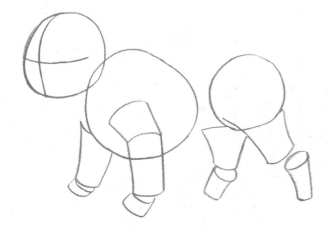

Step One I start by using a 3H pencil to block in the main forms of the body with simple shapes, such as circles and cylinders. Then I add facial guidelines on the head.

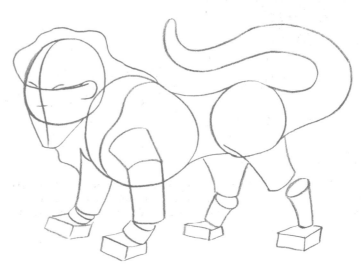

Step Two I continue building the figure by adding boxy feet, a serpentine tail, and a thick mane. I extend the face to include the chin, and I begin suggesting the features with curved lines for eyebrows, a line for the nose, and a half-circle for the ear.

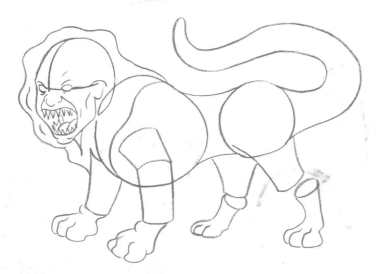

Step Three With a 2H pencil, I add the facial details. An important feature of the manticore is its prominent teeth, so I give it an extra-large mouthful. Then I refine the paws, separating the large toes. I also add a few wavy lines to the mane.

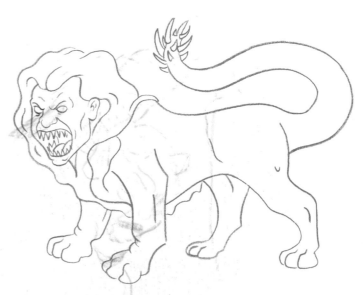

Step Four After drawing the mane around the face, I extend it down the chest and onto the underbelly. Then I refine the rest of the body, erasing my construction lines as I draw. I detail the ear, giving it a human appearance. Next I draw a cluster of spikes on the tip of the tail.

DID YOU KNOW?

- Manticores vary in size, from that of a lion to that of a horse.
- Manticores are said to have gray eyes and red fur.
- The manticore's voice sounds like a combination of a pipe and a trumpet.
- Like its cousin the sphynx, the manticore would challenge its prey by asking riddles.
- Whenever a person disappears completely, it is thought to be the work of a manticore.

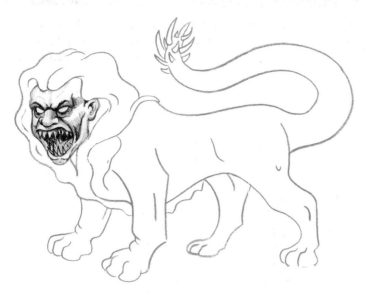

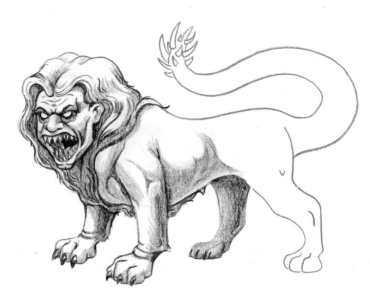

Step Five To achieve a soft, dark value, I use a black colored pencil to render the details of the manticore's terrifying face. The colored pencil allows for an exceptionally dark, rich tone. I apply the darkest tones in the mouth and around the eyes. I build up the tones slowly, because colored pencil is notoriously difficult to erase.

Step Six I progress to the mane, using wavy lines to illustrate the texture. Then I carry the tone down the chest and onto the legs; the beast's back right leg receives the darkest tone, as it is in shadow. I also add four dark lines to the back right paw, suggesting claws. Although I know the beast is entirely covered with fur, I merely suggest it with tone— I don't want to distract from the mane by adding a thick fur texture to the body.

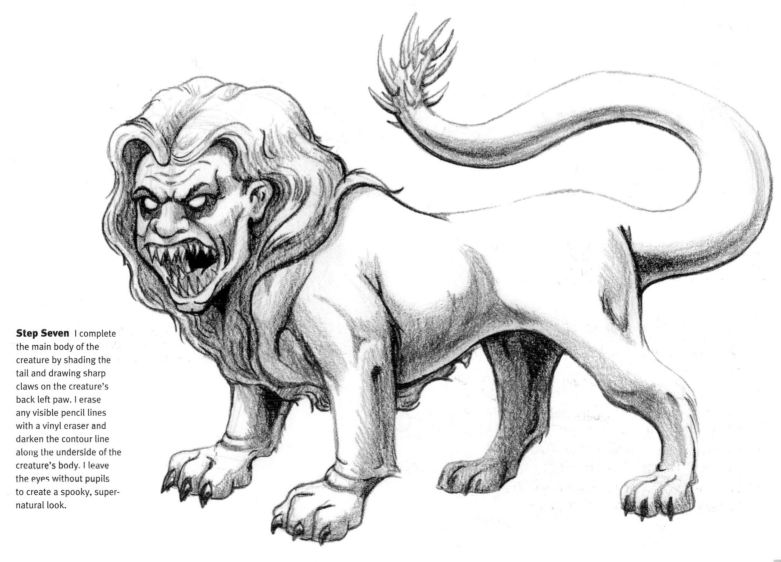

Step Seven I complete the main body of the creature by shading the tail and drawing sharp claws on the creature's back left paw. I erase any visible pencil lines with a vinyl eraser and darken the contour line along the underside of the creature's body. I leave the eyes without pupils to create a spooky, super-natural look.

PHOENIX

After living from 500–1,000 years, this mystical bird builds a nest cum funeral pyre and is consumed by flames. But when the embers cool, a new phoenix rises up from the ashes. Only one phoenix lives at any given time.

Step One Using a 2H pencil, I lay down simple shapes to position the head, beak, body, and legs of the phoenix.

Step Two I continue building the shapes of the phoenix. I add curved and straight cylinders to create the structure of the wings, and I use a rounded bell shape to block in the tail.

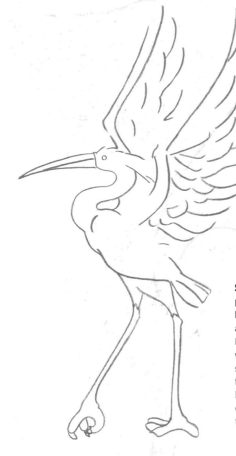

Step Three With an HB pencil, I refine the body, keeping the legs slender and the neck curved. I add plumage to the wings and tail and draw sharp talons on the raised foot. I draw a crest at the back of the head. Then I erase as many construction lines as possible.

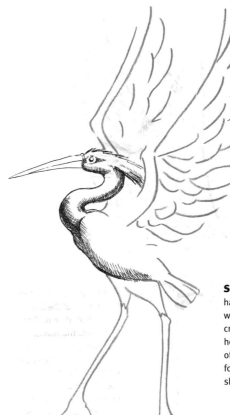

Step Four I apply hatching with a .3 mm waterproof ink pen to create the texture of the head, neck, and chest of the bird. I crosshatch for the darkest areas of shadow.

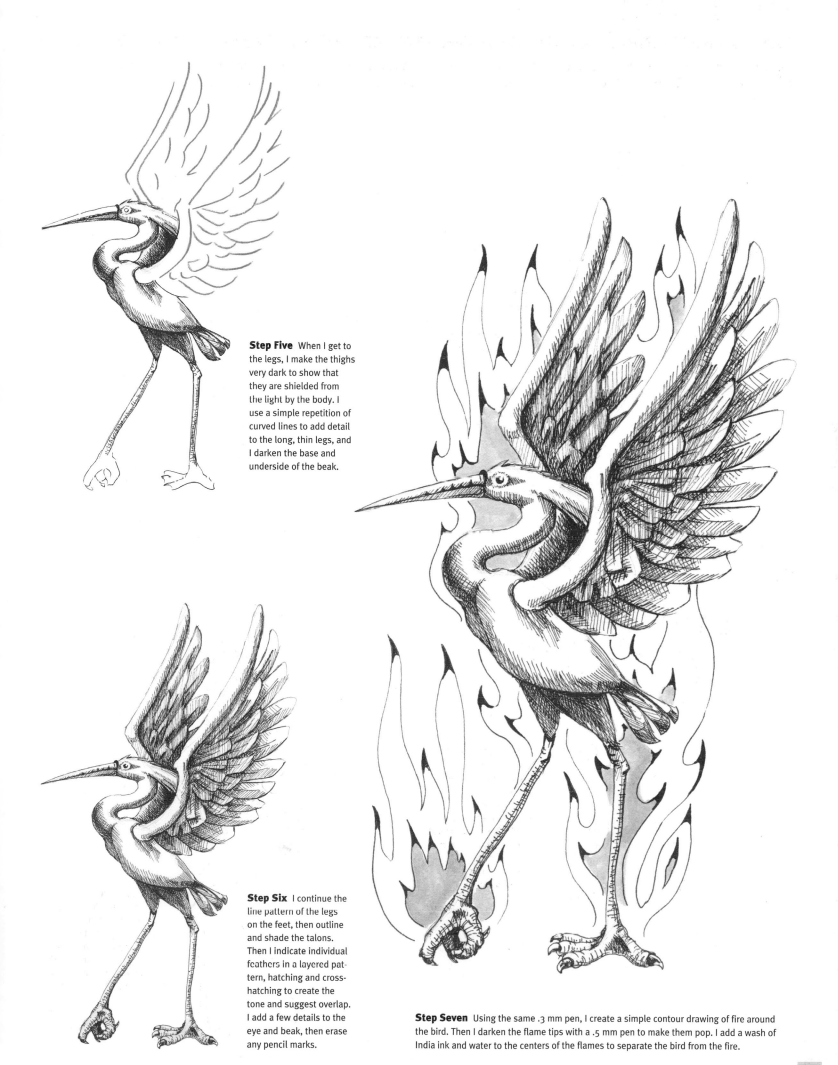

Step Five When I get to the legs, I make the thighs very dark to show that they are shielded from the light by the body. I use a simple repetition of curved lines to add detail to the long, thin legs, and I darken the base and underside of the beak.

Step Six I continue the line pattern of the legs on the feet, then outline and shade the talons. Then I indicate individual feathers in a layered pattern, hatching and crosshatching to create the tone and suggest overlap. I add a few details to the eye and beak, then erase any pencil marks.

Step Seven Using the same .3 mm pen, I create a simple contour drawing of fire around the bird. Then I darken the flame tips with a .5 mm pen to make them pop. I add a wash of India ink and water to the centers of the flames to separate the bird from the fire.

GRIFFIN

A griffin has the body of a lion and the head of an eagle. This nest builder takes a single mate for life and thus has become a symbol for marriage and fidelity. The griffin inhabits Scythia (now modern Ukraine, Russia, and Kazakhstan).

Step One With a 2H pencil, I start blocking in simple shapes to suggest the bulk of the griffin. Then I add the horizontal and vertical facial guidelines.

Step Two Following my guidelines, I place the facial features of an eagle. I also extend the wings and draw the feather pattern. Then I block in the lion paws and tail. Once I'm happy with the drawing, I erase the construction lines.

Step Three Using a .5 mm waterproof ink pen, I trace over the entire drawing with clean, bold lines. I draw heavier lines and darker areas along the shadowed bottom edges of the paws, and I draw a cast shadow from the tail to add a sense of depth. When working on the feather pattern, don't try to draw every single feather. As long as it looks plausible, it should be okay. If someone says it doesn't look real and brings you a live griffin for comparison, then you have your own set of problems.

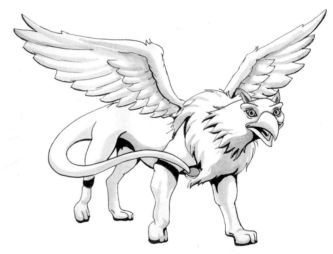

Step Four Simple black-and-white drawings like this one tend to be very flat. To remedy the flatness, I add some tone to areas of shadow. I mix India ink and water to make a light gray wash, and I lay in the wash with a small round brush. I try to keep the tone along the underside of the body shapes (where the lines already are thicker).

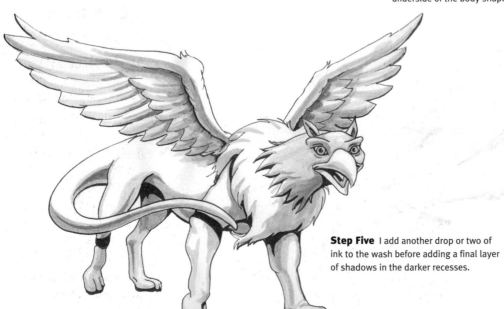

Step Five I add another drop or two of ink to the wash before adding a final layer of shadows in the darker recesses.

DID YOU KNOW?

- The natural enemy of the griffin is the horse. However, there are rare instances of offspring from the two creatures, called "hippogryphs."

- Griffins were commonly featured on gold coins in Scythia.

KRAKEN

The kraken is a sea monster of Norse mythology, described as having characteristics of an octopus and a crab or a giant squid, depending on the source! The kraken can sink a ship simply by submerging, thus causing a giant whirlpool.

Step One With a 2H pencil, I draw an almond shape, using construction lines to bisect it vertically and horizontally.

Step Two I block in the eye, ear hole, and the two protrusions, picturing the protrusions as can openers.

Step Three Now I draw the rubbery tentacles, keeping the lines long and flowing.

Step Four Picking up a 2B pencil, I render the facial details. I want to make the eye a focal point, so I place very dark tones next to a bright white to create an area of high contrast. I need the eye to be interesting enough to the viewer so that the tentacles won't overpower it. I add a soft gradation to the underside of the tentacles and give them a sense of depth with cast shadows. Like the eyeball, the shell is a simpler shape that needs extra attention to avoid being overshadowed by the tentacles, so I give it an interesting pattern.

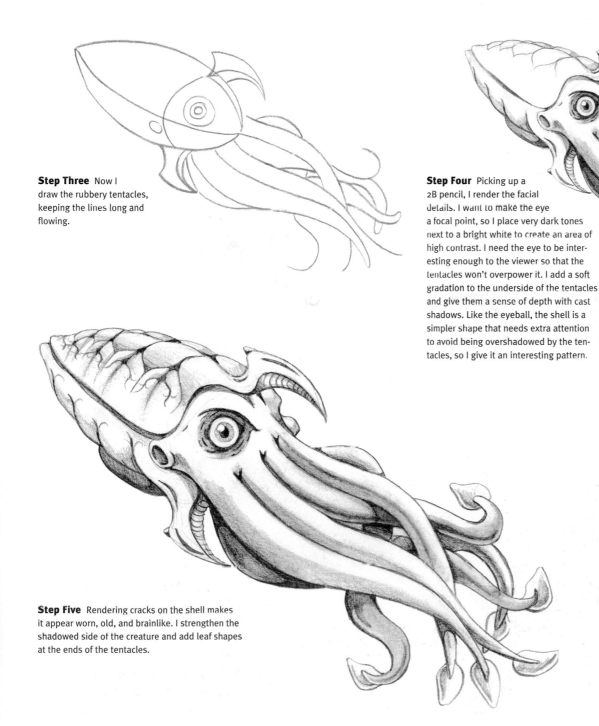

Step Five Rendering cracks on the shell makes it appear worn, old, and brainlike. I strengthen the shadowed side of the creature and add leaf shapes at the ends of the tentacles.

DID YOU KNOW?

- This sea monster was unnamed in the original Norse sagas.
- Schools of fish constantly swarm the kraken, which helps it lure unsuspecting fishermen.
- In Norwegian, "krake" means "something twisted" or "an unhealthy animal."
- The kraken is the size of a small island.

Unicorn

Many cultures reference unicornlike beasts, from early Hebrew and Greek to Chinese and Japanese. In the West, the unicorn is horselike in appearance, and has a single horn. During medieval times, the unicorn took on mystical healing properties—including a horn that could protect against poisons.

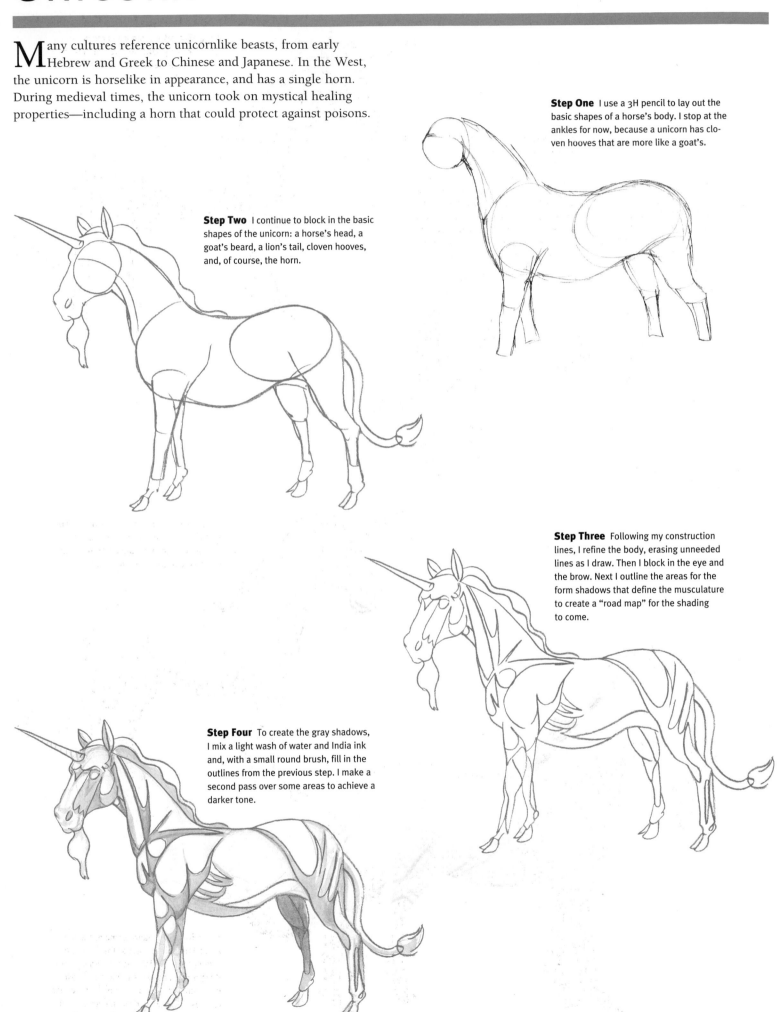

Step One I use a 3H pencil to lay out the basic shapes of a horse's body. I stop at the ankles for now, because a unicorn has cloven hooves that are more like a goat's.

Step Two I continue to block in the basic shapes of the unicorn: a horse's head, a goat's beard, a lion's tail, cloven hooves, and, of course, the horn.

Step Three Following my construction lines, I refine the body, erasing unneeded lines as I draw. Then I block in the eye and the brow. Next I outline the areas for the form shadows that define the musculature to create a "road map" for the shading to come.

Step Four To create the gray shadows, I mix a light wash of water and India ink and, with a small round brush, fill in the outlines from the previous step. I make a second pass over some areas to achieve a darker tone.

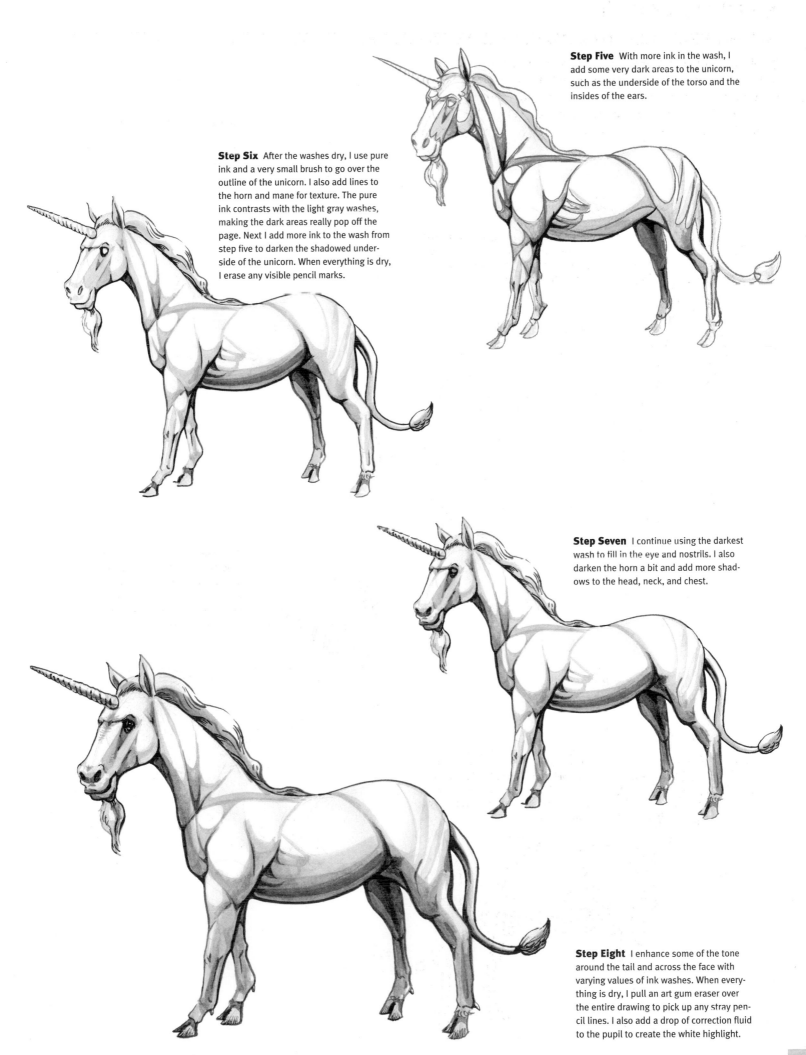

Step Five With more ink in the wash, I add some very dark areas to the unicorn, such as the underside of the torso and the insides of the ears.

Step Six After the washes dry, I use pure ink and a very small brush to go over the outline of the unicorn. I also add lines to the horn and mane for texture. The pure ink contrasts with the light gray washes, making the dark areas really pop off the page. Next I add more ink to the wash from step five to darken the shadowed underside of the unicorn. When everything is dry, I erase any visible pencil marks.

Step Seven I continue using the darkest wash to fill in the eye and nostrils. I also darken the horn a bit and add more shadows to the head, neck, and chest.

Step Eight I enhance some of the tone around the tail and across the face with varying values of ink washes. When everything is dry, I pull an art gum eraser over the entire drawing to pick up any stray pencil lines. I also add a drop of correction fluid to the pupil to create the white highlight.

PIXIE

The pixie is a very small creature, rarely standing more than a few inches tall. Fond of stealing people's belongings and throwing things at them, the pixie is a trickster who likes to play. But the pixie also works hard when a reward is at hand.

Step One I block in the basic form of the pixie with ovals and boxes, using a 2H pencil. I try to position the legs in a way that makes them appear to glide on air. Then I draw a large X behind the pixie to place the wings.

Step Two Switching to a 2B pencil, I make the cranium quite a bit wider. The larger head makes the figure look more child-like, which is a desirable quality for a pixie (even a grown-up one like mine). Of course, I give the character a short "pixie" hairstyle, along with almond-shaped eyes and a pointed ear.

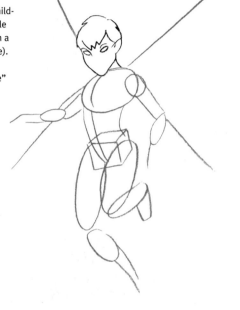

Step Three After I complete the button nose and full lips, I turn my attention to the delicate neck and shoulders. I decide to add an off-the-shoulder outfit to emphasize the graceful lines of the neck and shoulders. Then I refine the shapes of the arms and the pixie's left hand, wrapping bracelets around both wrists.

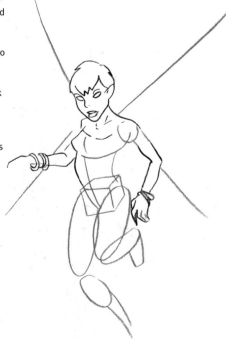

Step Four I refine the character's right hand, adding the handle of a magic wand. Following the construction lines, I draw the rounded shapes of the long, delicate wings.

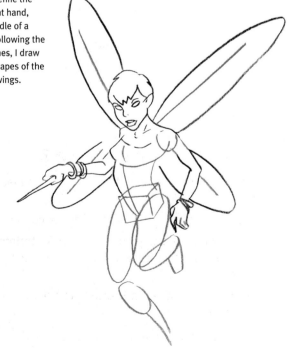

Step Five I refine the bottom of the legs and add ballerina slippers with ribbons that lace up the legs. As I draw, I slightly reposition her left leg so that less of the lower leg is visible. This new position makes her appear to be floating, rather than running.

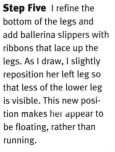

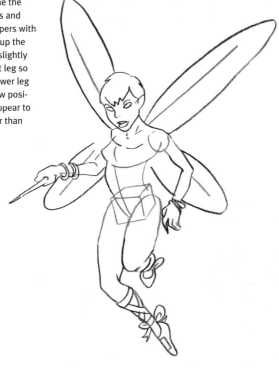

Step Six Concentrating on the dress, I draw the loose, off-the-shoulder sleeves, the bodice, and the ruffled skirt, erasing my construction lines as I go. I draw a line of Xs down the middle of the bodice to indicate lacing. Then I add creases on the upper legs to suggest musculature.

Step Seven After I clean up some of the line work with a vinyl eraser, I add a star at the top of the wand.

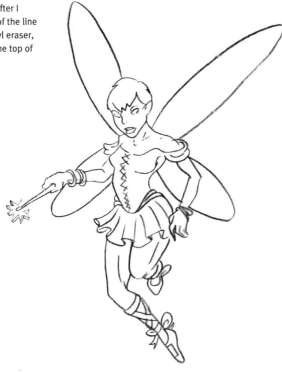

Step Eight I use a black colored pencil to trace over most of the line work and to shade the entire figure. I apply the shadows on the right side of the pixie's body because I imagine the light source to be the magical glow of the wand. I reserve the darkest tone for the eyes and the Xs on the bodice.

DID YOU KNOW?

- Pixies tend to have an aversion to all things made of iron.
- A pixie's eyes often are turned up at the corners.
- Some pixies leave "pixie dust" in their footprints, whereas others leave a trail of dust behind them as they fly.
- Tinker Bell, a character in Scottish novelist J.M. Barrie's *Peter Pan*, is a pixie.

Fairy

This spell-casting, magical creature is known for causing mischief, including tangling hair and disorienting travelers.

A fairy can bestow gifts upon a human child, but meddling in human affairs is a favorite hobby!

Step One With a 2H pencil, I establish the general shapes of the fairy's head, torso, arms, and legs using circles, ovals, and cylinders.

Step Two I use delicate lines to connect the shapes and then add the pointed feet and hand. I draw the shapes of the neck and nose, as well as the angled facial guideline. I draw a small circle at the end of the right arm, adding a line where the hand will be.

Step Three Using the facial guideline and a 2H pencil, I place the almond-shaped eye, upturned nose, and full lips. I also add a thin, arched eyebrow—then erase the construction lines. Next I draw the ear and the hair.

Step Four Building on my guidelines, I refine the forearms and the hands. I draw the fairy's right hand so that it is turned up, and the left hand with the fingers splayed.

Step Five Now I finish refining the arms, erasing guidelines as necessary. I also draw the scarf that wraps around her neck and flows behind her left shoulder.

Step Six I shape the torso, drawing curved lines to define the chest and stomach. Then I add the long, flowing hair, drawing a band around it at the base of the neck. Then I add the other end of the scarf. At this point, it's hard to tell where the scarf ends and the hair begins. I will correct this later with shading.

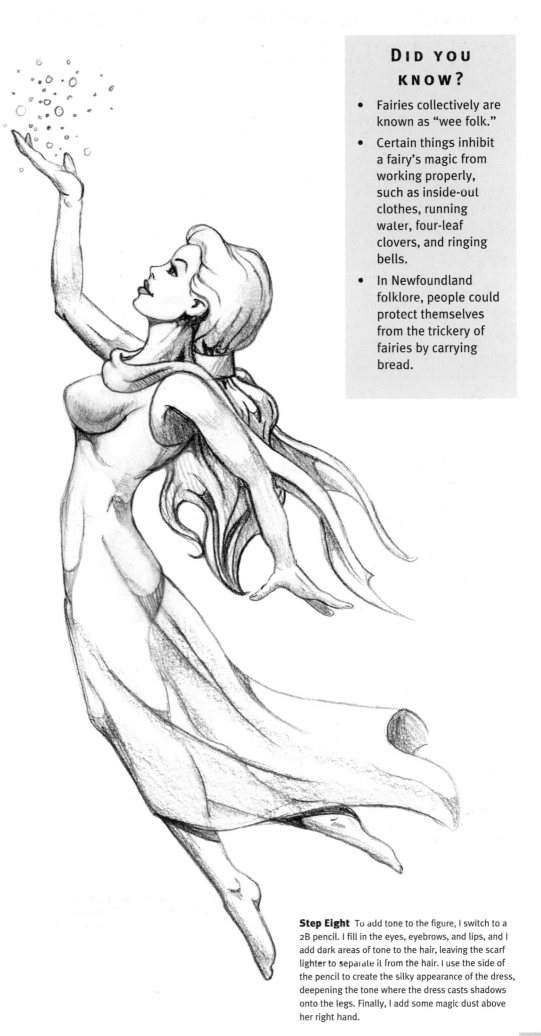

Step Seven After refining the forms of the legs and feet, I draw the general shape of the gown, which flows backward in the same manner as the scarf and hair. The lithe, graceful form of the body is still visible through the lines of the dress.

Step Eight To add tone to the figure, I switch to a 2B pencil. I fill in the eyes, eyebrows, and lips, and I add dark areas of tone to the hair, leaving the scarf lighter to separate it from the hair. I use the side of the pencil to create the silky appearance of the dress, deepening the tone where the dress casts shadows onto the legs. Finally, I add some magic dust above her right hand.

141

INDEX

ABOUT THE AUTHOR

Michael Dobrzycki is an accomplished painter, carpenter, puppet maker, and sketch artist whose work has been featured in more than a dozen children's books and small press publications over the last few years. Michael's illustration career began in 1999, when he toured the United States performing a one-man sketch-artist show called "Disney Doodles." Soon after, he began illustrating children's books for Yakovetic Productions. Michael has been a featured artist on Disney Channel Australia, and he was inducted into the Disneyland Entertainment Hall of Fame in 2001. Michael received his MFA in illustration from the California State University, Fullerton, and holds a BA in both art and history from Whittier College, where he has taught as a visiting professor. Michael currently serves on the Whittier Cultural Arts Foundation's Board of Directors.